MemyselfandI

Rogi André	Dora Maar
Richard Avedon	Madame d'Ora
Cecil Beaton	Man Ray
Bill Brandt	Willy Maywald
Brassaï	Gjon Mili
René Burri	Lee Miller
Robert Capa	Inge Morath
Henri Cartier-Bresson	Arnold Newman
Chim	Roberto Otero
Lucien Clergue	Irving Penn
Jean Cocteau	Julia Pirotte
Denise Colomb	Edward Quinn
Robert Doisneau	Willy Rizzo
David Douglas Duncan	Gotthard Schuh
Yousuf Karsh	Michel Sima
Jacques-Henri Lartigue	Horst Tappe
Herbert List	André Villers

MemyselfandI

Edited by

KERSTIN STREMMEL

on behalf of Museum Ludwig

Photo Portraits of Picasso

MUSEUM LUDWIG

HATJE CANTZ

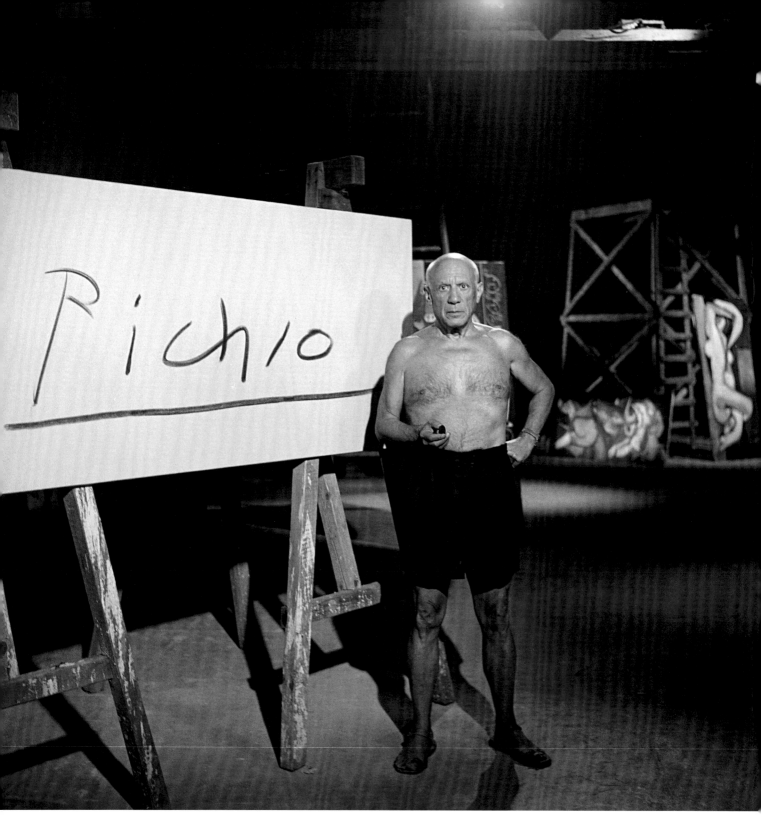

EDWARD QUINN Picasso in front of his signature for the film *Le mystère Picasso,* Studios de la Victorine, Nice 1955

Contents

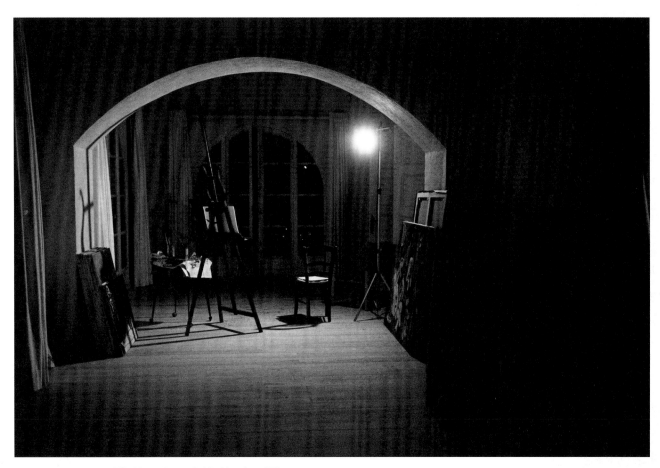

EDWARD QUINN Villa Notre-Dame de Vie, Mougins 1962

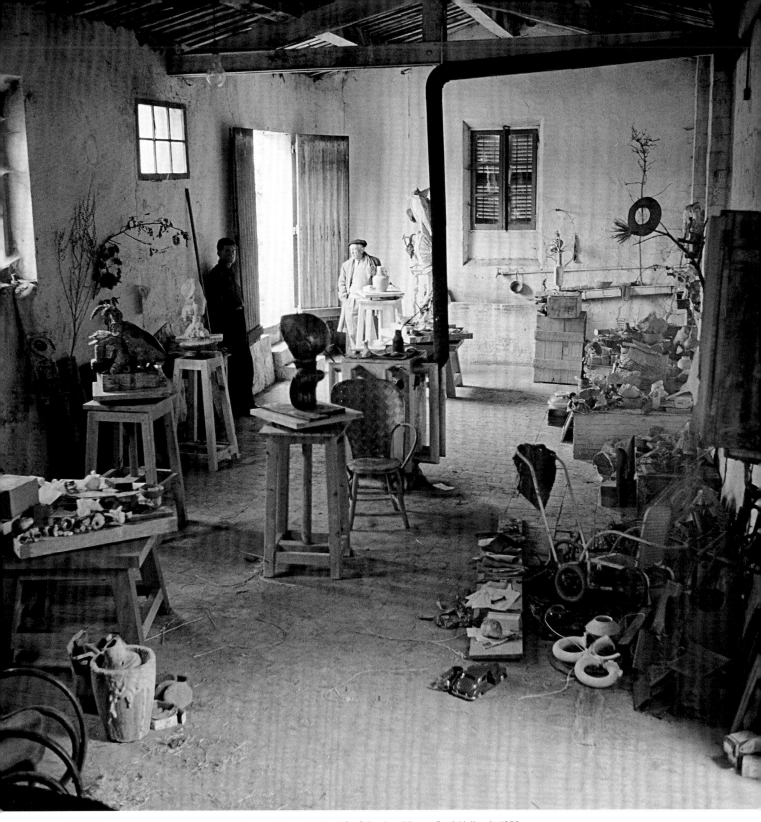

EDWARD QUINN Picasso in his studio Le Fournas, to the left of the door his son Paul, Vallauris 1953

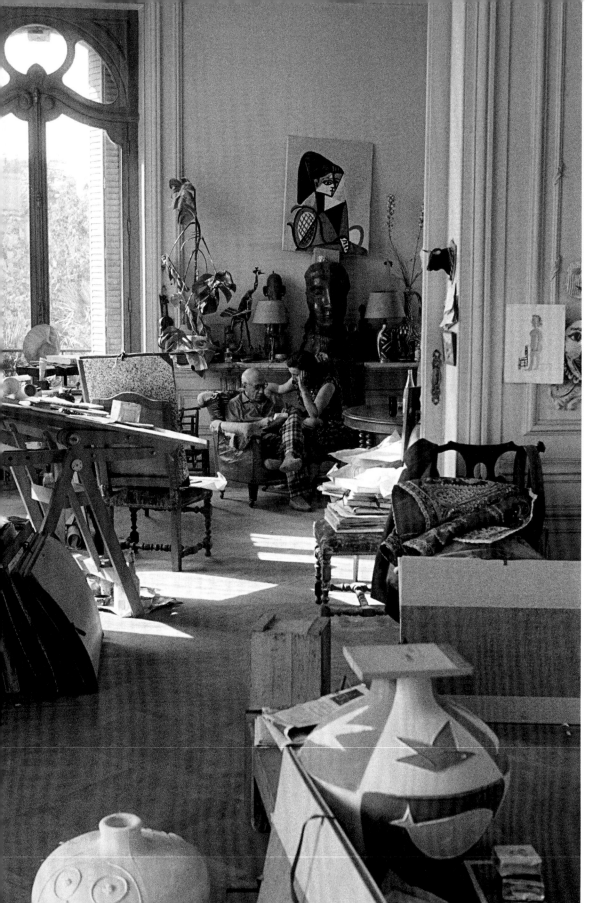

EDWARD QUINN
Picasso and Jacqueline,
Villa La Californie,
Cannes 1956

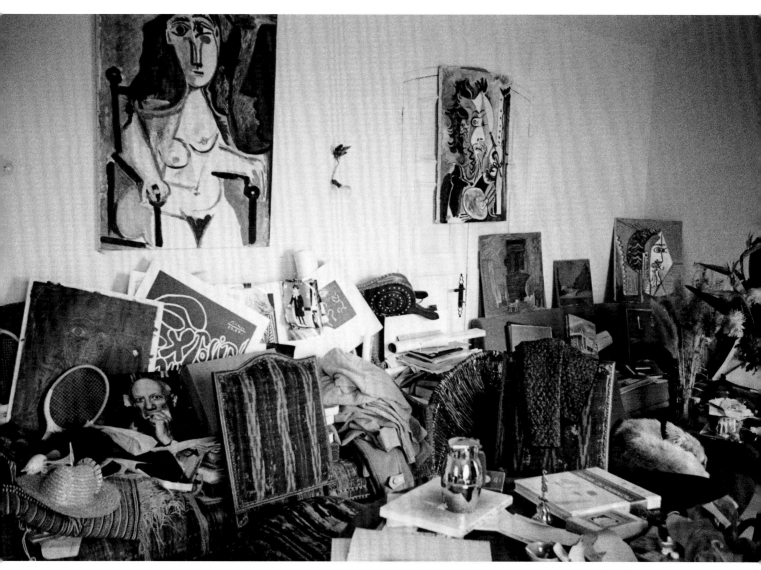

EDWARD QUINN Villa Notre-Dame de Vie, Mougins 1964

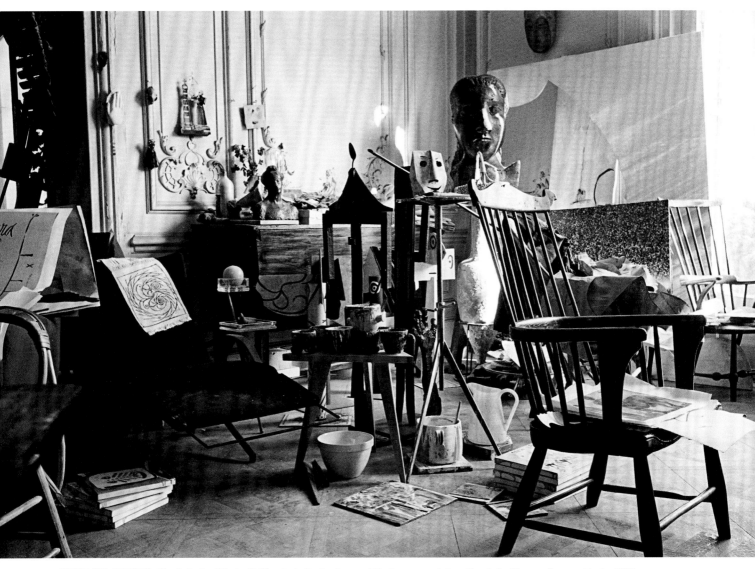

EDWARD QUINN Studio in the Villa La Californie, in the background the bronze sculpture *Head of a Woman*, Cannes, Easter 1961

Foreword

"Nothing is more daring than the attempt to define Picasso, the man more famous than Buddha or the Virgin Mary, more unpredictable than a crowd." This assessment of Picasso by his friend, the critic George Besson, may seem a little exaggerated, but it is probably true that there is no artist more famous than he is. The legend of his mercurial personality is fueled in large measure by the photographs that depict him. Some exhibition ideas seem so compelling that one really must verify several times over that they have never yet been done, but in actual fact the question of whether Picasso, brilliant and inspired self-promoter that he was, always stage-managed his own photographic portraits or whether some of his photographers—the famous ones, at least—were able to find their own pictorial language has never yet been investigated.

The point of departure for this exhibition was not only the well-known and extensive photographic collection of the Museum Ludwig, which includes numerous iconic works by such camera artists as Arnold Newman, Irving Penn, and Man Ray, but also the museum's rich holdings of works by Picasso himself, which make it possible to establish connections between his own masterpieces and those of famous photographers. For example, the collection includes Picasso's plaster sculpture *Head of a Woman (Dora Maar),* a bust of the Surrealist photographer whose works are represented in the exhibition. At the same time, the sculpture itself is visible in numerous images by photographers from Brassaï to Herbert List, from Edward Quinn to René Burri: his succession of lovers notwithstanding, Picasso lived with Dora Maar's face and made it almost a constant in his everyday landscape. Similarly, the sculpture *Woman with Baby Carriage* gains appeal when we see Picasso pushing his son Claude along the beach in the baby carriage in a photo by Robert Capa, or playing with the baby in photos by Lee Miller. These images not only show the faces and places that shaped the artist's life, but communicate a sense of the complex world of relationships that were important for Picasso's remarkable biography. The Museo Picasso Málaga, in turn, has dedicated its entire

collection to works by its native-born son, allowing fascinating connections to emerge between these pieces and many of the photographs.

In order to assemble a compelling overview, loans from other important collections and archives were necessary. We would like to express our sincere appreciation to these lenders for their generosity. The Peter and Irene Ludwig Foundation made a significant contribution, realizing key purchases to complement the holdings and strengthen the photographic collection with important bodies of work by such artists as Brassaï and André Villers. We would also like to thank the knowledgeable director of the photographic collection at the Museum Ludwig, Bodo von Dewitz, for his support, and the curator of the exhibition, Kerstin Stremmel, for providing thematic focus for the exhibition and publication. Our gratitude likewise goes to the authors who have contributed to the present publication, including Pierre Daix, longtime companion and connoisseur of Picasso's work; Katherine Slusher, who examines important women photographers; and Friederike Mayröcker, whose poetic text brings together the photographs and works from the collection into a sonorous collage. We would also like to thank the diligent staff of Hatje Cantz Verlag, the inspired graphic designers Lena Mozer and Ernst Georg Kühle, and the staffs of the Museum Ludwig and Museo Picasso Málaga. Both institutions are home to a rich assortment of paintings, graphic works, sculptures, and ceramics by this versatile master of many materials. The photographic portraits reflect Picasso's interaction with the medium of photography, convey new insights into his artistic oeuvre, and represent pinnacles of portrait photography.

KASPER KÖNIG
Museum Ludwig, Cologne

JOSÉ LEBRERO STALS
Museo Picasso Málaga

HERBERT LIST The building Picasso was born in, Málaga, 1951

Picasso

Short, dusky, stocky, nervous, with dark piercing eyes. gestures
big. feet small, and hands also
disorder, brutal and colorful
everyone welcome at his table
not cut out for Paris
mattress for friends
"are you working?"
the roguish bitterness
espadrilles. old cap, roofer, washed over and over.
shirt in cotton fabric sold for 2 F on the square Saint Pierre
old, small fedora for dinners at the art
dealers'.
the luxuries when fortune came
smell of dogs and paint
his father, professor at the Ecole des Beaux-Arts
The Bateau-Lavoir 13 Rue Ravignan humorists, washerwomen, colors
costermonger. chatting at the front door
continual procession of Spaniards: Paco Durio. Zuloaga the
monk-soldier, generous and lordly who showed me works
by El Greco before there were any at the Louvre or in books by
Barrès
bed base on 4 legs.
cast-iron stove.
earthen washbasin with dirty towel, trunk painted black
a wicker chair.
the Spanish piglets
a white mouse
Fernande
The blue period in 1903.
Picasso and the art dealers.
His grace.
Mournful, bearing some great sorrow; sarcastic
fond of animals, Frédé's donkey ate two scarves and a
packet of tobacco
he would have liked to have a rooster and a goat, stole cats, trained them
the safe (interior wallet with a pin)
suspicion.
The 5 o'clock visit to the dealers.
Matisse had brought Mr. Tchoukine
who displayed great warmth to visitors he secretly wished
would go to hell.

MAX JACOB · 1935

KERSTIN STREMMEL

Picasso and the Power of Photography

Stereotypes in the description of Picasso are legion: the magician with the deep, dark, penetrating eyes and a "strangely intense gaze,"[1] or, even more evocatively, eyes like "burning coals" or "black diamonds."[2] Yet one of his photographers—Henri Cartier-Bresson—was known as "Les yeux de la siècle" (the eyes of the century), while Henry Miller called Brassaï "the eye of Paris" in an essay of the same name.

Encounters between these people of the eye—the painter and the photographers—seem inevitable, and the result is art and cultural history. Some photographers virtually made a career out of portraying Picasso, filling illustrated magazines with his image and publishing numerous books;[3] they profited from the fame of their subject and helped intensify the myth surrounding him. Exhibition posters also frequently featured Picasso's face: his countenance stands for his work, with its ever-changing styles.

Figs. p. 15

Posters using photos by Herbert List (left), Edward Quinn (middle two), and Kurt Blum (right)

Yet despite the profusion of published photographs, the tension between Picasso's desire to control his self-representation and the ideas and ambitions of the photographers themselves—many of whom were famous—has not heretofore been explored. What role did Picasso play in the conception of these images? How effective were the strategies of an artist who made a public display of the women in his life and of his work, of his charades and his political views, and who selectively exploited his private life to create a cult of personality? At times the photographers were commissioned by Picasso, and they were often friends with him,[4] yet they also viewed themselves as autonomous and original visual artists. To what degree, if at all, could their individual pictorial languages assert themselves against the dominating presence of their subject?

Neue Illustrierte, Cologne, August 18, 1956

Detailed study of the topic brings to light not only famous photographic icons, but also images that are, surprisingly, unknown. A comprehensive overview would be both tedious and impossible; a more important task is to examine and present the differing types of photographers, from the Surrealist Dora Maar to the flaneur Robert Doisneau, from Magnum photographers like Robert Capa to society and celebrity photographers like Cecil Beaton and Edward Quinn, along with classical portraitists like Richard Avedon. Thematically, the images range from classic depictions of the artist in the *lieu sacré* of the studio—as in the quiet, almost monumental photographs by former sculptor Michel Sima—to images of spaces and works that combine to form a detailed overall picture, as in Brassaï's collection; from snapshots on the beach to images of the loving paterfamilias amid his clan to photos of the politically engaged artist surrounded by kindred spirits. Who was able to maintain their independence in the face of Picasso's need for self-fictionalization, and are some of the photographs interesting even apart from the identity of their subject?

He and he and he

While a portrait photograph is always the result of a relationship between the model and the photographer, Picasso's influence on the image-making process seems to have taken on unusual proportions. The title *MeMyselfandI* is intended to suggest not only Picasso's role in his photographers' creation of their works, but also the multifaceted quality that is expressed in these images. Not least, however, the title alludes to Picasso's

MAURICE FERRIER

Pablo Picasso with his left hand in his pocket, Vallauris, undated

Pablo Picasso signing his book, Vallauris, undated

Pablo Picasso with a cigarette in his mouth signing his book, Vallauris, undated

passion for poetry and to the poets with which he surrounded himself throughout his life. The following excerpt from the poem "If I Told Him: A Completed Portrait of Picasso" by writer, collector, and patron Gertrude Stein is more than just a tautology:

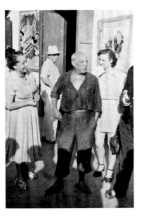

> "He he he he and he and he and and he and he and he and and as and
> as he and as he and he. He is and as he is, and as he is and he is, he is
> and as he and he and as he is and he and he and and he and he . . ."[5]

These lines verbalize the obsessiveness that fundamentally characterized Picasso, the "visual glutton" (as Pierre Daix called him), a trait also manifested in his excessive desire to be photographed.

Many of Picasso's friends were writers; as Gertrude Stein explains: "His friends in Paris were writers rather than painters, why have painters for friends when he could paint as he could paint."[6] One of the writers with whom Picasso enjoyed a long association, despite their differing political persuasions, was Jean Cocteau, whom he met in 1915. A year later, Cocteau also emerged as his photographer, creating a legendary series of images in the vicinity of the Café La Rotonde depicting Picasso with such figures as Moïse Kisling, Amedeo Modigliani, and André Salmon. Picasso is always at the center, making even the somber Modigliani laugh with his antics; he smokes and flirts with Pâquerette, who at that time was a successful fashion model for designer Paul Poiret—and Picasso's lover. The images capture the atmosphere of a summer day and the carefree spirit of bohemians who at that time of year didn't need to worry about fuel for heating.

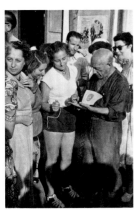

Figs. pp. 72–73

The poet Max Jacob, too, was with Picasso on that August 12, 1916; their friendship had begun in 1901, when their mutual friend Guillaume Apollinaire had introduced them to one another.[7] Jacob's poem of 1935, quoted at the beginning of this essay, bears witness to his familiarity with the artist and laconically evokes the subject at the center of the photographs: the all-dominating eyes, the small hands, the expansive gestures, the chaos all around (a defining characteristic of his diverse living and working situations), Picasso's relationship to his friends and his exaggerated friendliness to visitors—a trait also manifested in the number of photographers he allowed into his life without betraying his annoyance with them. The latter included local notables such as Maurice Ferrier, a resident of Vallauris in the south of France, who photographed Picasso mingling among crowds.

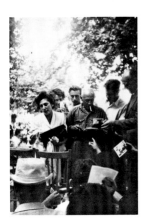

Figs. p. 17

But what explains the sheer quantity of the images, both incidental snapshots and carefully staged photographs, many of which have become so famous that they can be

used without commentary in advertising—paired with the slogan "Think different," for example[8]—or re-created with different protagonists, firmly anchored as they are in the collective consciousness?

Figs. pp. 24, 40

Picasso was indisputably photogenic, and his enthusiasm for photography—as evidenced by, among other things, the several thousand photos in his archive—has been the subject of an extensive publication.[9] This body of material includes about 100 negatives and prints made by Picasso before 1920. After that point, however, he rarely took photographs himself—at the most, he photographed playfully, as, for example, during photo sessions when both Lee Miller and David Douglas Duncan were present and Picasso began to take part in the reciprocal picture-making so as not to remain merely an object. The medium's significance for him is manifested in such statements as: "I've discovered photography. Now I can kill myself. I've nothing else to learn,"[10] words which, according to Fernande Olivier, were spoken under the influence of hashish around 1910, the same year he posed with her in a classically improvised self-portrait. To be sure, such statements did not mean that he viewed photography as an

Fig. p. 67

Fig. p. 18

art form; rather, it was a fascinating medium for recording and comparison, and was used as such. The best-known early examples of the latter are the pictures from the Spanish village of Horta de Ebro, which served as reference material for his Cubist paintings and which, according to Gertrude Stein, proved that the Spanish villages were as Cubist as Picasso's paintings.

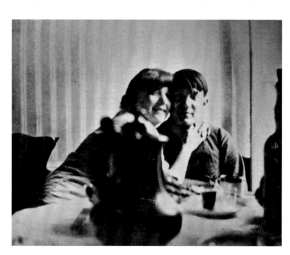

PABLO PICASSO
Self-portrait with Fernande Olivier, Paris, ca. 1910

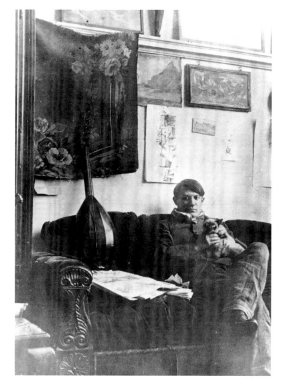

PABLO PICASSO Self-portrait in the studio on Boulevard de Clichy, December 1910

In the mirror "moi PICASSO"

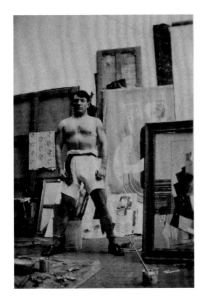

PABLO PICASSO Self-portrait with bare torso and in boxer shorts in front of *Homme assis au verre* in the studio on Rue Schoelcher, 1915–16

Interesting for our purposes are Picasso's photographic self-portraits, which in many respects set the tone for later photographers. In his 1904 portrait of Ricardo Canals, Picasso appears as an observer in the mirror, and on the back of the image he inscribed the following commentary: "portrait de la peintre Ricardo Canals de Barcelone / dans la glace moi PICASSO / sur la cheminée une photo de Benedetta femme de Ricardo Canals / photo faite à Paris dans l'atelier de Canals en 1904."[11] The capitalized "moi PICASSO" recalls the self-confidence of the famous painted self-portrait *Yo Picasso* of 1901. As Anne Baldassari has shown,[12] in allusion to Diego Velázquez's famous painting *Las Meninas,* Picasso here occupies the place which in that work is reserved for the royal couple; in this way he asserts himself as the actual subject of the image, under the pretext of a conventional artist portrait. In fact, Picasso's mastery of the photographic medium was so sophisticated that only recently has an alleged self-portrait in a mirror been attributed to Dora Maar.[13] The original attribution to Picasso speaks to the degree to which he himself was considered capable of interesting formal solutions.

Fig. p. 20

Costumes also appear in these early photographs; the best-known of these are Picasso's self-portraits in front of paintings in the studio on Rue Schoelcher in 1915–16. Here he poses in cap, work jacket, and strange two-colored pants, but also as a boxer in white shorts. Standing bare-chested, with legs apart and a challenging gaze, he practices a calculated effect, while the view from below gives him a monumental appearance. This and other photos from the Rue Schoelcher, "rather than depicting an artist who has already made it . . . show painting's forced-laborer, the 'good-looking bootblack,' the distillation of virility and artistic arrogance."[14]

Fig. p. 19

Picasso's love of experimentation manifests itself even more clearly in his shadow self-portrait from 1927, the same year André Kertész also created his own shadow profile. Many later portraitists used light and shadow to

Fig. p. 19

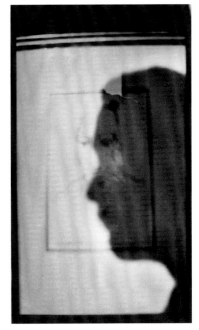

PABLO PICASSO
Self-portrait in profile, Paris, 1927

DORA MAAR Picasso in the mirror in his studio, Villa Les Voiliers, Royan, summer 1940

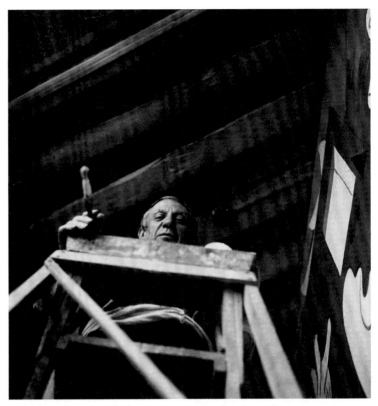

DORA MAAR Picasso on a ladder holding a paintbrush in front of *Guernica,*
Paris, 1937

DORA MAAR Picasso sitting on the floor working on *Guernica,*
VI bis stage, Paris, 1937

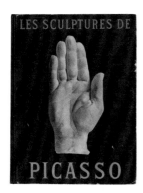

Cover of the book *Les sculptures de Picasso: Photographies de Brassaï*, Paris 1948

intensify the effect of their images: in his photograph of Picasso with bare torso, for example, Man Ray uses the cast shadow of the head to emphasize the sculptural quality of the image, while Edward Quinn transforms the artist into a supernatural apparition with the help of a beam of light. In a photograph by Horst Tappe, the shadow of a tree creates a kind of austere drawing on the surface of Picasso's face. Virtually no one, however, worked as experimentally with the medium of photography as Picasso did when he himself was the subject.

Fig. p. 54

Fig. p. 194

Fig. p. 221

Picasso also used photography to document his works,[15] but later relinquished this task to the outstanding photographers of his time. Dora Maar's photos of the creation of the painting *Guernica,* taken in 1937 and published in *Cahiers d'art*, are legendary. For many viewers, *Guernica* was accessible only through reproductions; for example, the protagonists in Peter Weiss's novel *The Aesthetics of Resistance* are discussing the photographs when they discover that "each of Picasso's works was to be seen as part of a multiplicity, the sum of which drew in even the most casual notice."[16] Brassaï's photographs of Picasso's three-dimensional works first communicated his significance as a sculptor to a larger public: the monograph *Les sculptures de Picasso,* published in 1949 with a foreword by Daniel-Henry Kahnweiler, bears witness to both the versatility of Picasso's genius and Brassaï's ability to give subtle life to the sculptures.[17] Later, the creation of *The Beach at La Garoupe* was meticulously documented in connection with the making of the film *Le mystère Picasso* by Edward Quinn. Here the role of photography is clearly defined: it documents the creative process and Picasso's talent, which includes the capacity for ruthless analysis of his own artistic approach. The artist always shows the same seriousness, whether in the composition of an eminently political picture like *Guernica* or in works devoted solely to the struggle for a convincing formal solution. Photography could also serve as a transformable material from which Picasso appropriated elements for collage and overpainting. Yet throughout his life, the images he allowed to be made of himself continued to express a deep ambivalence.

Figs. p. 21

"Mirrors lie, and photographs lie"[18]

"When I woke up and looked at myself in the mirror with my disheveled hair, do you know what thought came to me? Well, I was sorry I wasn't a photographer! . . . Someone ought to make a hole in a mirror so that the lens can capture your most intimate face unawares."[19] Other people could be photographed in this way, but what about his

own face, his own facial expression? Was Picasso seeking to observe it with the help of another's view, and was he aware of the failure of this attempt?

"What one sees in the mirror is a frozen object, an imaginary thing. In the same way, what one sees in a photograph is not oneself. I would say that the only one who cannot see me is ME—whereas others see me."[20] Perhaps it was this deficiency—this inability to see, of all things, his own self—that aroused Picasso's visual appetite and his desire for ever new photographic portraits of himself. How much can the photographs of others make visible, and how much remains concealed? Was Picasso's concern with his own external appearance a way of expanding his knowledge, since, as the only one who couldn't see himself, he lacked the capacity for visual corroboration? Or, knowing that the medium allows every photographic subject to anticipate its image, did he attempt to conceal certain things from others, too, and strategically employ only carefully selected and choreographed aspects?

Photographs of Picasso from various phases of his life differ in their dramatic intentions as well as in their increasing refinement of self-representation. The bohemian of the early years, huddled by the stove in his studio, does not Fig. p. 23 seem entirely sure how he wants to appear in front of the camera. The formal portraits by Man Ray from the early twenties reveal Picasso's social ambitions, as he carefully adapts to his environment and the representative aspirations of the photog- Fig. p. 74 rapher. Such images continue into the early thirties, as Picasso celebrates the successes of his show at the Galerie Georges Petit in Paris and his first museum exhibition in Zurich; the tasteful climax, full of casual elegance, is embodied in Man Ray's group portrait of Picasso with the attractive gallery owner Yvonne Zervos and another woman. Later, however, against Fig. p. 52 the background of political events that held particular significance for Picasso, the exiled Spaniard, such motifs no longer seem conceivable.

GELETT BURGESS Picasso, 1908

Instead, such images give way to the seriousness visible in the photograph by David Seymour, who portrayed Picasso as a political figure in front of his painting *Guernica:* "This portrait shows Picasso not as the glamorous artist, but as a Spanish Republican, his eyes burning like those of the terrorized victims he painted."[21] The same seriousness appears in photographs Fig. p. 97

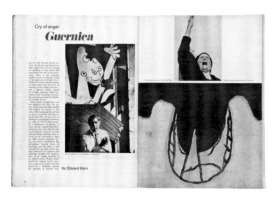

Life Magazine, December 27, 1968

made during the German occupation of Paris, when even Picasso's name and fame were not enough to shield him from deprivation or guarantee his security; thus the liberation of France in August 1944 is a moment of great joy and relief, made visible in the images by Robert Capa and Lee Miller. Perhaps it is no coincidence that with the end of World War II, Picasso once again began to place emphasis on his appearance: while a photograph by Herbert List shows the artist with *Still Life with Skull* under his arm and disheveled hair falling over his forehead, Brassaï reports an encounter after the German capitulation in May 1945 in which Picasso declared: "No more forelock!"[22] Picasso had decided to adapt his hairstyle to his receding hairline.

Fig. p. 124

Fig. p. 103

His move to the south of France brought a change not only in the lighting and ambience of the photographs, but also in the types of photographers who depicted Picasso. A few of them, like Lee Miller, photographed him over long periods of time. Artists like Dora Maar, whose assertiveness and sense of drama initially caused Picasso to seem surprisingly uncertain before her camera, were replaced by photographers who no longer had any connection to the Parisian set.[23]

Thus it remained an exception when a photographer like Robert Doisneau, who first photographed Picasso in 1944 and made portraits of him for the magazine *Le Point* in 1952, was able to assert a visual idea of his own, as in the legendary loaf-finger picture of 1952. In many of the images from the south of France beginning in the early 1950s, Picasso appears in self-chosen poses in accord with his own redundant pictorial ideas. Although some of his photographers maintain that at a certain point, he became so immersed in his work that he no longer noticed them, that too may be understood as a kind of pose, one that permitted Picasso to use the time during which he was being photographed productively. This phenomenon is brilliantly demonstrated in the photos by Edward Quinn and André Villers made during the shooting of the Clouzot film *Le mystère Picasso.*

Fig. p. 143

Figs. pp. 132–135

When Picasso's sculptures enter the field of vision, the concern is less to document his creative frenzy than to evoke an impression of this demiurge himself. This is most obvious in a series by Quinn that shows Picasso assembling *Woman with Key ("La Madame")*; at the end, he looks enthusiastically at his creation. This humanization

Figs. p. 189

LUTZ VOIGTLÄNDER
Maki Fingers, 2002

CHRIS BUCK
Steve Martin on the cover
of *Pdn*, 2006

Fig. p. 128
also occurs in the series by Lee Miller in which Picasso plays with the baby in the sculpture *Woman with Baby Carriage,* rocking, feeding, and teasing his own progeny.

Figs. p. 129

Fig. p. 87

Fig. p. 127
This motif recurs in several startling photographs by Picasso's second wife, Jacqueline Roque, where she poses as mother—or she and Picasso as parents—of a child they never had together. In Lee Miller's photograph of a tête-a-tête between Picasso and a sculpture of Jacqueline, the artist seems at least as interested as he would have been in a conversation with a real human partner. Picasso had already appeared as the dominant genius in earlier pictures by Brassaï, in which he pretended to strangle one of his sculptures.

The photographic transformation of Picasso into creator or magician also occurs without his works as accessories: Quinn photographed Picasso in a white robe in the crowd (of his disciples?). He appears prophetically inspired, and only on second

Fig. p. 197
glance do we realize that Picasso is actually posing in white shorts, holding a bull-fighter's cape in such a way that it looks like a priest's robe. Some of these "creator" pictures display a wonderful sense of irony and self-irony; while in the photograph by

Figs. pp. 140–141
Doisneau "la fleur volante" seems to hover above Picasso's hand, a closer look reveals part of a hand holding a fishing rod behind him, assisting in the telekinetic stunt. Irony also plays a role in the early tableaux with *La femme à la Palette,* a bronze figure with the body of a tailor's doll from 1900, which Picasso lovingly embraces in a photograph by Capa and arranges for Brassaï in an "authentic" scenario.

"It was at the Bateau-Lavoir that I was famous! When Uhde came from the heart of Germany to see my paintings, when young painters from every country brought me what they were doing and asked for my advice, when I never had a sou—there I was famous, I was a painter! Not a freak . . ." [24]

While the images from the early period seem uninhibited and playful—as in the photo by Brassaï in which Picasso himself plays the naïve *artiste* and the actor Jean Marais

Fig. p. 26
mimics the model—later the charades become more labored. The self-image of the early years seems to give way to a desire for greater control, without the influence of others. While previously his photographers had been artist friends, now he associated more and more with society photographers. An exception was Jacques-Henri Lartigue, who participated fully in Picasso's life for the duration of his photo series in

Fig. p. 173
1955 and whose album pages, supplied with handwritten commentary, maintain their relaxed, private character.

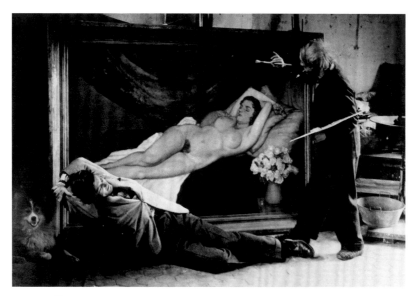

BRASSAÏ Picasso plays *artiste-peintre*, Jean Marais mimics the model, Paris, 1944

In reaction to growing interest in him as a personality, Picasso assumed the role of director, props manager, and actor for his photographs, and in so doing pioneered the kind of media-driven image creation that Andy Warhol, the "sphinx without a secret,"[25] would continue to pursue later in the twentieth century. The photo series from *Life* points to family life, thus satisfying public curiosity about Picasso the ladies' man. The images are interesting primarily from a sociological standpoint and vividly illustrate the changes Picasso underwent, from bohemian to bourgeois to a man who knew that art alone mattered to him; the image of Picasso's second wife, Jacqueline Roque, paying homage to the master with a kiss on his hand serves, *pars pro toto,* to exemplify this shift. A captivating photograph from 1948 appears to depict the epitome of ease and happiness, even apart from the identity of its protagonists: Capa's lighthearted image of the artist on the beach with Françoise Gilot is an icon of summer that deserves the title of a painting created two years earlier, *La joie de vivre.* The photograph of Picasso and Gilot with the baby carriage, on the other hand—taken by Capa on the same day—is interesting only because of its subject, and because the baby carriage—containing their son Claude—will later become part of the sculpture *Woman with Baby Carriage.*

Figs. pp. 27–28

Fig. p. 26

Fig. p. 152

Fig. p. 153

EDWARD QUINN
Jacqueline holding Picasso's hand,
Villa Notre-Dame de Vie, Mougins 1967

Picasso's delight in charades became an integral part of his photographs; it seemed to arise from a certain ennui, yet often tran-

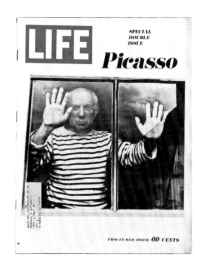

Life Magazine,
December 27, 1968

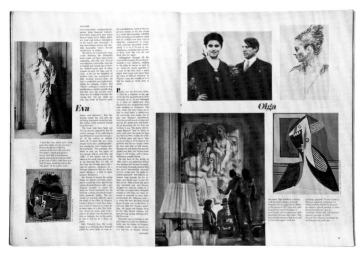

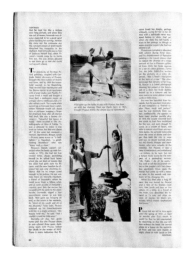

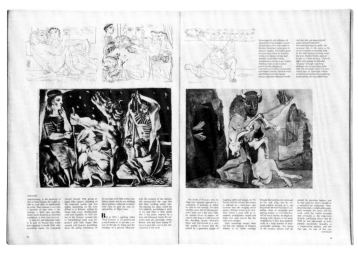

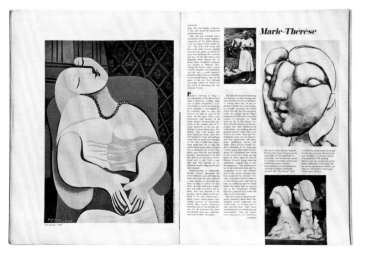

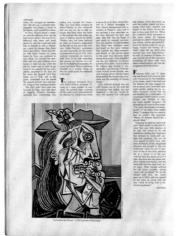

Life Magazine,
December 27, 1968

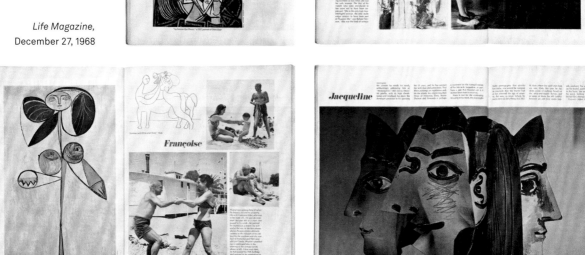

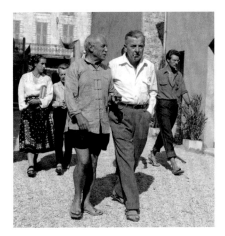

EDWARD QUINN
Picasso and the French writer Jacques
Prévert, behind them Françoise Gilot and
Janine Prévert, after a visit to a pottery
exhibition in Vallauris, 1951

scends that quality in its effect. Thus the bull mask in the photograph by Quinn transforms him into a minotaur, and the elegant wave of a white towel in an image by David Douglas Duncan demonstrates how he has internalized the gesture of the bullfighter, whose precision he admired his whole life. Again and again Picasso resorts to his arsenal of masks and hats, and most striking of all is the self-confidence he projects even in the most ludicrous costumes—for example, in the numerous portraits in undershorts.[26]

Fig. p. 187

Fig. p. 223
Figs. p. 186

Friends, too, are part of the drama, and at times are likewise outfitted with masks and costumes, as was the case with Picasso's secretary, Jaime Sabartés. As such, the friends belong to the Picasso portrait. Cocteau shows up again and again as a companion in the bullfight or at a table, where Lartigue and Quinn photograph him being fed by Picasso. The almost trenchant repetition of the motifs shows that several photographers were present, but perhaps also reveals a certain coolness on Picasso's part toward Cocteau on account of the latter's political aberrations. In the photographs of Picasso and Jacques Prévert, on the other hand, one can almost feel the sympathy between the two men in every picture, their cigarettes displayed as a mark of casual style.

Fig. p. 172

Fig. p. 29

At the same time, photography also served to document Picasso's political involvement. His friend Kahnweiler described Picasso's communism as unpolitical and sentimental,[27] yet although he hated public appearances, the artist emerged as a figurehead at peace conferences like those in Rome or Breslau, where Julia Pirotte photographed him with a serious expression, fully concentrated on "the cause." Later, he appears equally attentive in conversations with figures like Communist leader Maurice Thoret or antinuclear activists Yves Montand and Simone Signoret.

Fig. p. 69

Fig. p. 70

Fig. p. 29

And of course—since, after all, Picasso did spend decades on the Côte d'Azur—there was also a photo session with Brigitte Bardot.

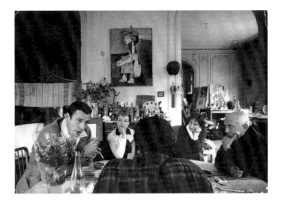

DAVID DOUGLAS DUNCAN Pablo Picasso seated
at a table with Yves Montand, Simone Signoret, Georges
Tabaraud and his wife, Villa La Californie, Cannes 1956

Neither of them seemed entirely comfortable with the encounter, and Picasso didn't need this kind of personality cult: he himself was the photographers' main prize.

"Well he was only 5'3"
But girls could not resist his stare"[28]

It is the magic of Picasso's eyes—their intensity already noticeable in a photo taken at age fifteen—that seems to overshadow all pictorial inventions. Photographers saw the possibilities in those eyes, and used them. Roberto Otero used them in a photograph whose title speaks for itself: *Picasso's Eyes, Life-Size*. The best-known example, however, is a photo by David Douglas Duncan that Picasso used as the basis for a collage, combining the photographed eyes with a drawn owl. Duncan documented the creation of this collage as well as an additional one; later, René Burri once again profited from the idea while shooting his three-part series. The complex relationship between photographer and subject, however, comes to most pointed expression in a collage by Arnold Newman, in which Newman tore out an eye from his famous portrait of Picasso[29] and glued it onto black photographic paper. The impact of the collage arises from the photograph of the eye, yet Newman still succeeds in creating a puzzle, since the viewer at first assumes that the intense gaze is passing through an opening in the wall: our habits of vision suggest that Picasso is looking through a hole, yet upon closer examination, the photographer emerges as the actual creator of the image, for whom the tearing up of a photograph is enough to entangle us in a game of gaze and counter-gaze.

Fig. p. 30

Figs. pp. 34–37

Fig. p. 33

Lee Miller doubled Picasso's eyes with a photo of his eyes in front of his face, and while Irving Penn—a portraitist whose pictorial inventions have a memorable yet matter-of-fact quality—shows the artist in a self-chosen costume with a dark, embroidered bullfighter's cape and a stiff-brimmed hat, the visual effect arises from his concentration on one of Picasso's eyes. This brilliant reduction is so effective that it even works in a re-creation by Ulrich Tillmann in which L. Fritz—the doyen of photography for whom this picture was "The Eye of the Century"—appears as Pablo Gruber.[30]

Fig. p. 65

Fig. p. 201

Fig. p. 40

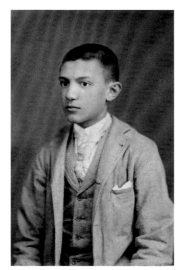

HERBERT LIST
Reproduction of a photo of the fifteen-year-old Pablo Picasso, 1944

"It is the eye of a visually oriented man, and designed for perpetual astonishment," said Brassaï of Picasso's gaze. His eyes

> continued on p. 40

ANDRÉ VILLERS Pablo Picasso, Cannes, 1955

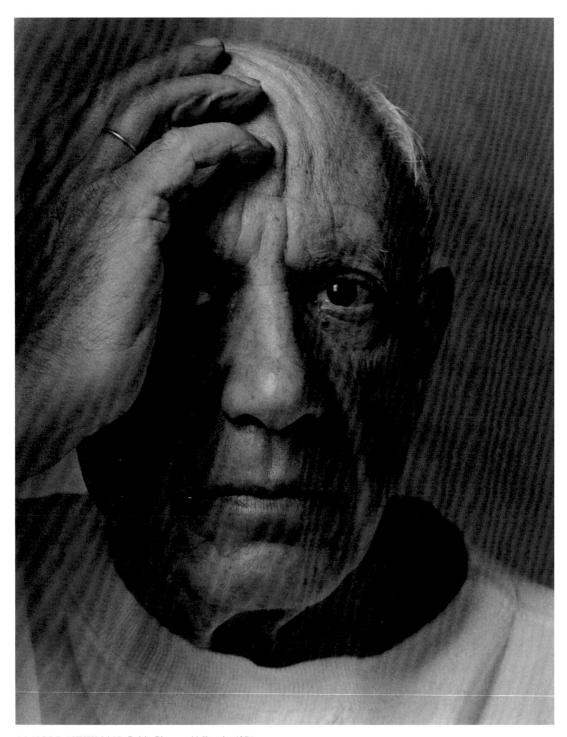

ARNOLD NEWMAN Pablo Picasso, Vallauris, 1954

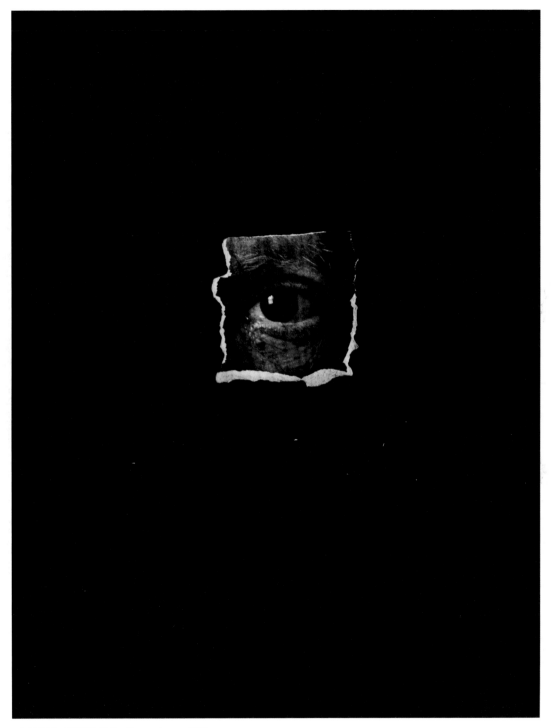

ARNOLD NEWMAN Picasso's eye, 1954

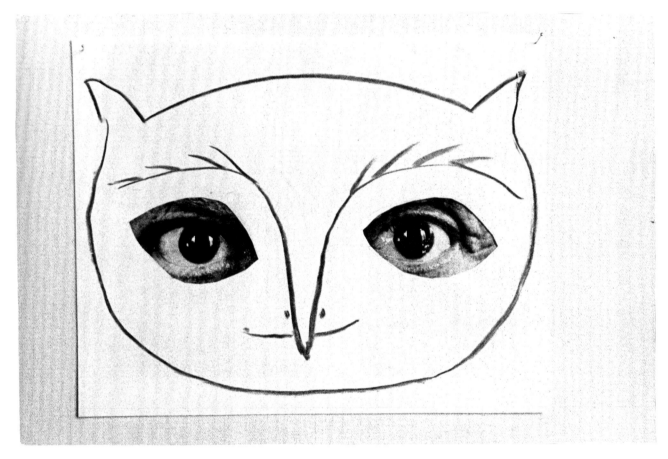

DAVID DOUGLAS DUNCAN *Small Snow Owl* (1-I), 1957

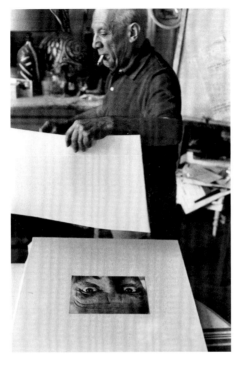
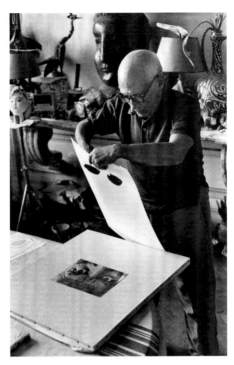

Making of
Large Snow Owl (1-II)

Making of
Large Snow Owl (1-IV)

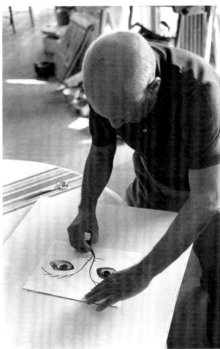

Picasso drawing
Self-Portrait as Owl

Making of
Small Snow Owl (2-IV)

DAVID DOUGLAS DUNCAN
Villa La Californie, Cannes 1957

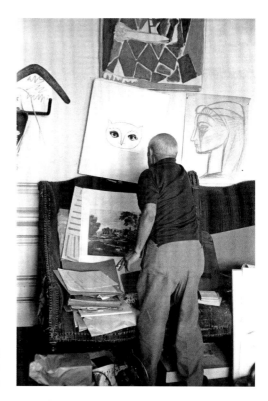

Picasso hanging
Self-Portrait as Owl
on the wall

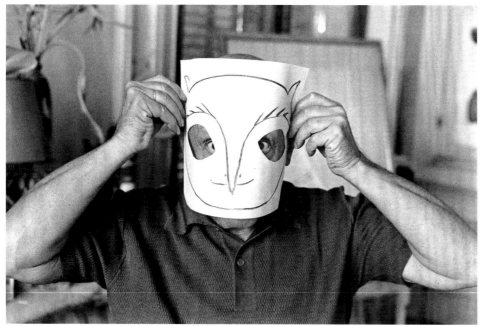

Picasso with *Self-Portrait as Owl*

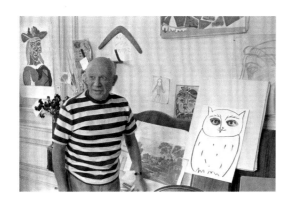

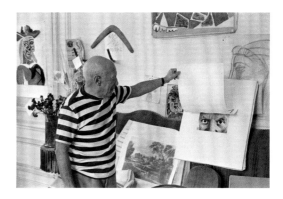

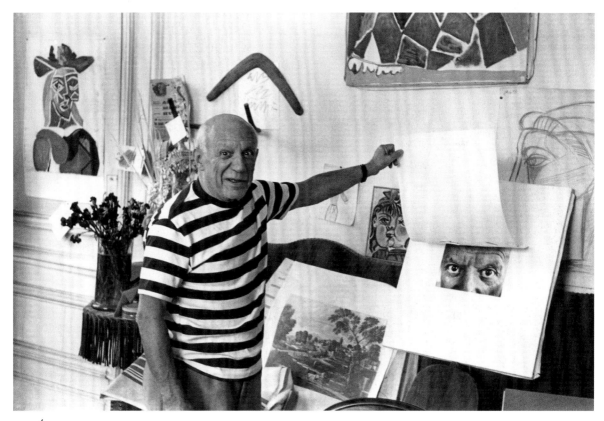

RENÉ BURRI Pablo Picasso, La Californie, Cannes, Provence–Alpes–Côte d'Azur region 1957

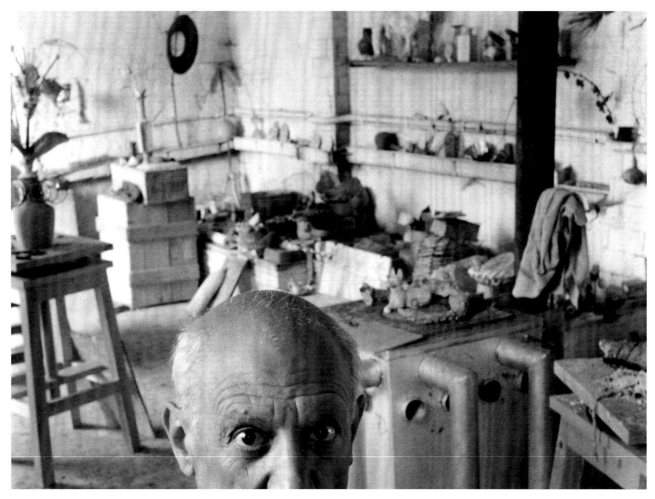

ROBERT DOISNEAU Picasso in the studio in Vallauris, 1952

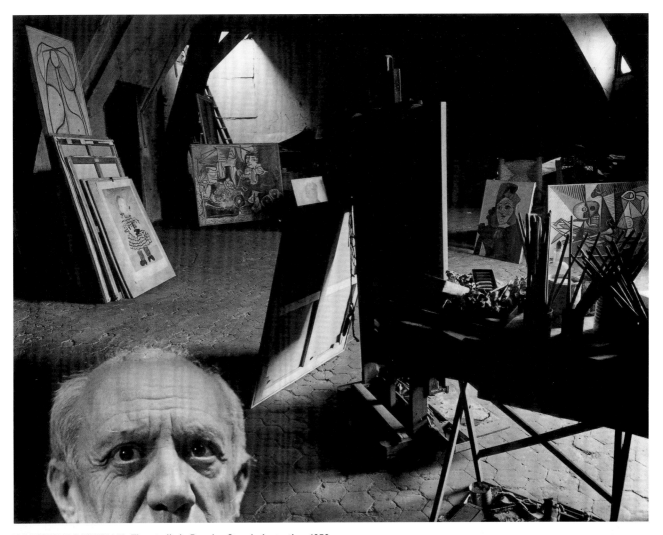

ROBERT DOISNEAU The studio in Rue des Grands Augustins, 1956

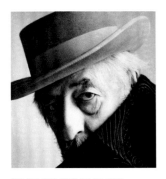

"appear enormous only because they have the odd ability to open wide, revealing the white sclera—sometimes even above the iris. . . . It is the wide eyelids that render his gaze fixed, mad, hallucinatory."[31] Photography was the medium that allowed Picasso to look at himself. Photographs also capture the fleeting moment and give it permanence, and Picasso, the painter and sculptor of numerous skulls and the creator of ephemeral works of torn paper, was well aware of the memorial function of portraiture. His attitude toward death may have motivated his relationship to photography— a medium Roland Barthes described as "mortification," since it removes the subject from the flow of life and documents it, and since it, in all probability, will outlast its subject's lifetime. The word *death* was never to be mentioned in Picasso's presence, and he never made a will: death was to be ignored, and as an attestation of presence, photography offered him a way of resisting his own transience while at the same time documenting conditions that, in the moment of the photograph, were irretrievably lost. This ambivalence was tolerable to Picasso, who despised mirrors—"which, day by day, with the cold cruelty of their reflections, throw the furrows, wrinkles, and dark circles that time never ceases to engrave, back in our faces."[32] And although he loved being in control, he nonetheless exposed himself to photographers even when his body's decline could no longer be overlooked.

Figs. pp. 104–5

Many of the monumental frontal views of Picasso preserve him and his gaze; Man Ray's chiseled-seeming portrait from 1933 is only the most famous of them.

Fig. p. 55

A recapitulation of photographs of Picasso shows that the strongest images were made by great portraitists. In the case of Richard Avedon, with his consistently reductive approach, the interaction of portraitist and subject resulted not in a Picasso, but in an Avedon; Picasso appears as if suspended for a brief moment within the frame of the picture.[33] The portrait by Madame d'Ora is equally impressive: here, based on a secret agreement, the mask that his face often becomes is allowed to fall. It is not the portrait's monumental quality, but the relationship between subject and photographer that evokes empathy in the viewer and maintains interest in the person depicted.

Fig. p. 165

Fig. p. 115

Many of the photographers for whom Picasso posed in later years had the same experience as René Burri, who was commissioned to take pictures for a publication on Picasso in 1957: "Picasso humored me. I was like the jester at the court of the king, who let me take part in the dance."[34] Certainly Picasso needed his photographers less than they needed him, but in the struggle against the inevitable loss of his eyes, he became

a generous object. The desire to see—and to be able to see himself—for as long as possible manifested itself in his artistic productivity as well as in the comprehensive photographic portrait that emerges from the works of his many photographers. They may be understood as a kind of self-portrait.[35]

1 Fernande Olivier, *Loving Picasso: The Private Journal of Fernande Olivier* (New York, 2001), p. 137.

2 Georges Besson, quoted in John Berger, *The Success and Failure of Picasso* (New York, 1989), p. 14.

3 David Douglas Duncan currently holds the record, with nine titles.

4 With regard to Picasso's friendships, the pragmatic observation of one of his companions should perhaps be kept in mind: "He was married to his art, and that was that. Everything else was accessory. Women, so-called friends, they were a backdrop…" Heinz Berggruen, "An Picasso kam man nicht vorbei," in *Du* 9 (1998), pp. 20–23.

5 Gertrude Stein, *Selections,* ed. Joan Retallack (Berkeley, 2008), p. 192.

6 Gertrude Stein, *Picasso* (London, 1938), p. 3.

7 Their friendship was most intense during Picasso's early years in Paris, in the period of the Bateau-Lavoir, and ended in 1944 when Max Jacob died in the internment camp at Drancy.

8 The Macintosh advertisement used two Picasso motifs, the classic portrait by Arnold Newman and a photo from a series by René Burri.

9 Anne Baldassari, *Picasso and Photography: The Dark Mirror* (Paris, 1997).

10 Ibid., p. 17.

11 "Portrait of the painter Ricardo Canals from Barcelona / in the mirror is me, PICASSO / on the fireplace a photo of Benedetta, wife of Ricardo Canals / photo taken in Paris in Canals's studio in 1904." Baldassari 1997 (see note 9), p. 245, n. 41.

12 Cf. Baldassari 1997 (see note 9).

13 Baldassari credited Picasso with the photo in *Picasso and Photography: The Dark Mirror* (see note 9), pp. 214, 217, while the correct attribution appears in *Picasso: Life with Dora Maar. Love and War 1935–1945* (Paris, 2006), p. 238.

14 Baldassari 1997 (see note 9), p. 126.

15 This was at the instigation of Daniel-Henry Kahnweiler, who generally had paintings by his artists photographed by Emile Delétang. Cf. Baldassari 1997 (see note 9), p. 16.

16 Peter Weiss, *The Aesthetics of Resistance*, vol. 1, trans. Joachim Neugroschel (Durham, NC, 2005), p. 294.

17 They are so well-known that a photographer like Hubert Becker could, in 2008, repeat the motif in full confidence that it would be recognized.

18 Picasso, as quoted by Max Jacob, in Marcel S. Béalu, "Dernier souvenir de Max Jacob," in: *Confluence* (April 1945), quoted in Baldassari 1997 (see note 9), p. 233.

19 Brassaï, *Conversations with Picasso* (Chicago, 1999), p. 165.

20 Roland Barthes, "Schreiben als Verausgabung für nichts: Ein Gespräch mit Jacques Chancel," in *Freibeuter* 6 (1980), pp. 2–14, here p. 9.

21 Inge Bondi, *Chim: The Photographs of David Seymour* (Boston, 1996).

22 Brassaï 1999 (see note 19), p. 206.

23 Although David Douglas Duncan's favorable reception with Picasso did arise from a recommendation by his reporter colleague, Robert Capa.

24 Picasso, as quoted by André Malraux, in idem, *Picasso's Mask* (New York, 1976), pp. 48–49.

25 Truman Capote's description of Warhol, taken from the title of a story by Oscar Wilde.

26 Cf. Brassaï 1999 (see note 19), p. 214: "When did Picasso acquire the habit of receiving guests in such skimpy outfits? A photograph of 1912… shows him already in shorts…"

27 Cf. John Richardson, "How Political Was Picasso?" in *The New York Review of Books* (November 25, 2010).

28 From the song "Pablo Picasso" by Jonathan Richman and John Cale.

29 In the Macintosh advertisement, this image functions alone, without commentary, as evidence of an original personality.

30 The significance and recognition value of photographic portraits of Picasso are manifested in their reception by other artists; examples include not only Martin Kippenberger's well-known painted adaptation, but also Arnulf Rainer's photo *Dieter Roth as a Clown* from 1975–76.

31 Brassaï 1999 (see note 19), pp. 31–32.

32 Ibid., pp. 165–66.

33 How important cropping is to the image's impact can be recognized in Arnold Newman's classic portrait, for which he tilted and sharply cropped the negative.

34 *Du: Jubiläumsausgabe 70 Jahre Du – René Burri* 3 (2011), p. 29.

35 André Villers, in a conversation with the author on July 2, 2011, described the majority of the Picasso portraits as self-portraits.

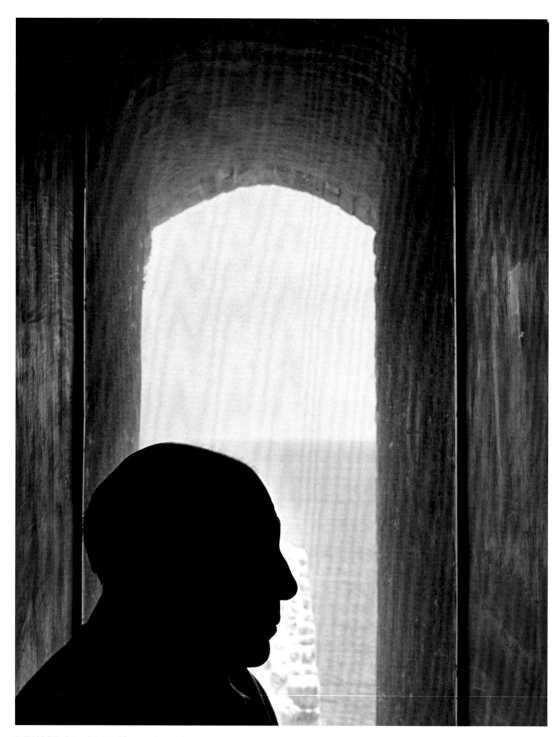

DENISE COLOMB Picasso in Antibes, 1952

PIERRE DAIX

Picasso, Photography, and Photographers

Discovering photography

Only in the late twentieth century, more than two decades after his death, did it become possible to assess Picasso's personal photographic work in all its precocious complexity: to home in on the artistic benefits accruing from both a steadily growing mastery of the discipline and his connections with photographer friends and acquaintances. While it was clear that his oeuvre, beginning with Cubism, bore the stamp of modernity's industrial upheavals, his involvement with reproduction techniques external to his own art was generally regarded as an occasional affair. This belief is mistaken.

Since Anne Baldassari's *Picasso photographe 1901–1916,* published in 1994 to accompany the exhibition of the same title at the Musée Picasso in Paris, we know that the Picasso archives contain "some 5,000 photographic works or documents he accumulated during his lifetime," including "prints which must be considered as by Picasso's hand, the oldest of which go back to 1901." The first significant one—Baldassari has titled it *Self-Portrait in the Studio*—shows the artist in a top hat, superimposed over his paintings hung on a wall: a tour de force Picasso was the first to acclaim, noting on the back: "This photograph could be titled, 'The strongest walls open at my passing, so behold!'"

His second major photograph is *Portrait of Ricardo Canals,* from 1904: a tribute to a painter/etcher/photographer five years his senior whom Picasso knew from Els Quatre Gats in Barcelona. Given that it was Canals who initiated Picasso into etching—with *El Zurdo* in 1899 and *The Frugal Meal* of 1904—it seems fair to assume that he played the same role for photography; and that this photo, so masterly in its mise-en-scène, was a homage not only to a friend but also to a photographic preceptor. This

would signal a mental link between the two registers: as Roger Passeron has noted, "For Picasso a stone or a sheet of zinc, linoleum, or, above all, copper, was a confidant."[1] Let us add to this list the photos he took, and think about them, so as to enhance our understanding of his relationships with the photographers—every one of them a master—who would be part of his life.

The photo as tool

In the Picasso photographs that have come down to us, in 1901–02 the studio was the dominant theme, and even more so in 1908, when Fernande, then various friends, appear in the company of *Three Women*. During the interval, as Anne Baldassari established in the exhibition *Le Miroir noir*,[2] Picasso had begun working from photographs, beginning with the meal in *The Soler Family* (1903), from his Blue Period, and likewise during a trip to Holland in 1905. However, the discovery that gave the exhibition its title can be traced to the first contribution to the oeuvre by another photographer, François-Edmond Fortier (1862–1928). After a visit to Senegal and "French Sudan"—now Mali—Picasso returned from Gosol to Paris in September 1906 with a set of Fortier's postcards showing African women in all the immediacy of their everyday lives, and in most cases naked to the waist. For Picasso, these were images of the primitive way of life he had gone looking for in Gosol and had seen in Paul Gauguin's work. He was overwhelmed, as is made plain in the definitive version of *Portrait of Gertrude Stein* and the succession of nudes that autumn, which would culminate in *Les Demoiselles d'Avignon*.

Until the *Miroir noir* exhibition, this turning point in the Picasso oeuvre had been interpreted in the light of his first contact with *art nègre* sculpture. But that discovery actually came a little later, the immediate influence being a photographer's vision of the plastic qualities of African women—something which, at the time, also guaranteed erotic and commercial success. Seen through the Fortier filter, the women took on the status of artist's models; and for Picasso, himself a photographer, that of a trigger for line and brushwork. This makes it clearer, too, why the painter, endlessly harassed with questions about "Negro Art" in the 1920s, put paid to the subject with a dismissive "Never heard of it!" And why, when we began working together on the catalogue of his Cubist oeuvre in 1969–70,[3] he was at great pains to show me how Iberian art had been the primary influence—as art—in *Les Demoiselles d'Avignon*. It is only now, with photography having in the meantime achieved full artistic status, that we have come to appreciate Fortier's vision and his transmission of truly living African models.

The significance of Picasso's studio photos prior to *Three Women* in 1908, followed by the landscapes and life of Horta de Ebro and the portrait of Clovis Sagot in 1909, is now beyond dispute; as is also the case with the photos of friends in the studio in 1911, at the time of the move beyond the early Cubist portraits. Photography played its own autonomous part in the transformations of *Composition with Guitar Player* early in 1913, and recorded Picasso's presence in his studio during the solitary period in 1916 occasioned by Éva Gouel's death and the war: here we note the initial resolutions of the problematic aspects of Cubism.

It was, then, both as innovator and as skilled practitioner of the medium that he would encounter leading photographers throughout the rest of his long life. And this—despite a widespread belief to the contrary—was quite independent of his reassessment of classical painting and Nicolas Poussin during the "return to order."

Picasso and photography's innovators

At one point, Anne Baldassari cites Marius de Zayas, co-founder with Alfred Stieglitz of the Photo Secession in America, describing to Stieglitz, in June 1914, a conversation he had had with Picasso: "He was most insistent that he had absolutely mastered the field of photography." De Zayas adds that Picasso admired Stieglitz's manifesto work *Steerage* (1907), and that he was "the only one, really the only one, to have understood it." This opens up the field—unexplored as far as I know—of what Picasso might have learned from the pioneering works of Stieglitz and Edward Steichen from the magazine *Camera Work,* which he had doubtless read at the Steins' before 1911. Whatever the case, his interest in the great American innovators at this time is clear; as is, once more, his avant-garde stance.

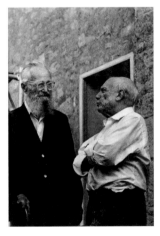

ROBERTO OTERO
Pablo Picasso and Edward Steichen,
Notre-Dame de Vie, Mougins 1966

Another American, Man Ray (1890–1976), would be the first of these innovators to enter Picasso's life, photographing him in 1923 in Montparnasse and, in doing so, robbing Montmartre of its status as the heart of Parisian modernity. Their close friendship was reinforced in the 1930s by the presence of Man Ray's lover and collaborator Lee Miller, who would later marry Roland Penrose. When Picasso fell in love with Dora Maar, who was herself a photographer, he used her for experimental portraits in the form of "rayograms," a combination of drawing and photography invented by Man Ray.

It was not until 1932 that Brassaï (1899–1984) first met Picasso, but as I pointed out in my preface to the American edition of his *Conversations with Picasso,*[4] it was thanks to him that we gained access to the Rue de La Boëtie studio, where Picasso had been working since late 1920; and we also owe him the discovery in 1932 of the Boisgeloup sculpture studio, and that of the Rue des Grands Augustins in 1937. The moment he began contributing to Fig. p. 84 the magazine *Minotaure,* the man Henry Miller called "the eye of Paris" made himself the perfect conduit for Picasso's life and art, leaving us not only his images, but also those *Conversations* dating mainly from the period of German occupation and combining invaluable eyewitness accounts of the Grands Augustins studio with information on the attitudes of Picasso and his friends and their own

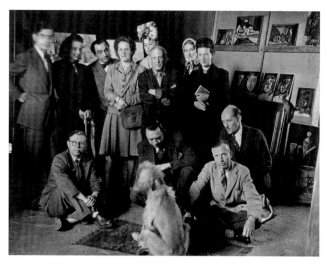

BRASSAÏ The actors of *Desire Caught by the Tail,* June 16, 1944 (Picasso at center; to his right, Zanie de Campan, Louise Leiris, Pierre Reverdy, Cécile Éluard, Jacques Lacan; to his left, Valentine Hugo, Simone de Beauvoir; on the floor, Jean-Paul Sartre, Michel Leiris, Jean Aubier, Albert Camus)

conversations. Brassaï noted, for example, this remark by the painter: "Seeing what you express through photography, one becomes aware of all the things that are no longer the concern of painting." We also owe Brassaï the photo, taken on June 16, 1944, of the reading of Picasso's play *Desire Caught by the Tail,* with Jean-Paul Sartre, Albert Fig. p. 46 Camus, and Pierre Reverdy. And with his revealing of *The Reaper* and *Tête de mort* he was the first, after Daniel-Henry Kahnweiler, to make it clear that Picasso was a great sculptor.

In the meantime, photographer Dora Maar, after frequenting the Surrealist groups —she photographed Alberto Giacometti's *Invisible Object* and took excellent portraits of Nusch Éluard—became part of Picasso's life in the summer of 1936. As already mentioned, he immediately used her for his Man Ray—invented rayograms (it was said she had wanted to be Ray's assistant), swathing her in a Spanish mantilla just as he had done in their time with Fernande and Olga. It was Dora who found the Grands Augustins studio, where she documented with her photos the step-by-step creation of *Guernica.* On vacation with him later, she caught André Breton and Nusch and Paul Fig. p. 21 Éluard in historic photos, including one of Picasso as a minotaur. She outdid herself Fig. p. 58 with her images of their private life amid the silence of the occupation, but it was Brassaï who photographed Picasso piling up his portraits of Dora.

When the liberation came, in September 1944 in Paris, Picasso's exhibit at the Salon d'Automne provoked a furor recorded by talented newcomer Robert Doisneau (1912–1994). Doisneau showed an occupation scene and *Tête de mort,* drawing as many police officers as viewers. At the same period, Lee Miller brought her personal vision to a group shot—Roland Penrose, Louis Aragon, Picasso, Nusch and Paul Éluard, and Elsa Triolet—in Picasso's studio.

Fig. p. 159

Michel Sima (1912–1987) had ambitions as a sculptor. After surviving Auschwitz, in 1946 he went to see Picasso in Antibes; he left us handsome photos of his time there. Picasso kept Sima's image of him in Paris, holding a wounded baby owl he had taken in, in front of the painting *Owl in Interior.* Doisneau was back in 1952 with a reportage for the magazine *Le Point*[5] on Picasso in his studio in Vallauris. The real chronicler of the artist's new life on the Côte d'Azur, however, was the Irishman Edward Quinn (1920–1997), in his *Picasso avec Picasso.*[6] "Quinn," I noted in my preface to the book, "never stopped asking himself the same question: 'What do I see in Picasso that makes him Picasso?'" There followed unequaled views of the houses—La Galloise, La Californie,

Figs. pp. 6–10

Vauvenargues, the Mas de Mougins—and, each time, of Picasso's way of living and working in them: what those who didn't know him called his "mess," with the things pinned down in his work or his visual reflections on them. This vision of Picasso in his living space bears Quinn's personal stamp and signals the oeuvre to come—obviously, of course, with Picasso's enriching collusion.

André Villers (b. 1930) was twenty when he turned up at Picasso's and had the unparalleled good luck to be able to hone his photographic eye under that of the master. As I noted in my preface to a selection of his images, "André Villers learned from Picasso that things never come easy: that in visual terms, you always have to look beyond appearances to catch what makes a moment unique."[7] The result is Picasso truly as himself—with Henri-Georges Clouzot when they were making the film *Le*

Figs. pp. 134–35

Mystère Picasso together, and with his young model, Sylvette. Then, in his studio, as if Villers were not present. And then there was the arrival of Jacqueline, and the spirited conversations with Jacques Prévert, Aragon, and Maurice Thorez. Villers was so

Fig. p. 48

effortlessly self-effacing that I was stunned when I saw the photo of myself chatting with Picasso during preparations for a bullfight at Vallauris in the summer of 1954. With Picasso as he truly was: often amused, and loving to amuse. Loving to play.

When he met Picasso, David Douglas Duncan (b. 1916) was known mainly as a photographer of America's wars, from the Pacific to Korea. "In the spring of 1956," he recounts in *Picasso's Picassos,*[8] "while switching from one assignment on the Russian

frontier of Afghanistan to another with the Berber tribes in the High Atlas Mountains of Morocco, my work as a foreign correspondent took me through Cannes, on the French Riviera, where Picasso lives." The outcome was a year spent working together, with the revelation in color of Picasso's personal collection of hitherto unknown youthful works, and then of all the phases of his creative life, accompanied by the painter's comments on them. Remarking on the impossibility for Duncan of doing justice to all the contrasts of a complex collage of 1937, Picasso quipped, "At last we can see it's not painted!"

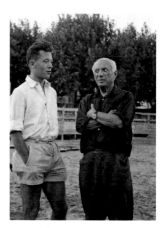

ANDRÉ VILLERS
Picasso with Pierre Daix,
Vallauris, 1954

By contrast, *Picasso and Jacqueline,*[9] which Duncan published as a tribute to them after Jacqueline's death, remains the most intimate of all the books of photographs on Picasso, immersing us in the couple's life together at La Californie, the big house they had bought just outside Cannes, and showing them with Françoise Gilot's children and with such friends as Kahnweiler. Even more invaluable are the images of Picasso in Château de Vauvenargues.

Fig. p. 226

Picasso becomes timeless under Duncan's eye, free of all convention as he goes about his oeuvre within the framework he chose for his life: a life of work that did not, however, exclude relaxation. Duncan's vision conveys, too, his own emotion at penetrating these secrets and sharing them with us—including those of Jacqueline, whom he calls "the magician who prolonged her husband's life." The life that Duncan in turn prolongs for us.

If only, one day, all the photos taken by Jacqueline could be brought together. Not just for her own view of things, but also because many of them were taken at Picasso's request. With their account of life at the Mas de Notre-Dame de Vie at Mougins, they would be a precious adjunct to Duncan's.

I cannot, of course, omit Lucien Clergue (b. 1934), whose *Picasso mon ami,*[10] like Villers's book, brings the eye of another generation to bear in a precise rendering of the last years at Mougins and Picasso's passion for the corrida in Arles.

Picasso looking at photos

When Picasso was living at Notre-Dame de Vie, I had the privilege—on the understanding that I told nobody—of bringing him the photos of Paris exhibitions he was so

keen on. Each time, I was taken aback by the sheer voracity of his gaze. Most were unremarkable photos of vernissages supplied to the magazine *Lettres françaises,* but Picasso would devour them hungrily. And as he looked intently on after cobbling together a lighting system, I also had to photograph the unshown paintings he was preparing for my catalogues. Picasso was boss.

Missing from the work of those whose cameras covered his life—most likely for reasons of politeness—are the reactions of this photographer to the work of others. One of the most striking photos in Duncan's *Picasso and Jacqueline* shows us master printer Jacques Frélaut, sculptor-writer Jaime Sabartés, and Jacqueline examining prints with Picasso after working all night on the old press in the cellar at La Californie. As Duncan points out, only Picasso shows no signs of fatigue as he scrutinizes a work. And as Doisneau demonstrated, he devoured the photos taken by his photographers in the same way.

Fig. p. 49

The visual glutton was never sated.

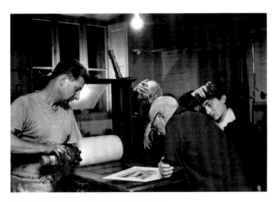

DAVID DOUGLAS DUNCAN
Jacques Frélaut, Jaime Sabartés, Pablo Picasso,
Jacqueline Picasso, La Californie, ca. 1957

1 Roger Passeron, *Maîtres de la gravure: Picasso* (Paris, 1984).
2 Anne Baldassari, *Le Miroir noir: Picasso, sources photographiques 1900–1928,* exh. cat. Musée national Picasso (Paris, 1997).
3 Pierre Daix, *Le Cubisme de Picasso: Catalogue Raisonné de l'Oeuvre Peinte, 1907–1916* (San Francisco, 1979).
4 Brassaï, *Conversations with Picasso,* trans. Jane Marie Todd (Chicago, 2002).
5 *Le Point,* October 1952.
6 Edward Quinn, *Picasso avec Picasso* (Paris, 1987).
7 *Picasso dans l'oeil de Villers* (Paris, 1999).
8 David Douglas Duncan, *Picasso's Picassos* (New York, 1961).
9 David Douglas Duncan, *Picasso and Jacqueline* (New York, 1990).
10 Lucien Clergue, *Picasso mon ami* (Paris, 1993).

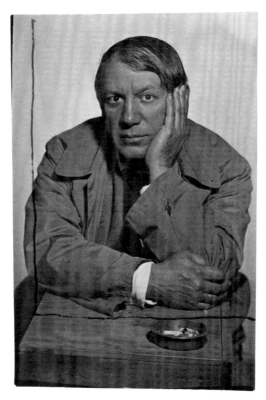

MAN RAY Pablo Picasso, 1933

FRIEDERIKE MAYRÖCKER :

the serial principle
of Man Ray in tears

your libido your lido, thus Man Ray to Picasso, your shuddering seehole. He smooched Picasso's trousers he smooched Picasso's dove in drum washer
a half head of a woman ("pour l'album 1920/1934"), a little feather on meadow ground, thus Man Ray to P., the christenling's and dovelet's coloratures at moon night, thus Man Ray to P., who with dog Kasbec at the shore, "2 Nudes and 2 Doves", pencil 1972 –
Picasso with aroused nature or nectar coalburning eyes and suntanned, "Woman seated in a Chair" water colour and oil crayon 1913, irritation of thin breasts narrowing down to points in fact like pointed manicured claws, thus Man Ray, "Youth with Laurel-adorned Head, chewing (eating) on Meadow Grass" : "mangeant de l'herbe", the body preminted by rose scent e.g., thus Man Ray to Picasso.
Entangled in shrill thoughts, thus Man Ray to Picasso, while the felled tree trunks at our feet on the occasion of any season primarily pre-spring's, that is the little herbs' looks into the deep valley, as soon as we had reached a lttle.height, already we were flaked at by flocks of walkers who came swarming down from the top of the mountains, so unforgotten so mule and stallion and blue hydrant, already the morning was flagging the morning hour, thus man Ray to P., and much too big chemise, thus Man Ray, had cut myself on the barberry bush, artichoke and river mouth into the sea etc., the giant artichoke revised as morning star, thus Man Ray, palm of the martyrs –
as far as the portrait of Pablo Picasso is concerned, thus Man Ray, it appears to me with tangled hair, the parting actually twisted, reversed, with strand of hair growing (=stabbing) into his eye, behind it the dark glowing eye that seems to miss nothing, a posy of dew and stars on the left cheek, I mean while the black sloes of the eyes were looking at me for a long time, Man Ray

12.2.2011

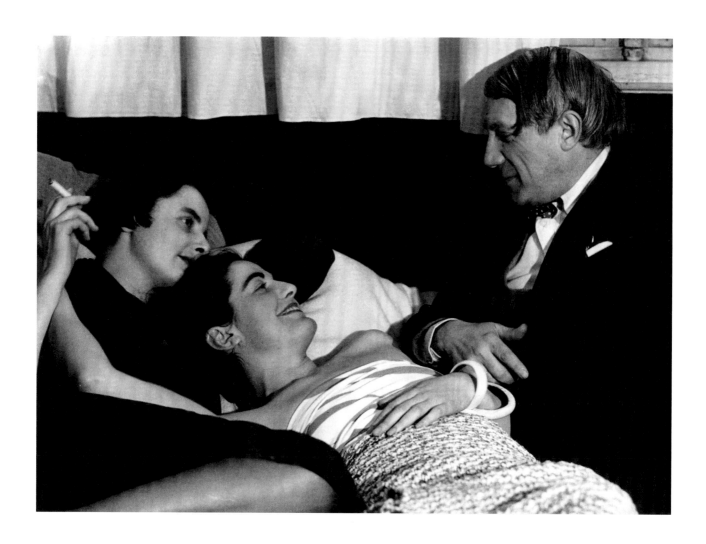

MAN RAY
Picasso with Yvonne Zervos and another woman, 1930s
Untitled (hands of Picasso and Yvonne Zervos), 1930s (1967)
Untitled (from: Paul Éluard and Man Ray, *Les mains libres),* 1956

MAN RAY Picasso, Juan les Pins, 1926

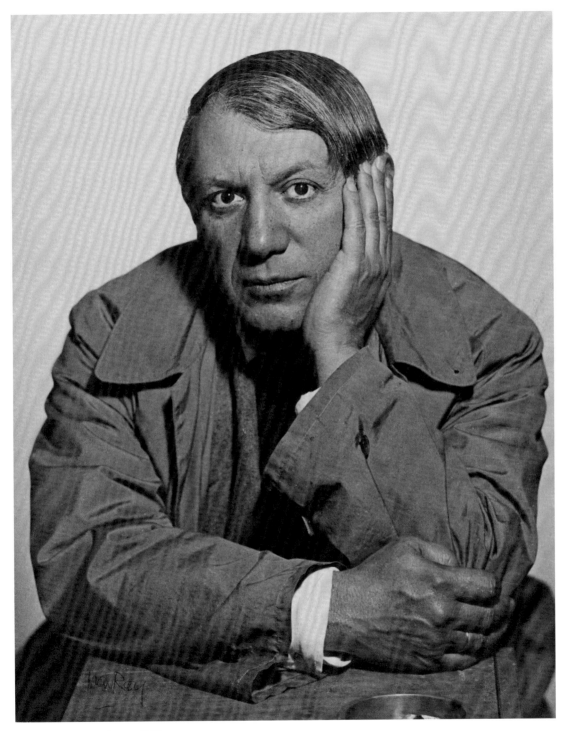

MAN RAY Pablo Picasso, 1933

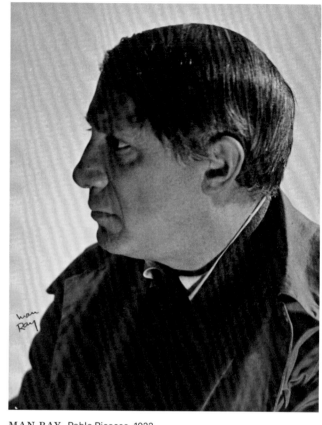

MAN RAY Pablo Picasso, 1933

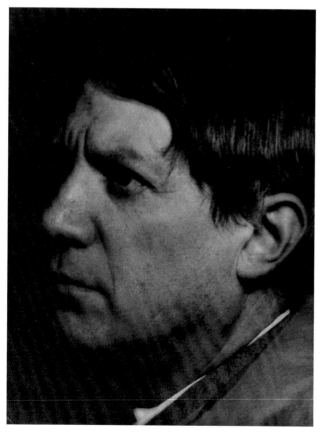

MAN RAY Pablo Picasso, 1932

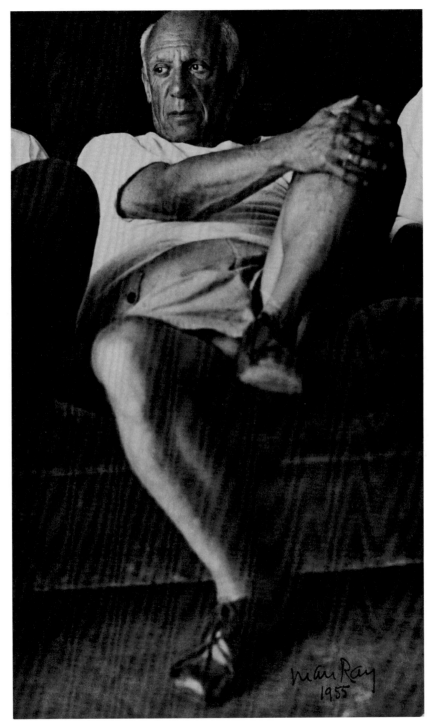

MAN RAY Pablo Picasso, 1955

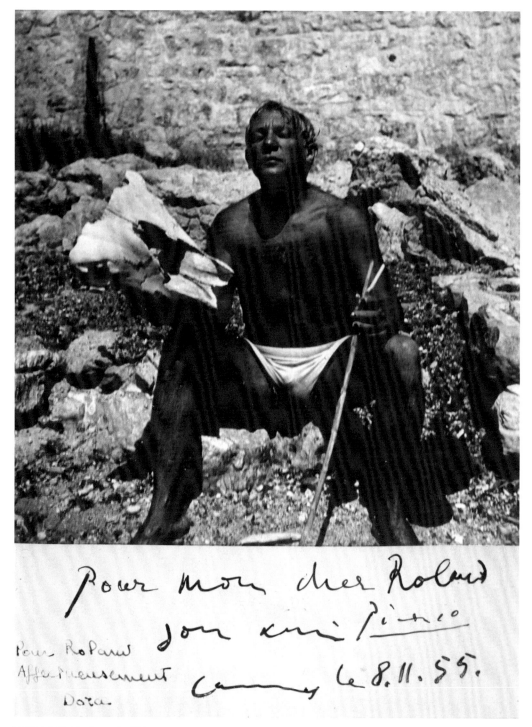

DORA MAAR Portrait of Picasso with bull's skull, 1937

KATHERINE SLUSHER

The Women
Who Shot Picasso

The early twentieth century saw the birth of modernism, and no one embodied modern art like Picasso. While his art now feels firmly placed within its own time, his approach to presenting his own artistic persona through photographic portraiture could not be more contemporary. Picasso clearly understood the public's fascination with the man behind the work and its iconic force. The seven women photographers in this exhibition all came to photograph Picasso in different ways: the relationships ran the gamut from lengthy intimacy to fortuitous encounters on Parisian streets. Picasso was the photographic prize. He was pursued, and occasionally he was also the pursuer, complicit in the resulting image. Some of the women photographers were new acquaintances, others were friends and lovers, but all were well aware of his importance in the art world.

Picasso's history with women is well documented in his art and in numerous biographies. He is in control of the painted image; he is the one who will depict these women as he believes they should be seen while they passively allow his interpretation. So what happens when the artist becomes the subject? Or, more to the point, when it is the woman who is controlling the image? The resulting portraits illustrate the women's diverse relationships to him. In one curious parallel, two of the women, Rogi André and Dora Maar, took portraits of him in 1936 and physically altered them, independently of each other, in an unusual and perhaps telling manner. They each added a dark halo around his head, achieving not just an accentuated contrast in the background, but also a much more complex reading by means of violent gouges and rough-edged brushstrokes.

Figs. pp. 99, 101

Rogi André, Denise Colomb, Dora Maar, Lee Miller, and Julia Pirotte were all born in the first decade of the twentieth century and came of age with modernism. Some of them moved within the same artistic circles in Paris, or in overlapping circles. Not only

did they all photograph Picasso, but in some cases they also photographed each other. The other two women who shot Picasso, Madame d'Ora and Inge Morath, were innovators in their chosen field; as women, they entered what had been the entirely male-dominated area of photography. Besides working in France, all of these photographers shared the experience of living through both world wars (with the exception of Morath, who came of age in Germany during World War II). The wrenching tragedy of war left its mark on all of them. Julia Pirotte and Lee Miller documented the war—Pirotte the French resistance in Marseilles, Miller in the field—and they kept going even after the fighting had stopped. In a break with portraiture, d'Ora also joined in recording the tragic aftermath. They all suffered deep personal and emotional losses; their work was perhaps an attempt to make sense out of senseless destruction, despair, and loss.

Rogi André, the photographic nom de plume of Rózsa Klein, was born in Budapest and moved in 1925 to Paris, where she studied fine arts. After her marriage to André Kertész three years later, she began working as a photographer (signing her early work as Madame Kertész). While the marriage lasted only four years, her commitment to photography was lifelong.

Rogi André gave Lisette Model her first photography lessons, as well as the only advice Model ever listened to: never photograph something you are not passionate about. By 1934, Rogi André had struck out on her own, establishing herself as a portrait photographer who preferred photographing subjects in their own settings. Picasso was not her only famous personality; the list includes André Breton, Antonin Artaud, Max Ernst, Peggy Guggenheim, Jean Cocteau, Henri Matisse, André Gide, Max Jacob, André Derain, Marcel Duchamp, and Dora Maar. Breton reproduced one of her photographs, of Jacqueline Lamba in an aquarium—which became one of Surrealism's most iconic images—in *L'Amour Fou* (1937).[1] The London Gallery exhibited her work in 1949, and the Pompidou showed a selection of her portraits in 1982. Rogi André's rich photographs were, and still are, so ubiquitous that it is mystifying that few people even today know who she is, despite her work being scattered among a number of important museums.

In Rogi André's two portraits of Picasso, both from the same sitting, she created bright spots of light by subtly scraping her negatives. This is particularly evident in the sitter's eyes, which are brought almost weirdly to life. In another portrait of Picasso with striped scarf, this sharper contrast of light and dark is evident not only in the eyes, but also in the white handkerchief in his pocket, manipulated to a captivating brightness.

Figs. pp. 98, 99

One could argue that she was simply putting the shine on the star, except that this was a common effect in her work. Perhaps for Rogi André, Picasso was no different from any of her other stellar sitters. The one fact that could refute this idea is that of the intriguing halo she painted in her other portrait of Picasso.[2]

Dora Philippine Kallmus, known professionally as Madame d'Ora, opened one of the first woman-owned photographic ateliers in Europe, Atelier d'Ora, specializing in a pictorial portrait style.[3] Born in 1881 in Vienna, she divided her work between Vienna and the fashionable health resort in Karlsbad, Czechoslovakia, that catered to aristocrats and an international clientele. A hallmark of her photographic style was elaborate settings with rich textures, then in vogue with the Secessionist arts and crafts movement, exquisitely lit to show off the splendor of the sitters.

Madame d'Ora moved to Paris, where she had worked off and on, in 1925, and, once firmly established, she photographed the beau monde. Her glittering clientele included Josephine Baker, Mistinguett, Maurice Chevalier, Tamara de Lempicka, Tsuguharu Foujita, Colette, and the bullfighter Dominguín. D'Ora remained in the city until the Nazi occupation forced her into hiding in the remote southern French village of Lalouvesc.[4]

Madame d'Ora's sister died in a concentration camp, and when d'Ora returned to Paris at the end of the war, she embarked on a series of pictures that were a radical departure from her prewar work, including graphic slaughterhouse images of butchered animals, the severed legs carefully arranged in symmetrical compositions; or, in one case, a portrait of Georges de Cuevas with dead sheep heads placed around his shoulders. An important stylistic difference was the use of ambient light in her portraits, employing a more casual snapshot aesthetic.

Fig. p. 115

D'Ora's portrait of Picasso, taken a number of years after the war, is one of the most natural, unmannered images of him that exists. In his studio on the Rue des Grands Augustins, his dark penetrating eyes do not dominate; rather, it is his seldom seen spontaneous grin that engages the viewer. There is no manufactured sparkling, as in Rogi André's picture; here, Picasso is the mortal, the Great Artist caught mid-laugh.

This sole d'Ora photograph of Picasso is unlike the other pictures by this group of women in that he seems relaxed and at ease. It may be because he is being shot by a woman who was born in the same year he was, making them both in their early seventies; somehow their connection feels palpable, as if their having both seen Paris at its

best, then suffered through the shock of the war, has allowed them to be two survivors without pretense. It is as if they understand each other.

Denise Colomb (née Loeb) was born in Paris in 1902 and originally studied music. After her marriage to engineer Gilbert Cahen[5] and three children, she travelled extensively, taking photographs in mid-1930s Indochina (Vietnam, Cambodia, and China), with a humanist slant.

During World War II, she changed her name to Colomb and took refuge in the French village of Dieulefit until France was liberated. In 1947, she began a series of portraits that continued throughout the 1950s of artists she met through her brother, Pierre Loeb, art dealer and owner of a well-known gallery exhibiting the Surrealists.

Picasso had been spending his summers working in Antibes in a large studio space in the Château Grimaldi (which became the Picasso Museum in 1966). In 1952, Colomb took a number of pictures of the artist, one of which shows him in shadowy profile against the blinding backdrop of the Mediterranean. It is impossible to make out a single facial feature. Her most recognized photograph of him shows Picasso in his Rue des Grands Augustins studio, sitting on the staircase. He is an old man in an overcoat staring pensively out the window, again in profile, accompanied by two of his owl sculptures. No heavy shadow obscures his unsmiling expression.

Fig. p. 42

Fig. p. 117

Colomb published her work and exhibited it, doing documentary work in the 1950s and 1960s in Antilles, Norway, Italy, Israel, and France. She left more than 50,000 negatives to the French Cultural Patrimony Archives upon her death in 2004.

There is a famous anecdote relating to the meeting of Picasso and Dora Maar. It is said that she had been pursuing him without his knowledge, somehow contriving to end up in Les Deux Magots.[6] She sat alone at her table, wearing a pair of black gloves embroidered with roses, and began to play a game, throwing a pen knife between her fingers. This behavior caught Picasso's eye, making him curious to know more about the young woman with the now bloody gloves with roses upon them. (It is also said he kept the soiled gloves throughout his life.)

Dora Maar, like Rogi André, Madame d'Ora, and Denise Colomb, also had a birth name different from her professional name. She was born Henriette Theodora Markovitch in Paris in 1907. Dora Maar was a classmate of Henri Cartier-Bresson's, and, like Rogi André, she studied painting with André Lhote. When Maar decided upon photogra-

phy, she enrolled at the École de Photographie de la Ville de Paris, and was eventually mentored by Emmanuel Sougez. Man Ray refused to take her as an apprentice, but he was supportive of her work and they began a friendship.

Maar's first photo studio was with Pierre Kéfer; her work in the early 1930s bears their joint stamp. She explored a broad range of interests in photography, engaging in the more commercial areas of portraiture and couture photography. In her other work, she displayed a strong Surrealist vein, portraying a hand emerging from a seashell or enigmatic figures scattered throughout a cloister. By the time she met Picasso in the winter of 1935, she was fairly well established as a photographer.

Based on their auspicious first meeting and given Maar's Surrealist bent, it would seem that her initial pictures of him would reflect their mutual sexual tension, but oddly, they did not. In fact, the portraits she took of him at her studio at 29 Rue d'Astorg are strangely static and erotically neutral. Picasso's hair is combed flat and pomaded to one side, he wears a tie and immaculately pressed trousers, and his boxer shorts ooze over his belt in a rather endearing, un-self-conscious way. She captures him frontally, and in semi-profile, sometimes smoking or with his arms crossed as he leans, debonair, against a wall, almost as if he's acting for her (and his) amusement.[7] Later on, it is one of these first photographs to which she takes a knife, scraping the negative and creating a darkly haloed quasi-religious icon of the object of her lifelong obsession.

Fig. p. 101

Shortly thereafter, Picasso began *Guernica,* with Maar documenting its creation over a two-month period in 1937. Their affair lasted ten years, during which she was his intellectual equal, moving in the same social and professional circles. They collaborated on a series of rayographs and *clichés verres* that were new to Picasso's oeuvre. Picasso, the minotaur, appears over and over in his portraits of Dora; she in turn depicted him as a minotaur in a photograph with his face covered by a bull's skull.

Maar largely abandoned photography when their relationship ended and returned to painting, using a dark palette. In the beginning, she kept up with friends, but she became more isolated as time went by. Maar died in 1997, in the apartment in which she had lived for over half a century, just around the corner from the studio where Picasso had painted *Guernica* sixty years earlier.

Inge (Ingeborg) Morath was born in 1923 in Graz, Austria. As a child she traveled widely throughout Europe with her family. During World War II, she studied lan-

guages in Berlin, and was just able to finish her exams before she was forced into factory work that ended only when the Russians bombed the place, enabling her to escape.

After the war, Morath worked for Magnum Photos in Paris as an editor. In 1951, she began taking photographs, and knew immediately that it was her medium. At the invitation of Robert Capa, she was employed by Magnum as a photographer, also spending (at Capa's suggestion) two years working with Henri Cartier-Bresson. By 1955, Morath was the first woman to become a full-time member of Magnum.

Morath first photographed Picasso in 1953 while traveling across Europe with Cartier-Bresson. They were on assignment for *Holiday Magazine* and stopped to see Picasso in Vallauris while he was working in ceramics at Madoura Potter. Flirting with Morath, Picasso gave her a vase that he had made when she photographed him.[8] Then, in 1958, Morath traveled to Vallauris once again to photograph the unveiling of Picasso's mural for the UNESCO headquarters in Paris. Among the 300 people in attendance in the school courtyard were Georges Salles, the director of French museums, and Communist leader Maurice Thorez. Published in *Time* magazine, the text copy Fig. p. 70 states, "Picasso had painted the mural on 40 separate wood panels in his studio. Seeing the panels assembled for the first time, he stared intently, then exclaimed: 'It's quite good—better than I thought.' It was difficult to believe that this time Picasso had tried very hard. To help reporters puzzle out the meaning of the big, empty mural, Salles explained, 'The painting represents the victory of forces of light and peace over those of evil and death. The skeleton-like figure with black wings is falling through an infinity of blue, like the fall of Icarus, while a female form rises majestically, white and radiant . . .'"[9]

Lee (Elizabeth) Miller photographed Picasso over a period of thirty-six years, her longest-running body of work. Born in upstate New York in 1907, she began working in photography as Man Ray's apprentice and assistant after moving to Paris in 1929. Her background studies in theatrical lighting and design proved valuable as she learned the technical aspects of photography. Miller experimented with a Constructivist aesthetic in her early pictures, but it was Surrealism—even later on the battlefield—that best defined her work. After returning to New York, Miller had her own photography studio; like most women photographers of the time, she primarily did portraiture, which was the only real commercial option. From there, she moved to Egypt, doing her best to avoid the "pearls and satin set." Instead she ventured off into the sand dunes with her Rolleiflex.

Miller's first documented meeting with Picasso was in the summer of 1937 in Mougins, where she arrived with Roland Penrose, Nusch and Paul Éluard, Man Ray, and Ady Fidelin. They all joined Picasso and Dora Maar, who were installed in the Hôtel Vaste Horizon, enjoying days at the beach. Picasso painted six large portraits of Miller as *L'Arlésienne* that summer, and she in turn began photographing him, their sexual chemistry in all likelihood driving Dora to despair. Her portraits of Picasso are often spontaneous, more so than much of her other work, although sometimes Picasso literally sat for his portrait, confronting the camera with his unflinching gaze and the dark intensity of his eyes. His expression is impenetrable, like the masks he fondly wore at play or the masklike faces in his paintings.

Miller's use of reflections, a Surrealist device, adds a fourth dimension to her works, making the invisible visible in windows, mirrors, and objects. There is a parallel be-

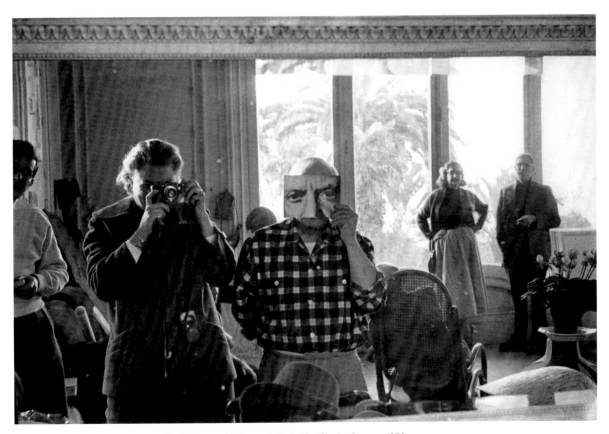

LEE MILLER Roland Penrose, Lee Miller, and Picasso, Villa La Californie, Cannes 1956

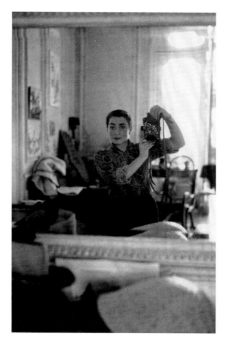

JACQUELINE ROQUE
Self-portrait, undated

tween Miller's self-portrait and the photograph that Jacqueline Roque, Picasso's second wife and companion for twenty years, took of herself in a mirror. It is as if she were exposing her hidden role in Picasso's life. Miller by now is hidden as well. David Douglas Duncan, the legendary combat photographer, was present one day, photographing Picasso being photographed by Miller. He met her there as Mrs. Penrose, and to his everlasting regret, never associated her with the legendary Lee Miller, who had carried her camera into Buchenwald and whose war photographs had run in almost every issue of *Vogue* during the last two years of the war.[10]

Fig. p. 66

Miller's documentation of Picasso's life counts as the closest thing to a visual biography, capturing him in his various relationships with Dora Maar, Françoise Gilot, and Jacqueline Roque, at play with his children and grandchildren, and in the large chaotic rooms of Villa La Californie in Cannes, the hillsides of Mas Notre-Dame de Vie in Mougins, the stately spaces of the Château de Vauvenargues, and the high barren windows in the studio on Rue des Grands Augustins. Miller also published articles about Picasso, one a tribute on his seventieth birthday.[11] At times the photographer and subject's lives intersected, as when Picasso visited her home with Roland after she became

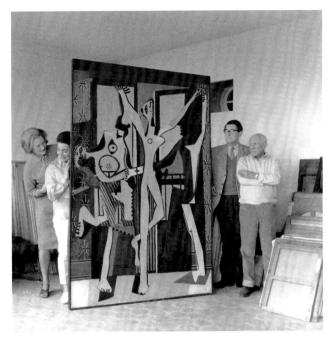

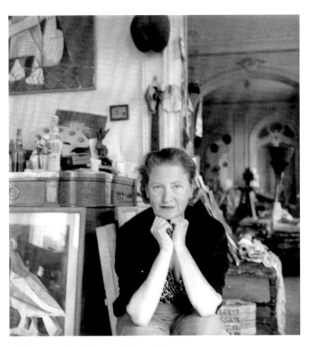

LEE MILLER Lee Miller, Jacqueline Roque, Roland Penrose, and Picasso next to the painting *Three Dancers* (1925), Villa Notre-Dame de Vie, Mougins 1965

PABLO PICASSO Lee Miller, 1960

Mrs. Penrose, or playfully interacted with Miller's only child, Tony. Her lifelong portrait of Picasso, in over a thousand images, came to an end with his death in 1973.

Julia (née Djament) Pirotte was born in Końskowola, Poland in 1907 into a mining family, and, like her siblings, she held strong political convictions and became an idealistic activist at a young age. Self-schooled, she became part of a young progressive movement that fought the social and political injustices happening around them. When Pirotte was eighteen, she was incarcerated for four years; her brother fled to Moscow and her sister to Paris. After she was released, Pirotte was en route to join her sister in Paris when she stopped in Belgium. She remained there, married Jean Pirotte, and became involved in organizing miners who were fighting for better conditions. Pirotte soon decided to study journalism and photography as a means of making a bigger impact. In 1939, she went to the Baltic states and, like much of her subsequent work, the images she made there were social, humanistic documents exposing poverty and exploitation. Upon hearing that Poland had been invaded, Pirotte began her odyssey to get back to Belgium; discovering that war was imminent there, she continued on to France.

In Marseille the Vichy government was in power; Pirotte joined the resistance, working as a freelance photographer on the waterfront for cover. Later, she was contracted as a photojournalist for *Dimanche Illustré,* which provided her with the necessary credentials to move about. Her pictures of street children and mass protests are less about lighting and composition than about exposing injustice, although she took some extraordinary portraits of Edith Piaf in Marseille. Pirotte worked in many different capacities, transporting arms, forging papers, and leading an uprising in August 1944 against the prefecture through the streets of Marseille. Pirotte was the only member of her family who survived: her sister Maria, also doing clandestine work in Marseille, was beheaded by the Nazis; her brother, a poet, died in a gulag in Siberia; her husband in Belgium disappeared, as did all her remaining relatives in Poland. Pirotte continued to fight on, photographing the Allied troops as they entered Marseille and the resulting street celebrations. She returned to Poland to document Warsaw in ruins and the bloody and beaten bodies of the Kielce pogrom in 1946. She photographed the returning exiled miners and the rebuilding and literacy campaigns in Warsaw; many of these images have a triumphant Soviet aesthetic, with towering figures against large open skies.

Pirotte's only known photographs of Picasso were taken at the World Congress of Intellectuals for Peace in Wrocław on August 6, 1948. What she thought of Picasso is unknown; her pictures capture a solemnity in his bearing that confirms their mutual commitment to world peace. He is pensive and serious as he sits among the hundreds in attendance in the enormous vaulted hall. His presence there is extraordinary, and not only because it was his first airplane trip ever. He believed in what was at stake, making a point of visiting Auschwitz before leaving.

Fig. p. 69

In looking at modernism, and at these photographers, there are several considerations that bear reexamining. One of them is ethnicity. A disproportionately large number of Central European modernist photographers were Jewish women who strongly identified with the project of modernization and national identity formation.[12] In spite of being caught in wartime Europe—with Denise Colomb, Madame d'Ora, and Rogi André forced to go underground to save their lives, and Pirotte risking her life fighting for the resistance—they not only forged ahead, but became even more committed to their work. Maar, whose father was, by some accounts, Jewish, had other battles and demons to fend off.

Another consideration is gender. Why separate out the women? Many of them have virtually disappeared from photographic history, particularly those who have not had

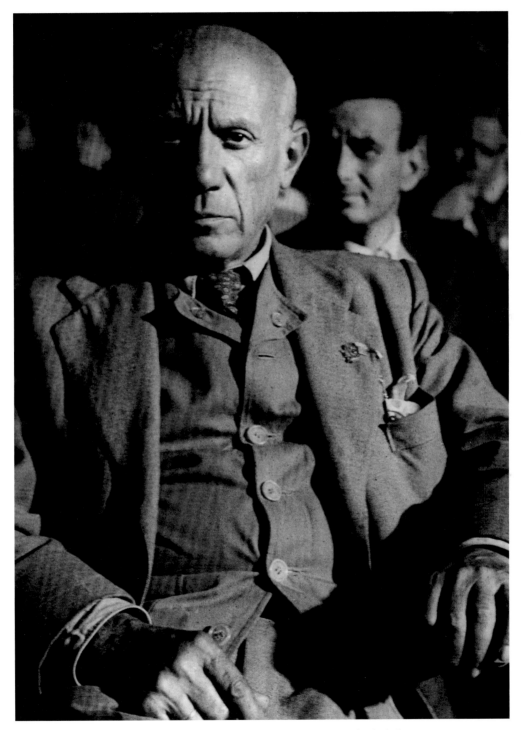

JULIA PIROTTE World Congress of Intellectuals for Peace in Wrocław, Poland, 1948

INGE MORATH Pablo Picasso seated next to Maurice Thorez (former French politician and member of the Communist Party) at the inauguration of a Picasso mural at the UNESCO Building in Paris, 1958

a champion to keep their works alive. In *A History of Women Photographers,* Naomi Rosenblum points to numerous factors that have contributed to this state of affairs: institutions have not collected their work with the same diligence; their writings and work in photographic criticism and theory have not been accessible; there is a gender imbalance in the quantity of text and illustrations dedicated to women in historical literature; and women's photographic work has been considered a hobby and not a vital focus.[13] This has changed significantly over time, yet it is precisely in the context of this exhibition that several of these photographers who fell through the cracks have been "recovered." It is the common thread of Picasso tying them together that provides a portrait—not just of the artist, but of the fascinating women who were there and took his picture.

1 *La Subversion des images— surréalisme, photographie, film,* exh. cat. Centre Pompidou, Paris; Fotomuseum Winterthur; Instituto de Cultura, Fundación Mapfre, Madrid (Paris, 2009), pp. 368–69.

2 Bernard Dufour, "Rogi André: Negative Work," *Art Press* (November 20, 1999), p. 63.

3 Matthew S. Witkovsky, *Foto: Modernity in Central Europe,* exh. cat. National Gallery of Art, Washington, D. C.; Scottish National Gallery of Modern Art, Edinburgh (New York, 2007), p. 78.

4 Monika Faber, *D'Ora: Vienna and Paris 1907–1957* (Poughkeepsie, NY, 1997).

5 His sister Thérèse le Prat was a Parisian portrait photographer.

6 Victoria Combalía, *Dora Maar: Fotógrafa* (Valencia, 1955), p. 195.

7 Anne Baldassari, *Picasso— Dora Maar: il faisait tellement noir . . .* (Paris, 1997), pp. 42–45.

8 Correspondence with Rebecca Miller, Morath's daughter, April 2011.

9 "Art: Skeleton for UNESCO," *Time* (April 14, 1958).

10 Letter from David Douglas Duncan to Antony Penrose, May 21, 2007.

11 Lee Miller, *Vogue* (November 1951).

12 Witkovsky 2007 (see note 3), p. 83

13 Naomi Rosenblum, *A History of Women Photographers,* 3rd edition (New York, 2010), pp. 7–12.

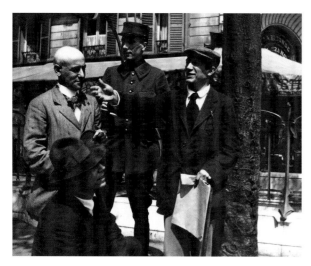

Manuel Ortiz de Zárate, Max Jacob, Henri-Pierre Roché,
Pablo Picasso

JEAN COCTEAU
Paris, August 12, 1916

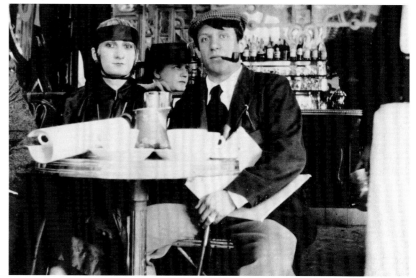

Pâquerette, Marie Vassilieff, Pablo Picasso in front of Café La Rotonde

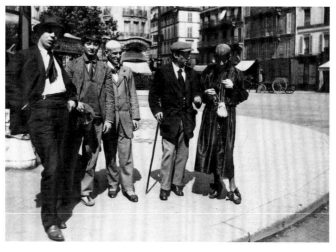

Manuel Ortiz de Zárate, Moïse Kisling, Max Jacob, Pablo Picasso, Pâquerette

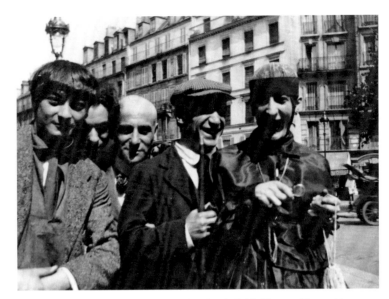

Moïse Kisling, Manuel Ortiz de Zárate, Max Jacob, Pablo Picasso, Pâquerette

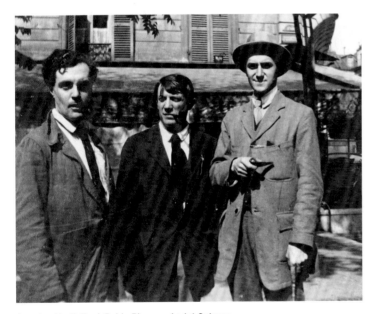

Amedeo Modigliani, Pablo Picasso, André Salmon

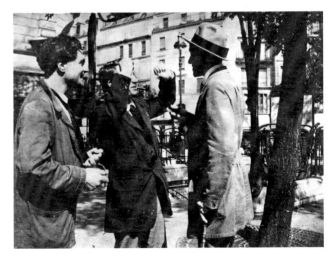

Amedeo Modigliani, Pablo Picasso, André Salmon

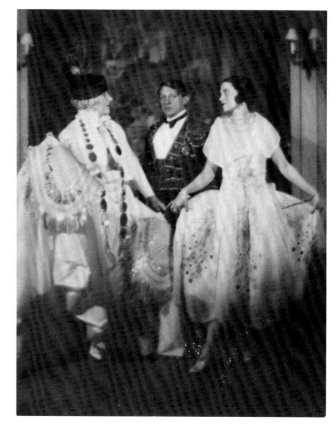

MAN RAY Picasso between Mme. De Erraguyen and Olga
as toreador at the Comte de Beaumont costume ball, 1924

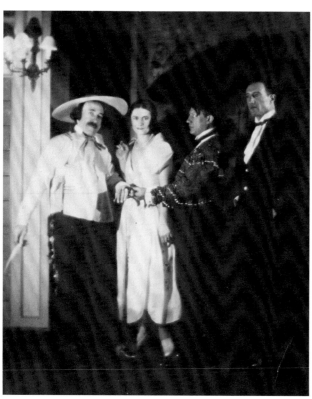

MAN RAY Ricardo Viñes, Olga Picasso,
Pablo Picasso, and Manuel Ángeles Ortiz, 1924

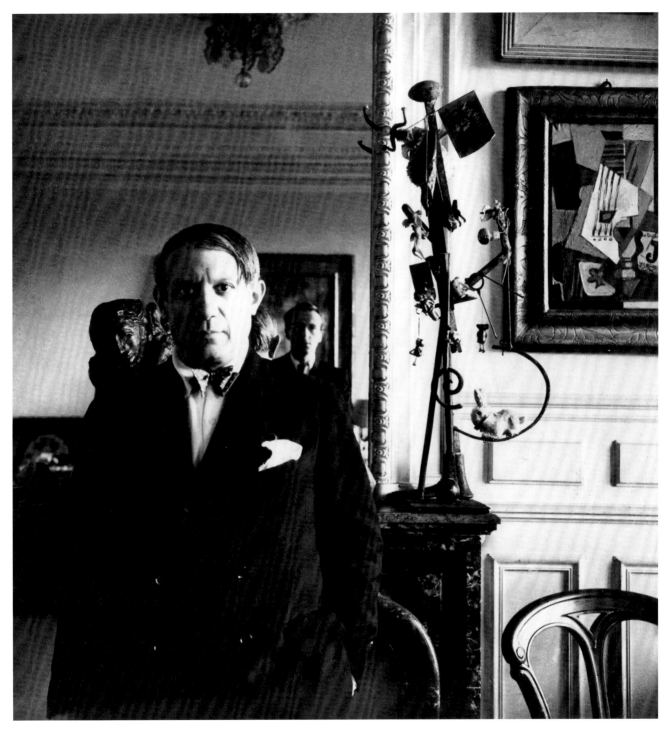

CECIL BEATON Pablo Picasso, 1933

BRASSAÏ The studio on Rue La Boëtie, 1932

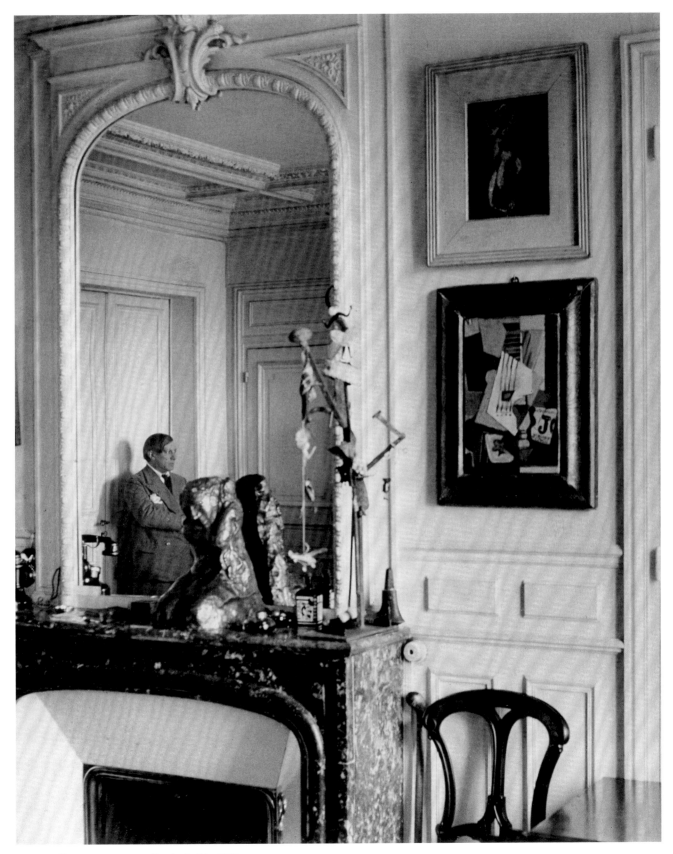

BRASSAÏ The apartment on Rue La Boëtie, 1932

BRASSAÏ The Bateau-Lavoir by night, 1946

BRASSAÏ The studio on Rue des Grands Augustins with easel
and canvases, 1945

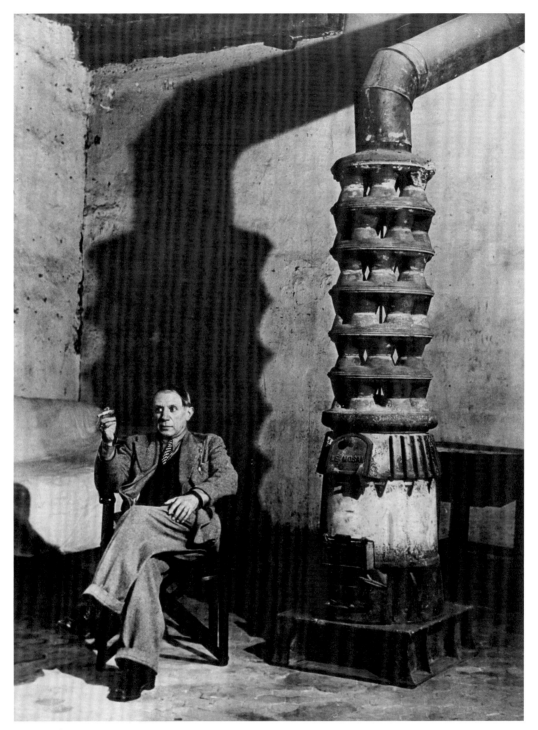

BRASSAÏ Picasso next to the oven in the studio on Rue des Grands Augustins, 1939

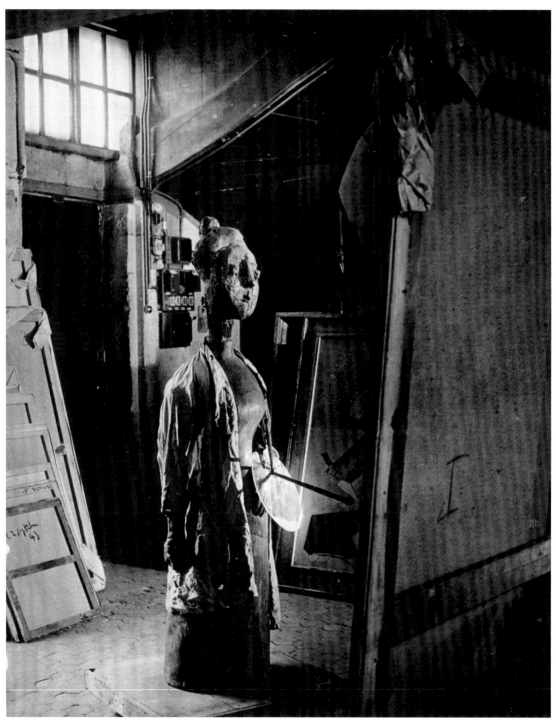

BRASSAÏ *The Woman with the Palette* in the studio on Rue des Grands Augustins, 1946

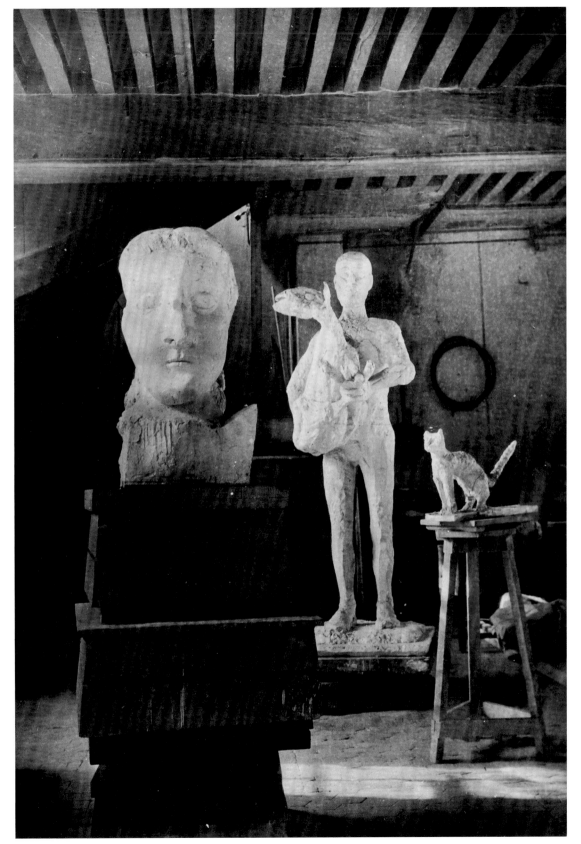

BRASSAÏ Bust of Dora Maar for the Apollinaire memorial, Rue des Grands Augustins, Paris 1943–44

BRASSAÏ The dove, 1944

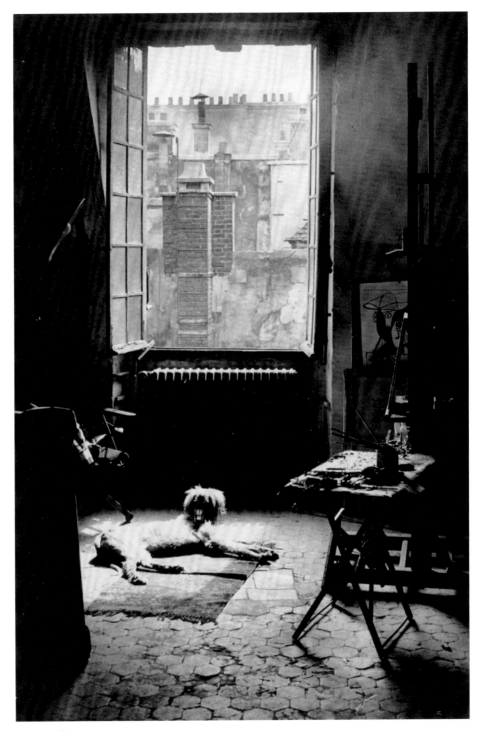

BRASSAÏ The dog Kazbek in the studio on Rue des Grands Augustins, Paris, May 2, 1944

Life Magazine, March 4, 1940

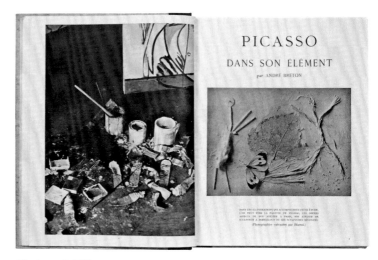

Minotaure 1, 1933

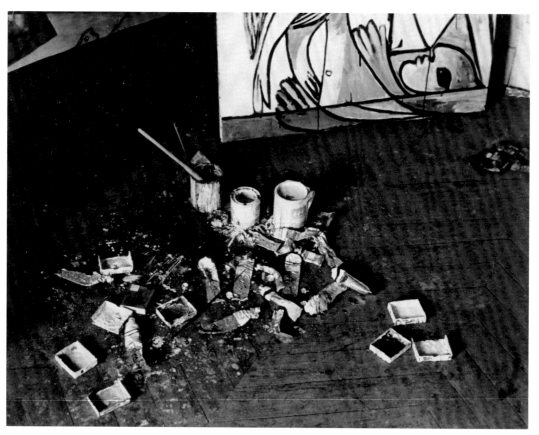

BRASSAÏ The paint pots in the studio on Rue La Boëtie, 1932

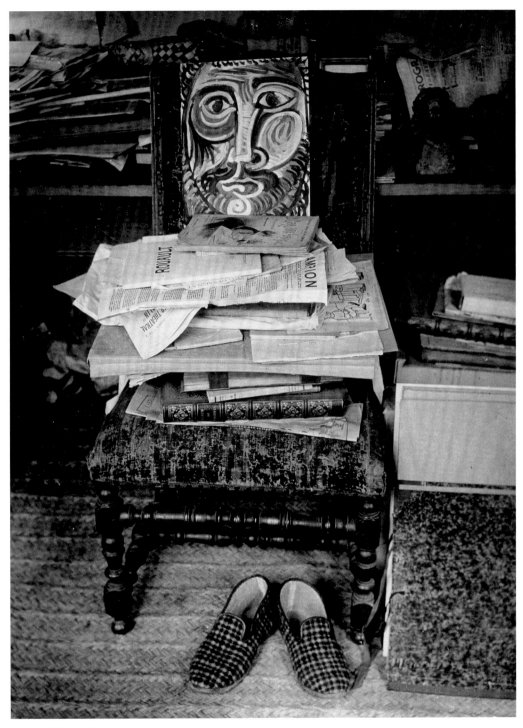

BRASSAÏ The slippers, 1943

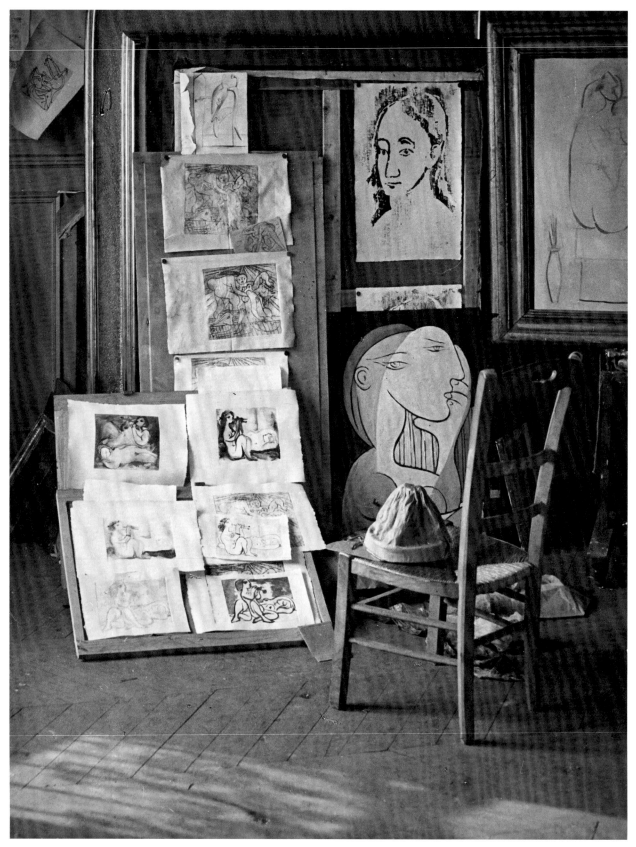

BRASSAÏ Corner of the studio, chair with hat, 1932

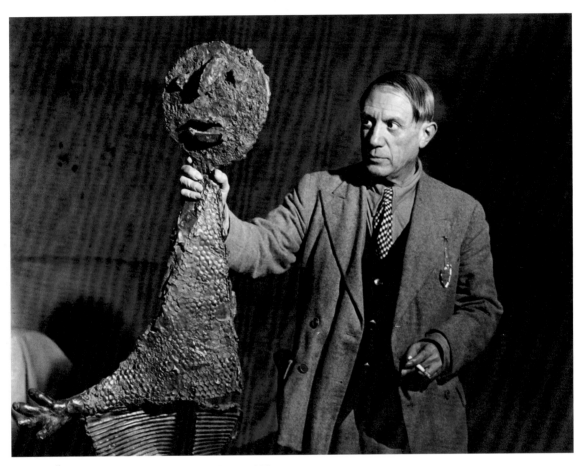

BRASSAÏ Picasso holding the sculpture *The Orator*, 1939

BRASSAÏ Untitled (Picasso with paintbrush on newspaper base), 1944–45

BRASSAÏ Cast of Picasso's right hand, 1944

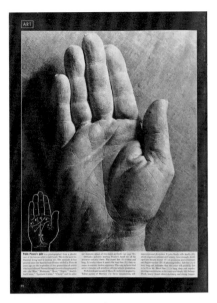

Life Magazine, November 13, 1944

BRASSAÏ The closed fist, 1944

BRASSAÏ Studio in Boisgeloup with sculptures by night, 1932

BRASSAÏ Studio door in Boisgeloup with two dogs and Tériade, 1932

BRASSAÏ Picasso at Café Flore, 1939

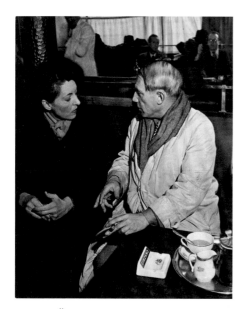

BRASSAÏ Picasso at Café Flore, 1939

BRASSAÏ Picasso at Brasserie Lipp with Pierre Matisse and Jaime Sabartés, 1939

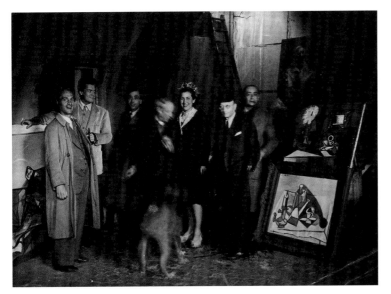

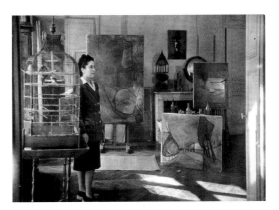

BRASSAÏ Dora Maar in her studio, 1945

BRASSAÏ The group in the studio on Rue des Grands Augustins
(left to right: Apel les Fenosa, Jean Marais, Pierre Reverdy, Pablo Picasso,
Françoise Gilot, Jaime Sabartés, Brassaï), 1944

BRASSAÏ
The group in the studio on
Rue des Grands Augustins
(left to right: Manuel Ortiz
de Zárate, Françoise Gilot,
Apel les Fenosa,
Jean Marais, Pierre Reverdy,
Pablo Picasso, Jean Cocteau,
Brassaï), 1944

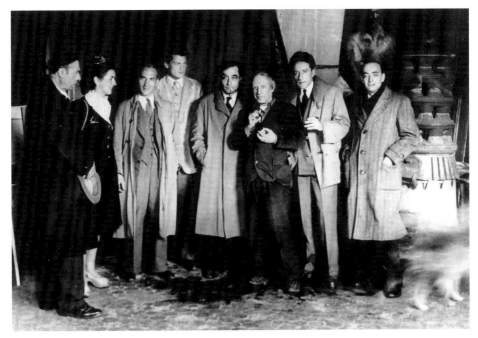

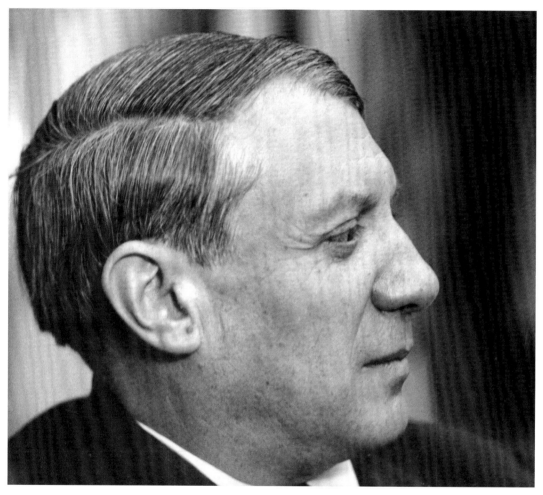

GOTTHARD SCHUH Portrait of Pablo Picasso at the opening of his exhibition at Georges Petit, Paris, 1932

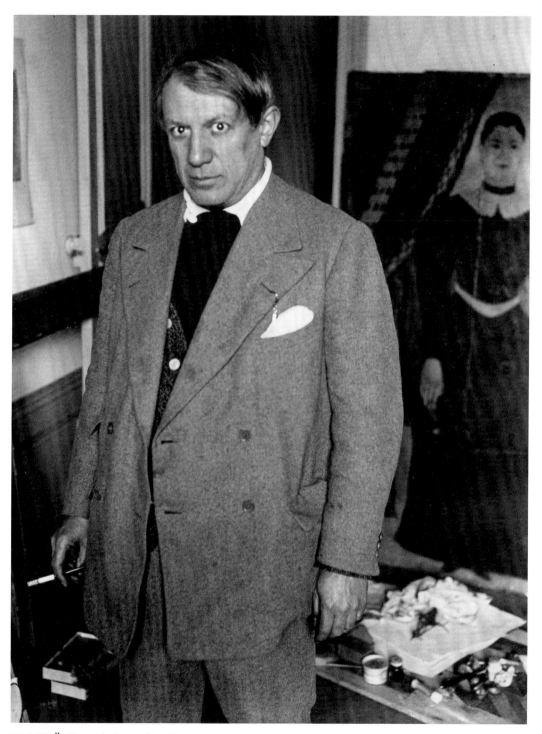

BRASSAÏ Picasso in front of Henri Rousseau's portrait of "Jadwiga," 1932

CHIM Picasso in front of his painting *Guernica* at its unveiling at the Spanish Pavilion of the World's Fair, Paris, 1937

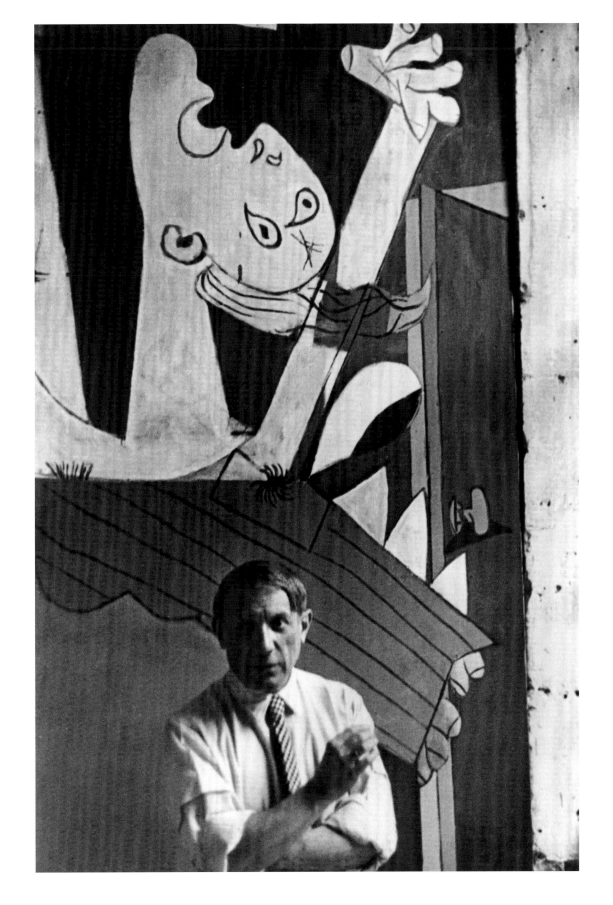

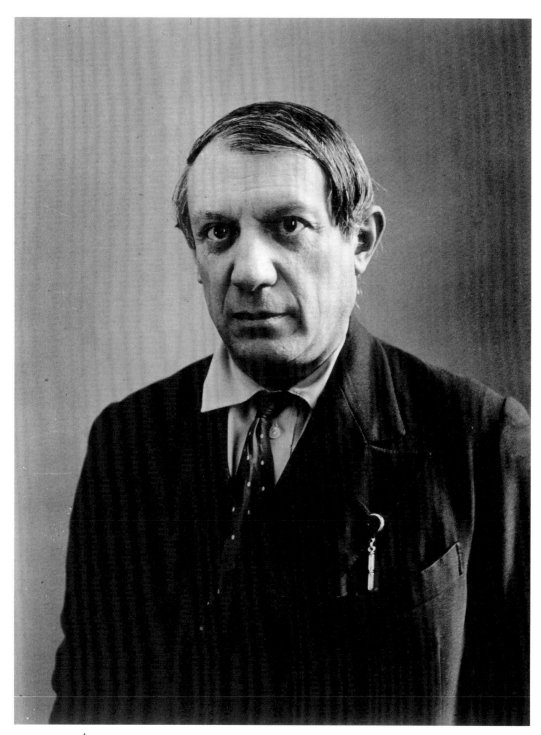

ROGI ANDRÉ Picasso, ca. 1936

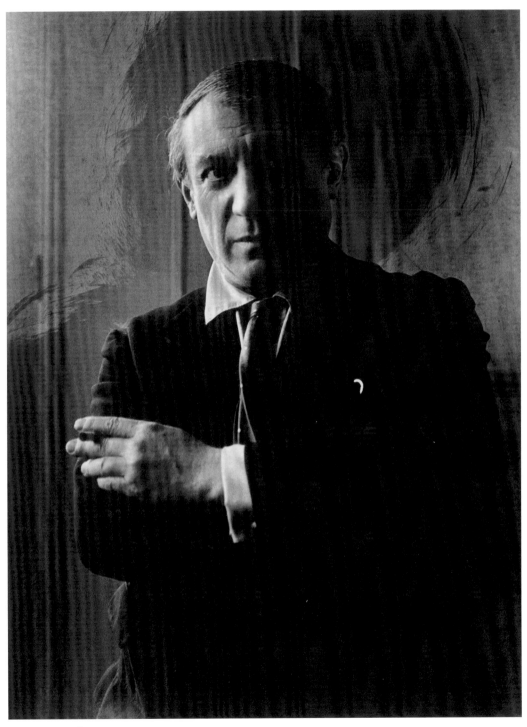

ROGI ANDRÉ Picasso, ca. 1936

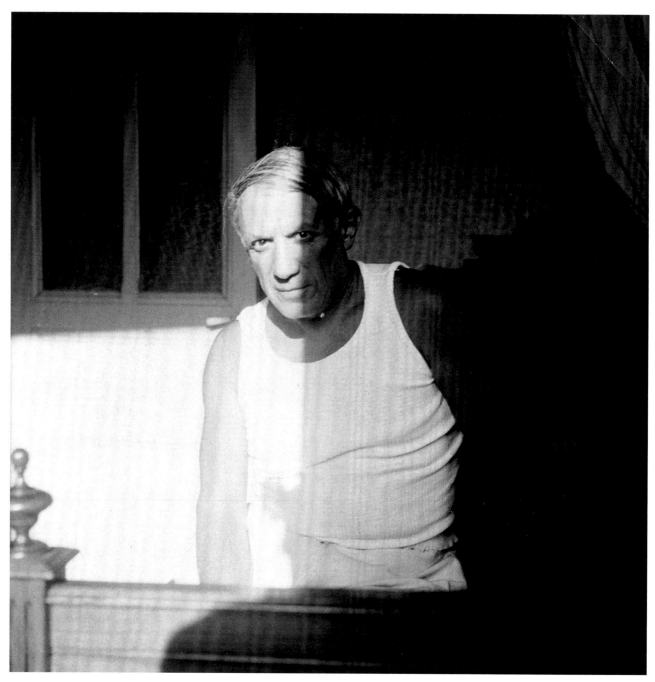

DORA MAAR Portrait of Picasso as bust, 1936

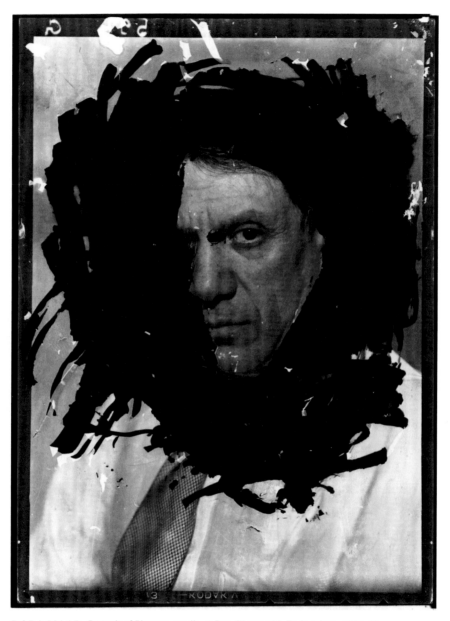

DORA MAAR Portrait of Picasso, studio at Rue d'Astorg 29, Paris, winter 1935–36

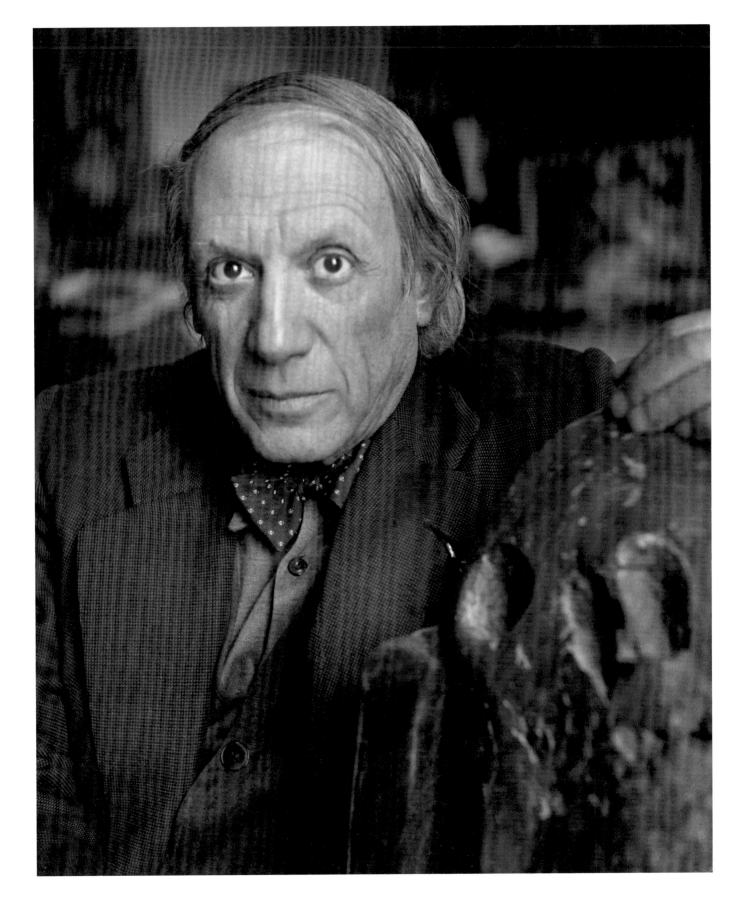

Page from Daniel-Henry Kahnweiler, *Les sculptures de Picasso: Photographies de Brassaï,* Paris 1948

HUBERT BECKER after Picasso/Brassaï, Skull, 2008

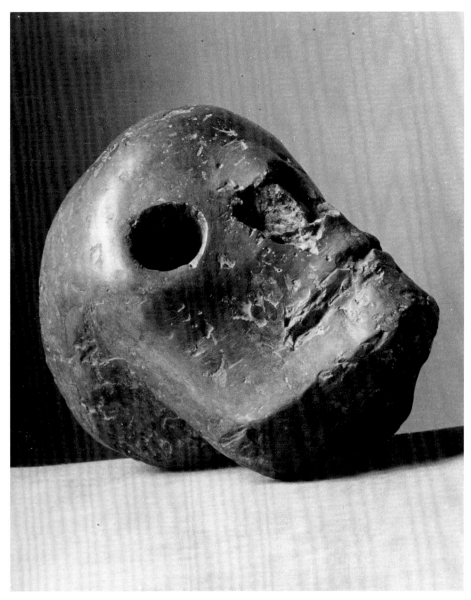

BRASSAÏ *Tête de mort*, 1944

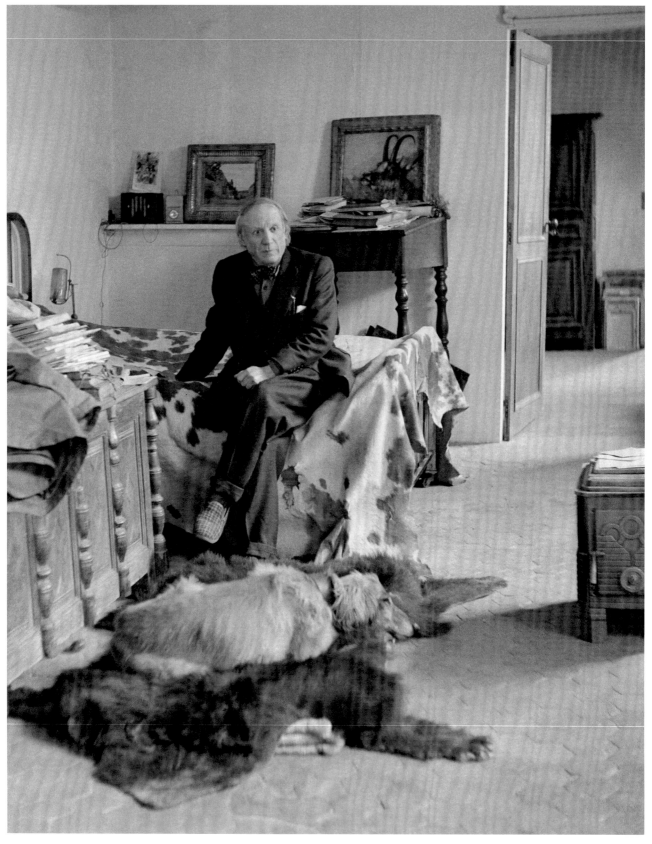

HERBERT LIST Pablo Picasso in his bedroom with his Afghan dog Kazbek, Rue des Grands Augustins, Paris 1944

HERBERT LIST Pablo Picasso at the window in his studio, Rue des Grands Augustins, Paris 1944

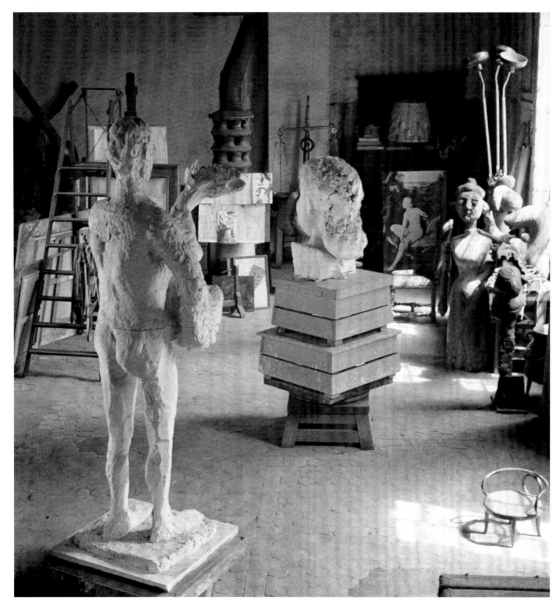

HERBERT LIST Pablo Picasso's studio on Rue des Grands Augustins, Paris 1944

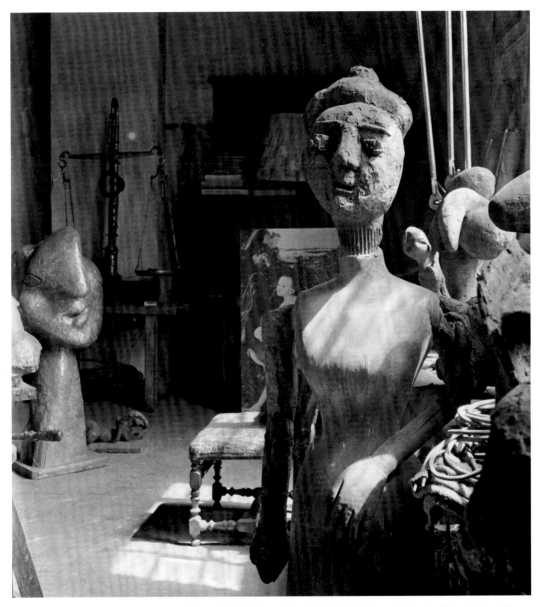

HERBERT LIST Pablo Picasso's studio, painting by Lucas Cranach in the background, Rue des Grands Augustins, Paris 1944

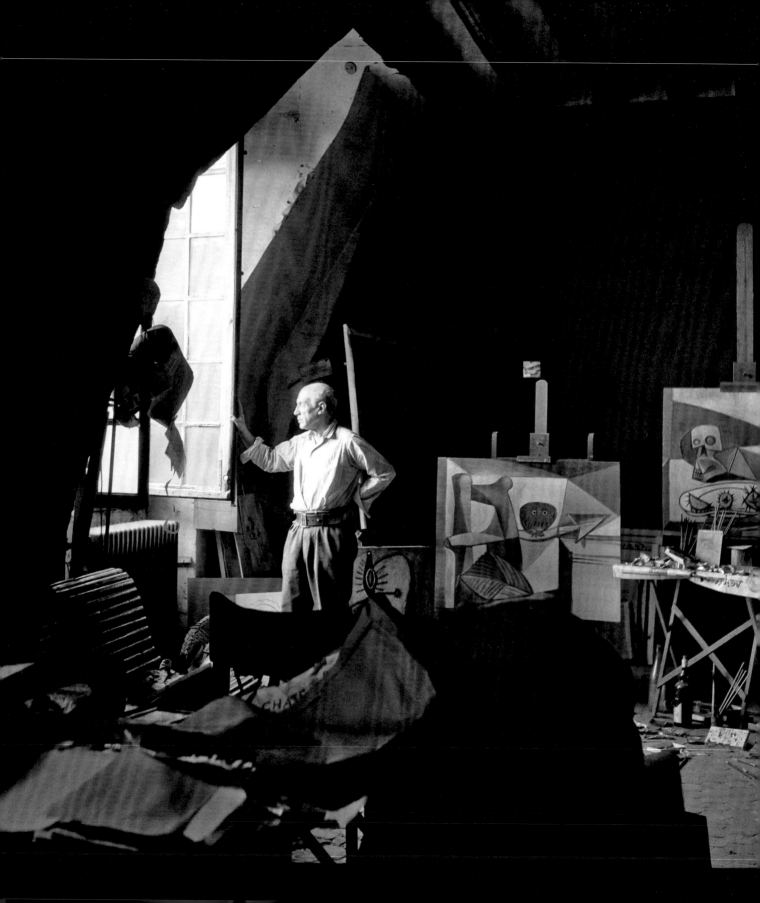

HERBERT LIST Pablo Picasso in his studio,
Rue des Grands Augustins, Paris 1948

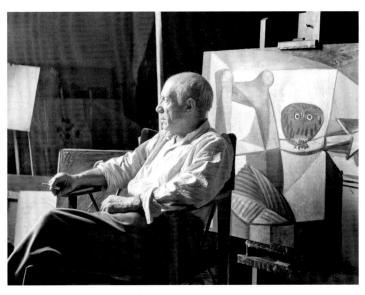

HERBERT LIST Pablo Picasso with *Owl in an Interior*,
profile, Rue des Grands Augustins, Paris 1948

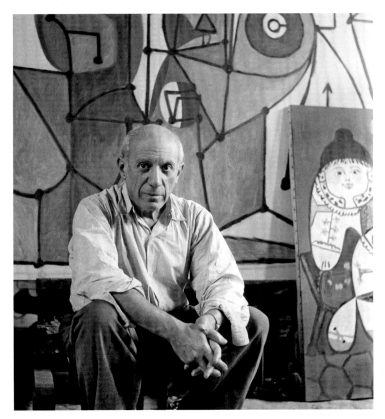

HERBERT LIST Pablo Picasso in his studio with *La Cuisine 2* and *Le Fils de
l'artiste "Claude" en costume polonaise,* Rue des Grands Augustins, Paris 1948

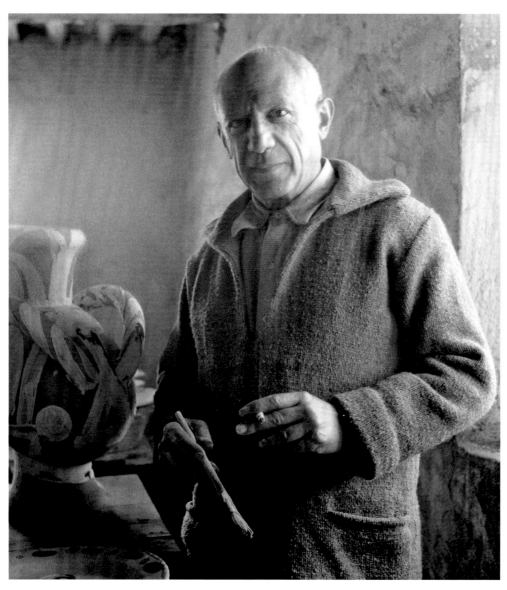

HERBERT LIST Pablo Picasso in Vallauris, 1949

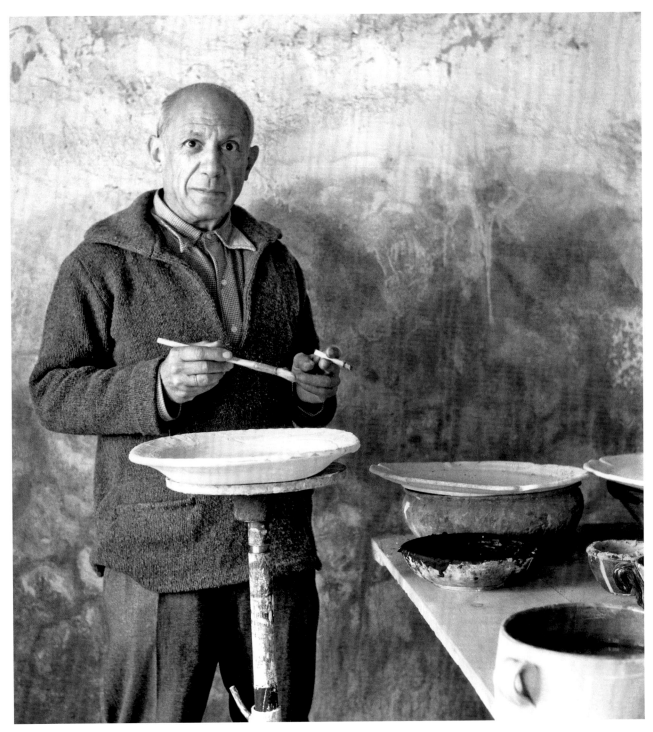

HERBERT LIST Pablo Picasso in Vallauris, 1949

MADAME D'ORA Untitled (Pablo Picasso), 1955

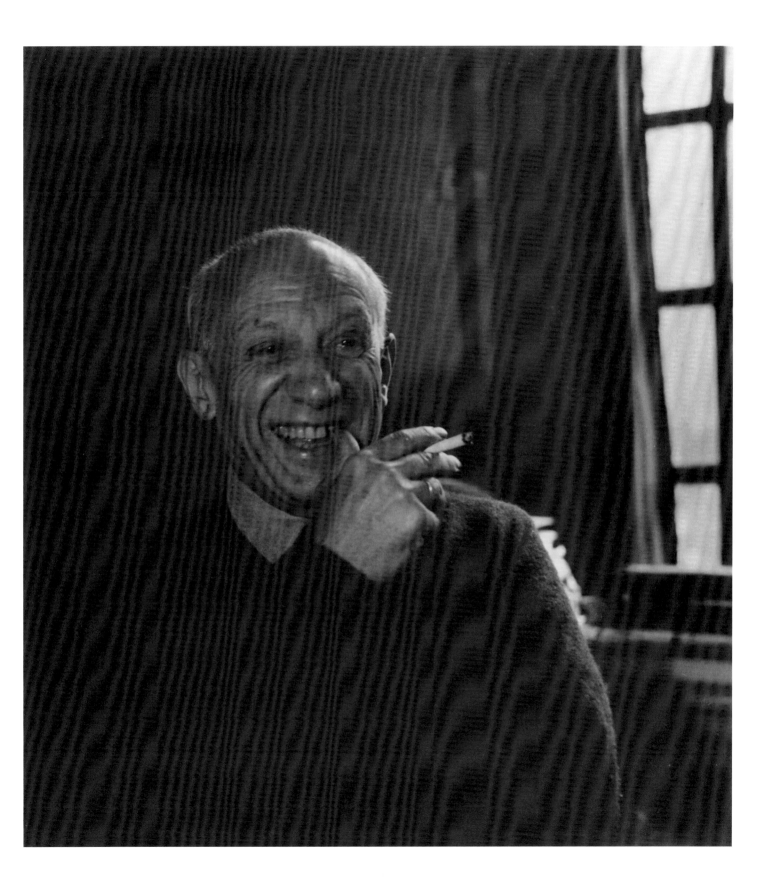

DENISE COLOMB Picasso's studio, Rue des Grands Augustins, Paris 1952

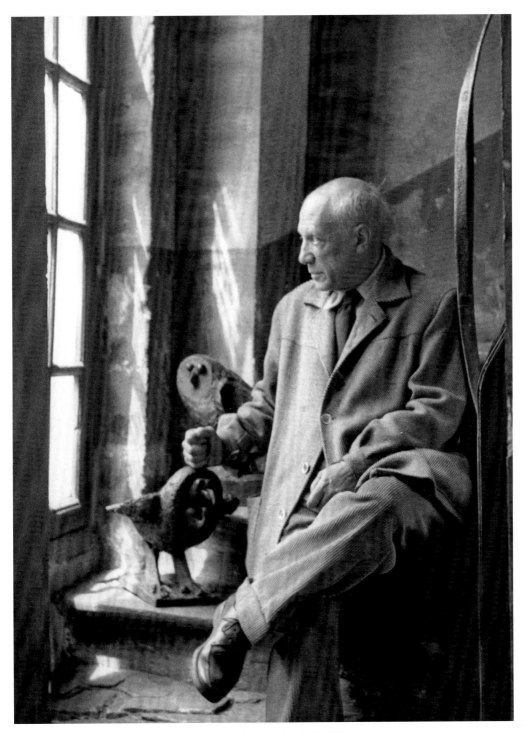

DENISE COLOMB Picasso in the Rue des Grands Augustins, Paris 1952

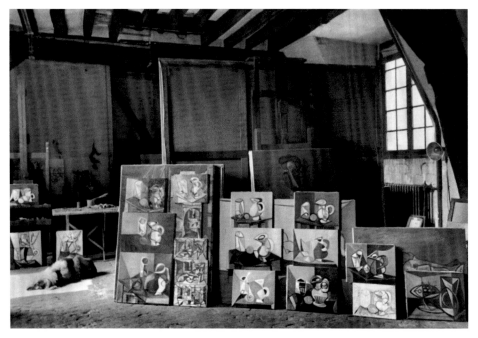

HENRI CARTIER-BRESSON Pablo Picasso's studio, Rue des Grands Augustins, Paris 1944

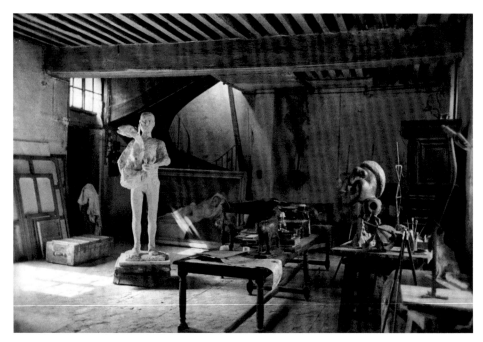

HENRI CARTIER-BRESSON Pablo Picasso's studio, Rue des Grands Augustins, Paris 1944

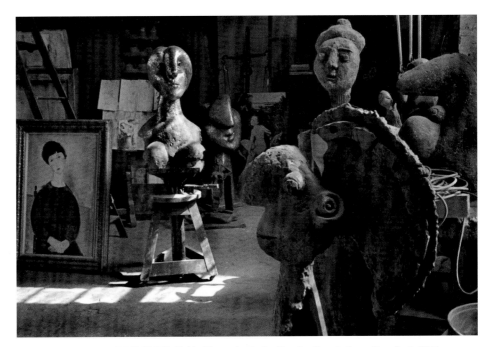

HENRI CARTIER-BRESSON Pablo Picasso's studio, Rue des Grands Augustins, Paris 1944

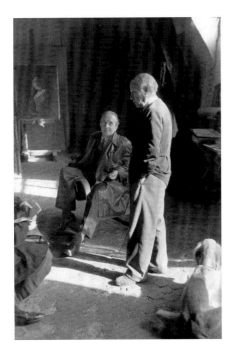

HENRI CARTIER-BRESSON
Paul Éluard and Pablo Picasso
in the studio, Rue des Grands
Augustins, Paris 1944

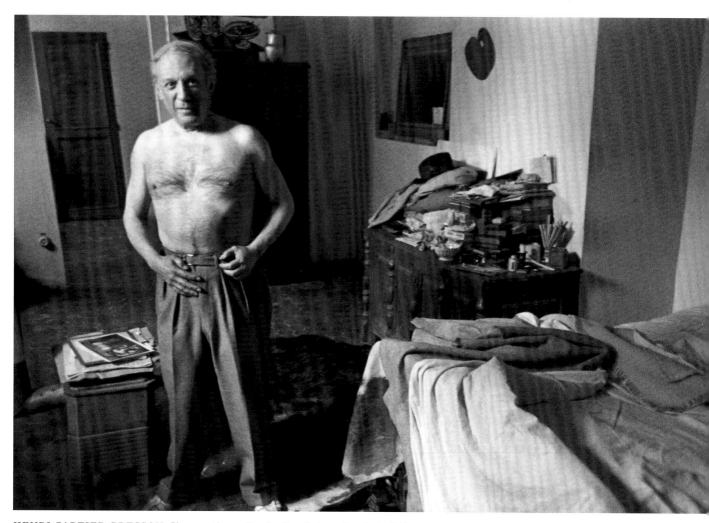

HENRI CARTIER-BRESSON Picasso at home, Rue des Grands Augustins, Paris 1944

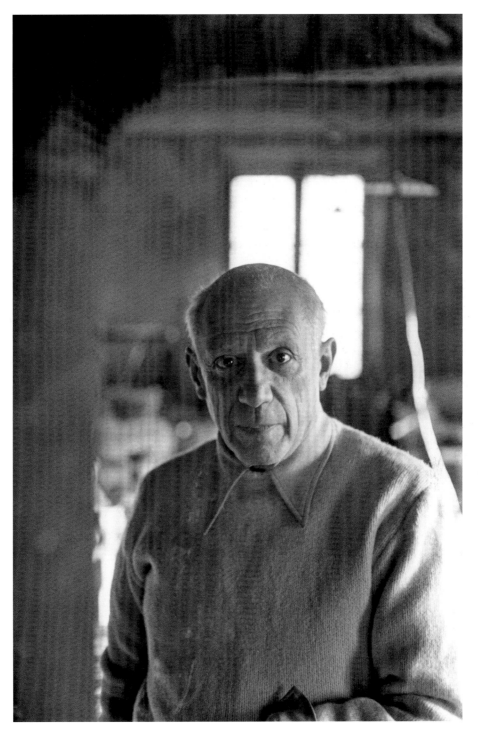

HENRI CARTIER-BRESSON Picasso in the ceramist Ramié's studio, Vallauris, 1953

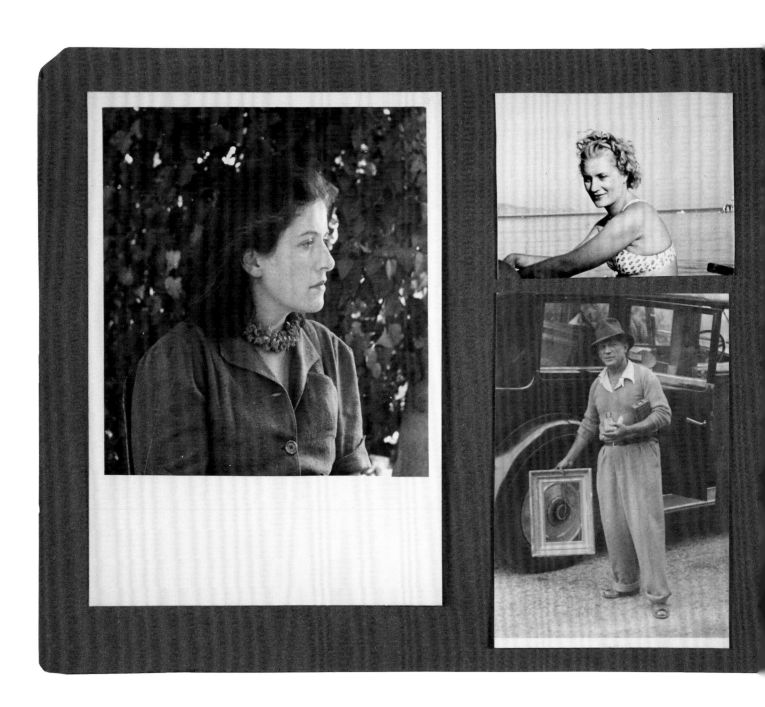

Album page assembled by Roland Penrose.
Dora Maar photographed by Lee Miller; Lee Miller photographed by Roland Penrose;
Picasso photographed by Man Ray, undated

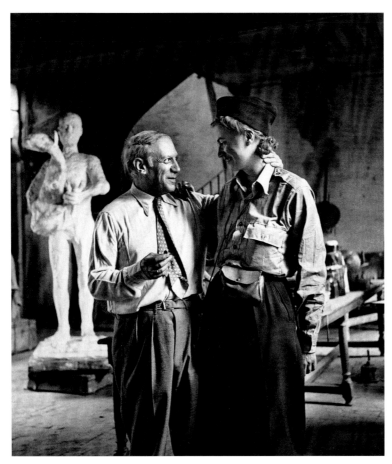

LEE MILLER Picasso and Lee Miller (after the liberation of Paris), 1944

British Vogue, October 1944

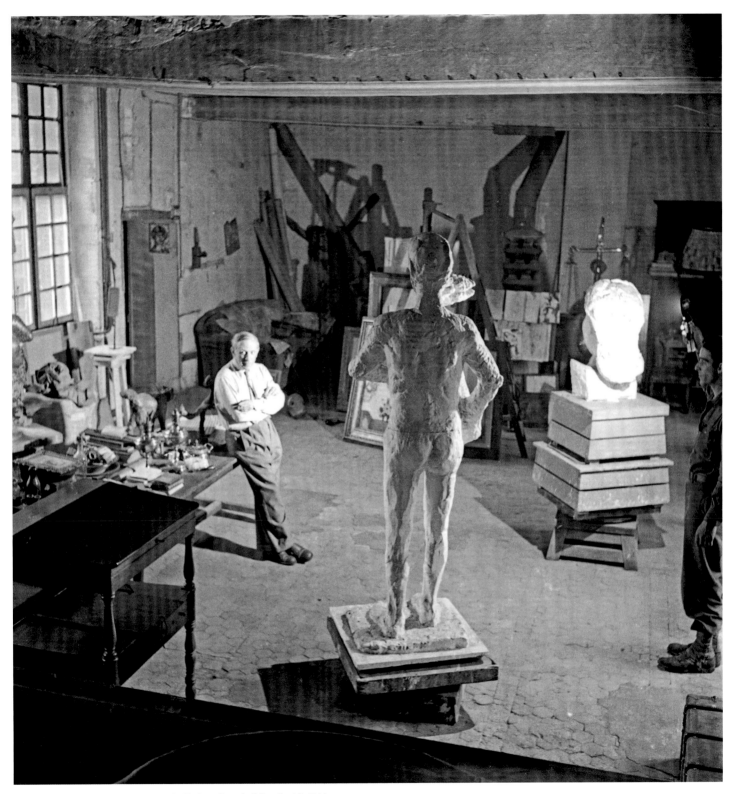

LEE MILLER Picasso in his studio (Robert Capa holding flash), 1944

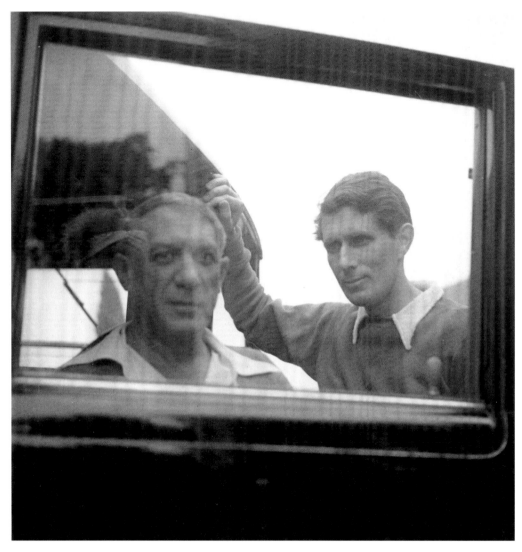

LEE MILLER Picasso and Roland Penrose, Mougins, 1937

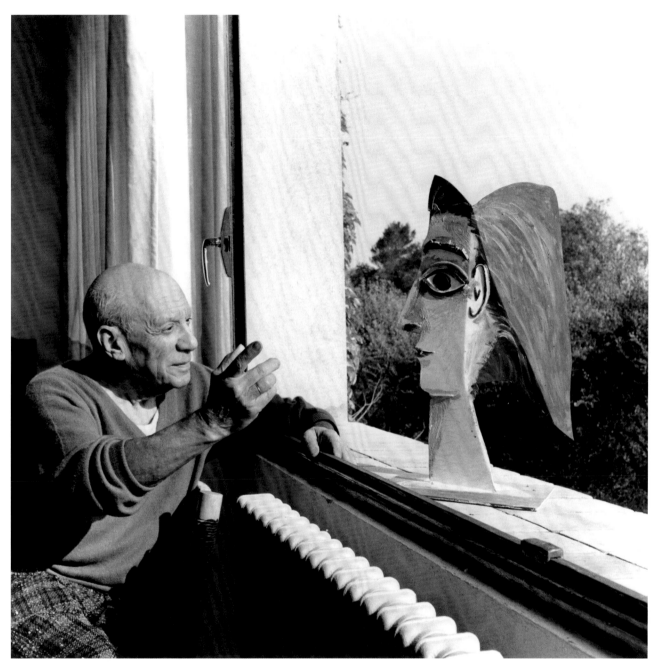

LEE MILLER Picasso and sculpture of Jacqueline, 1963

LEE MILLER "Pottery baby series" (showing, among others, Picasso and Georges Braque), 1954

JACQUELINE ROQUE (attributed) Picasso and Jacqueline with a ceramic sculpture, undated

JACQUELINE ROQUE (attributed) Jacqueline with a ceramic sculpture, undated

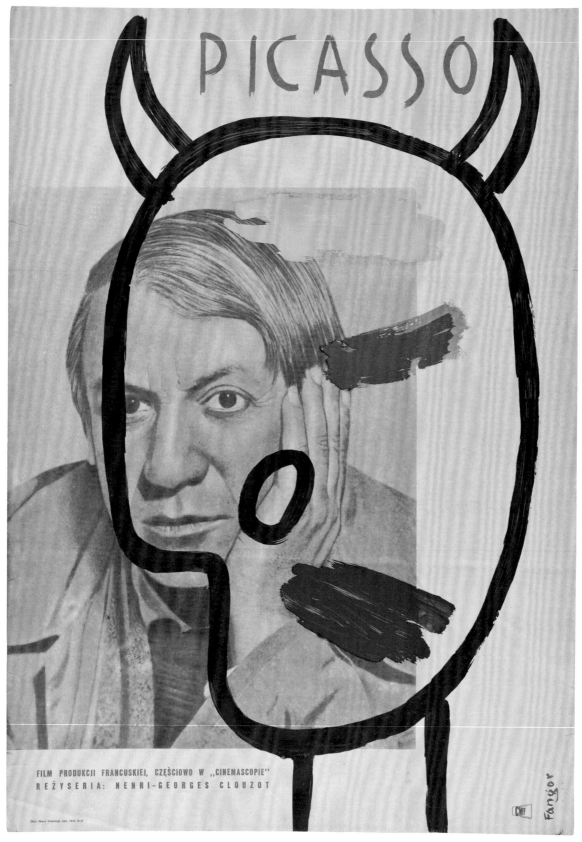

Poster for *Le mystère Picasso* by Henri-Georges Clouzot, France 1956, photo: Man Ray

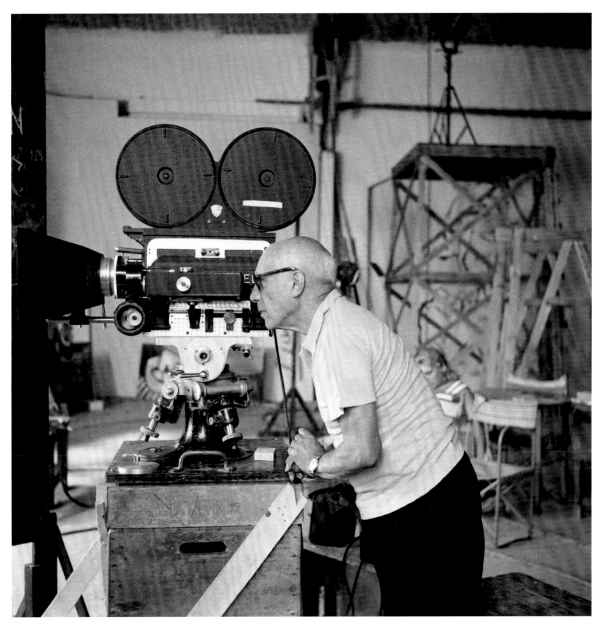

EDWARD QUINN Picasso at the Cinemascope camera during the filming of *Le mystère Picasso*, Studios de la Victorine, Nice 1955

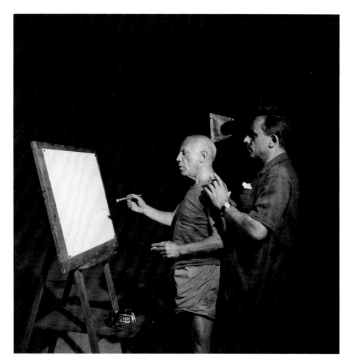

EDWARD QUINN Picasso in front of the white
paper on which he will paint *Dove of Peace,* observed
by Henri-Georges Clouzot, the director of *Le mystère
Picasso,* Studios de la Victorine, Nice 1955

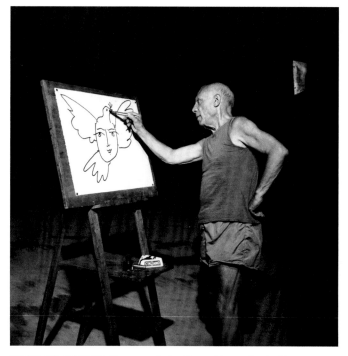

EDWARD QUINN Picasso painting *Dove of Peace* for the film
Le mystère Picasso, Studios de la Victorine, Nice 1955

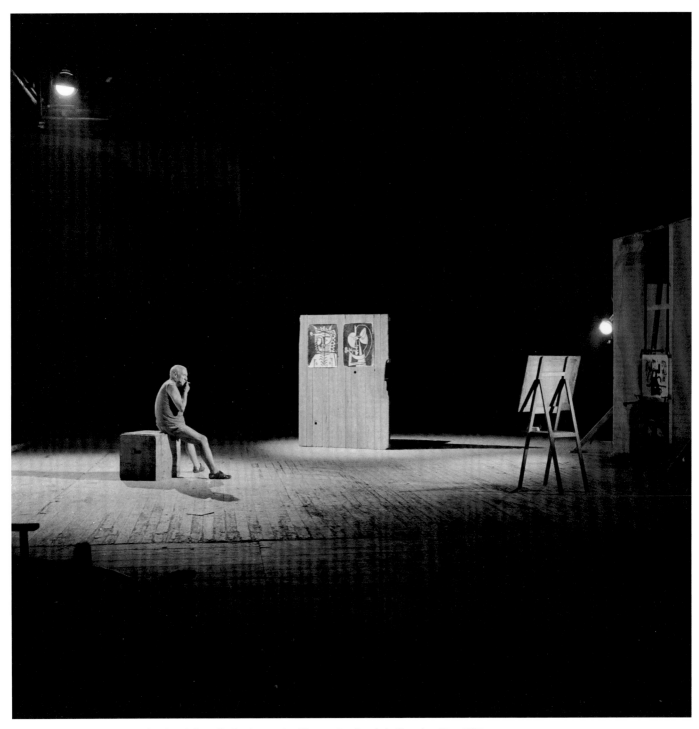

EDWARD QUINN Picasso in a break from filming *Le mystère Picasso*, Studios de la Victorine, Nice 1955

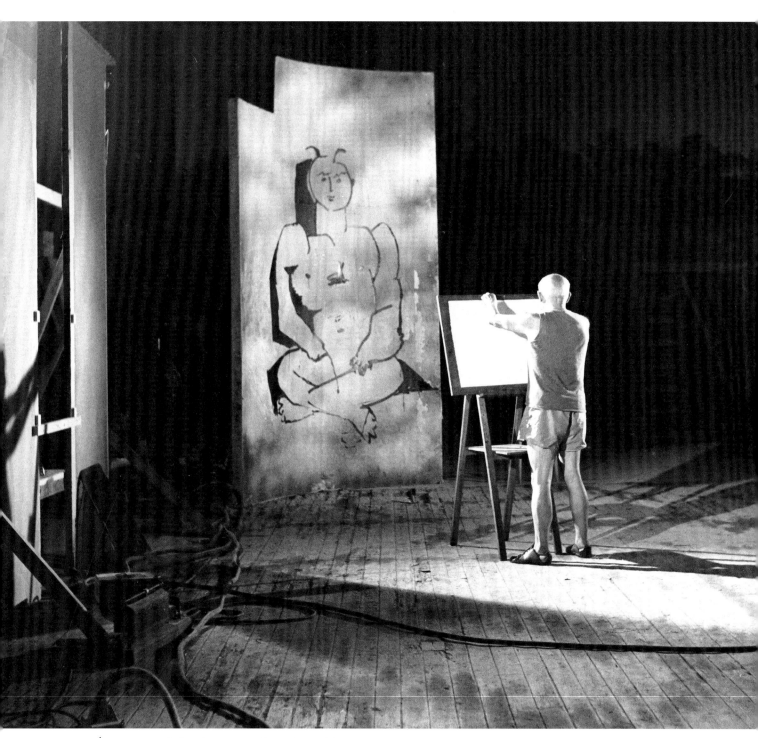

ANDRÉ VILLERS Filming of *Le mystère Picasso* by Henri-Georges Clouzot, Studios de la Victorine, Nice 1955

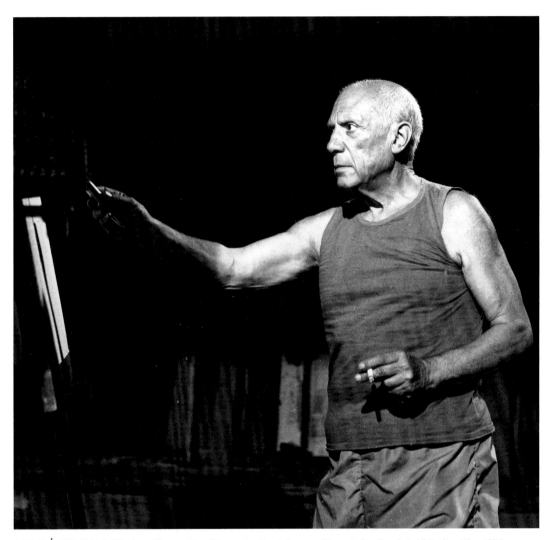

ANDRÉ VILLERS Filming of *Le mystère Picasso* by Henri-Georges Clouzot, Studios de la Victorine, Nice 1955

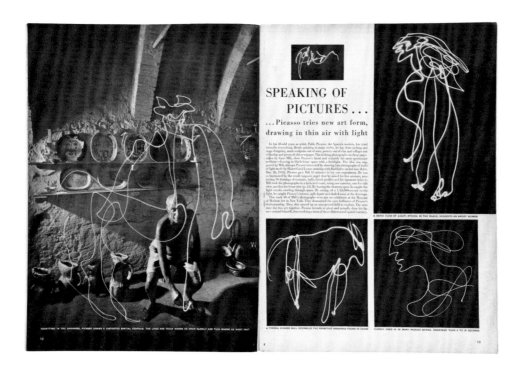

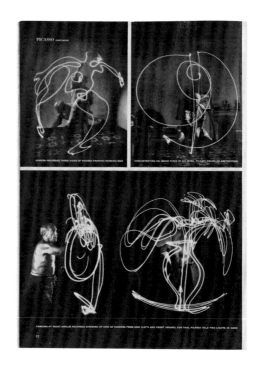

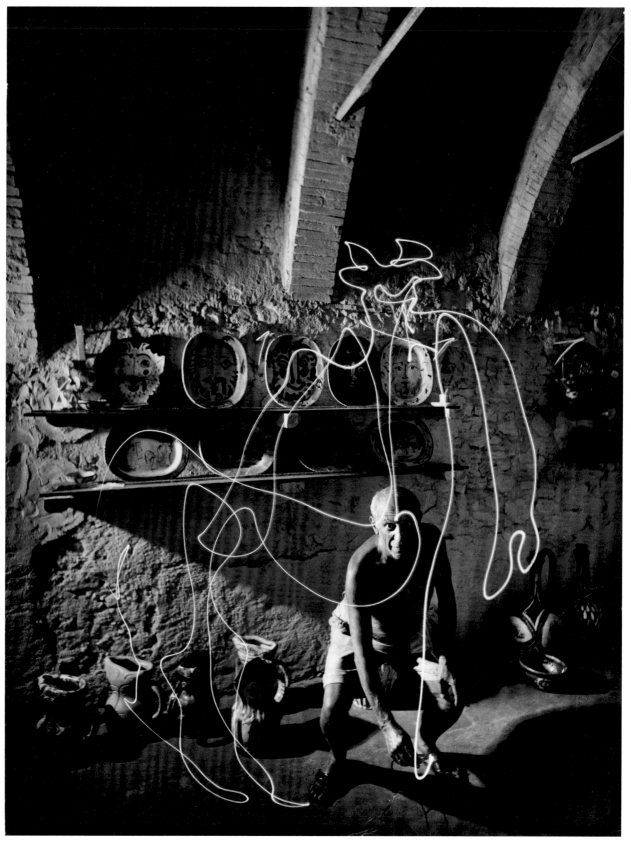

GJON MILI A centaur drawn with light—Pablo Picasso in the Madoura pottery workshop, Vallauris 1949

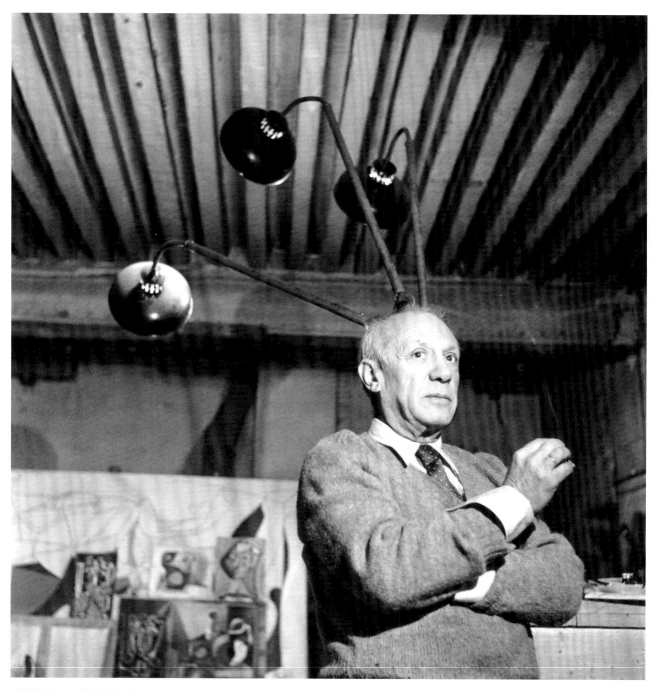

ROBERT DOISNEAU Picasso under the lamps, Rue des Grands Augustins, Paris 1959

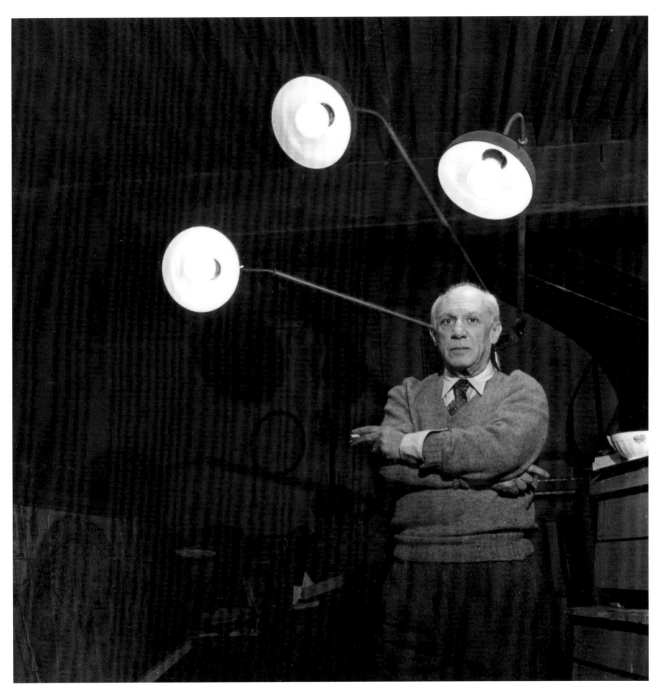

ROBERT DOISNEAU Picasso under the lamps, Rue des Grands Augustins, Paris 1959

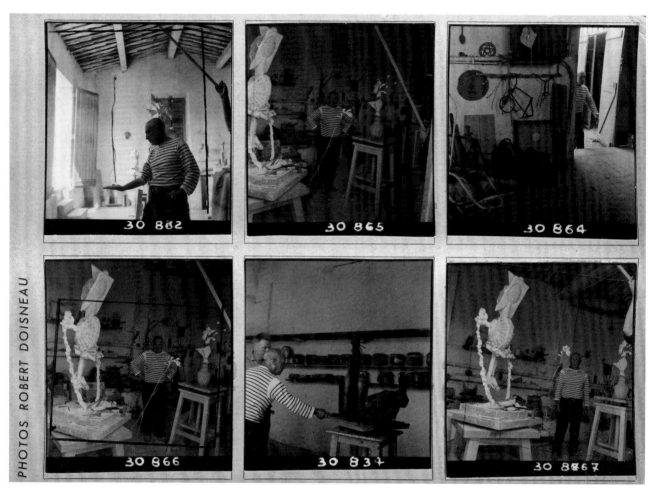

ROBERT DOISNEAU Glued-on contact sheet "fleur volante," undated

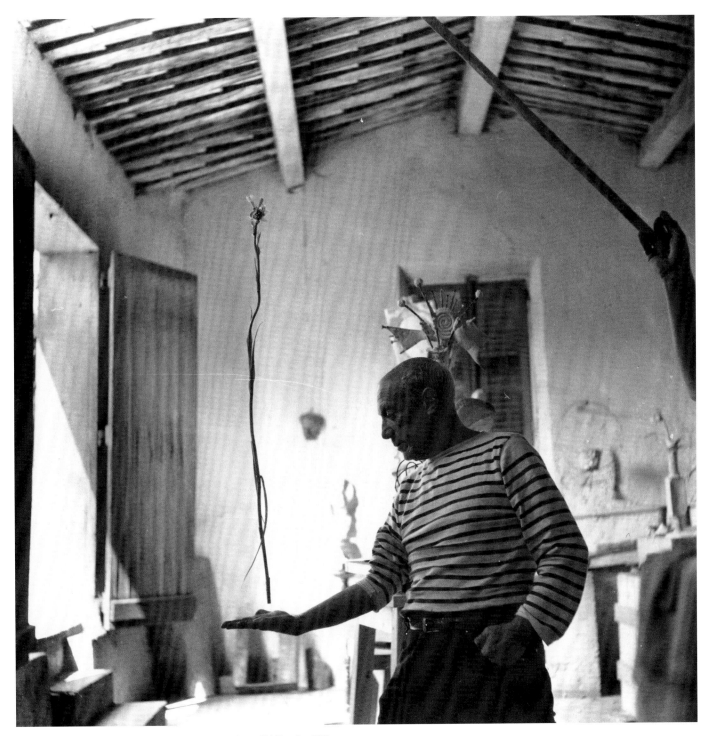

ROBERT DOISNEAU Picasso and "la fleur volante," Vallauris, 1952

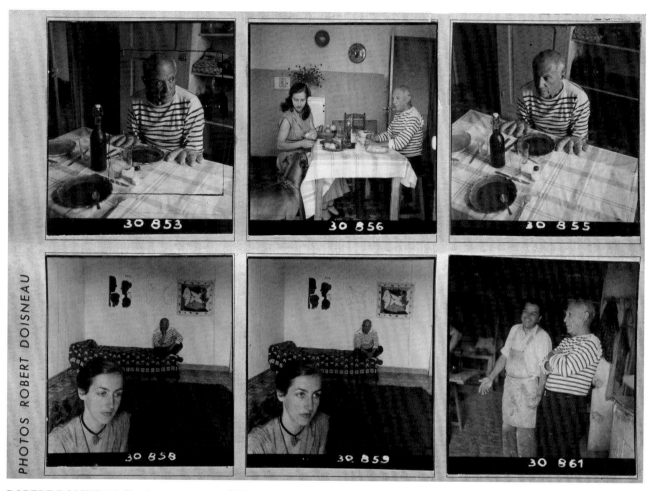

PHOTOS ROBERT DOISNEAU

ROBERT DOISNEAU Glued-on contact sheet "déjeuner," undated

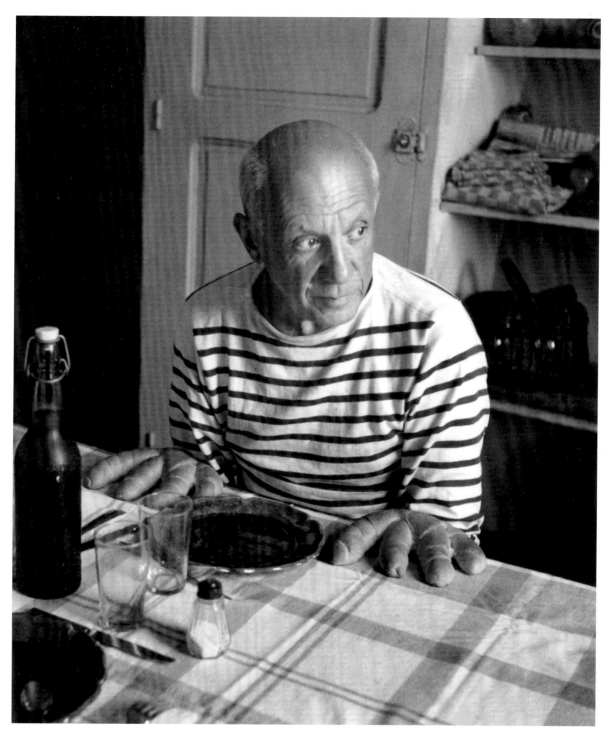

ROBERT DOISNEAU Pablo Picasso with bread fingers, Vallauris, 1952

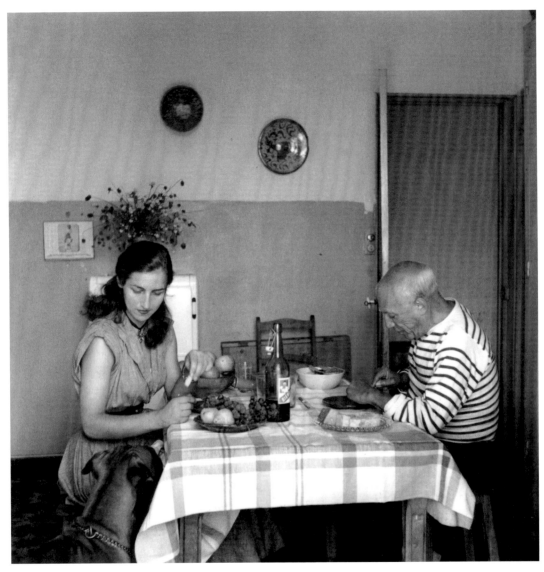

ROBERT DOISNEAU Picasso eating lunch with Françoise Gilot, Vallauris, 1952

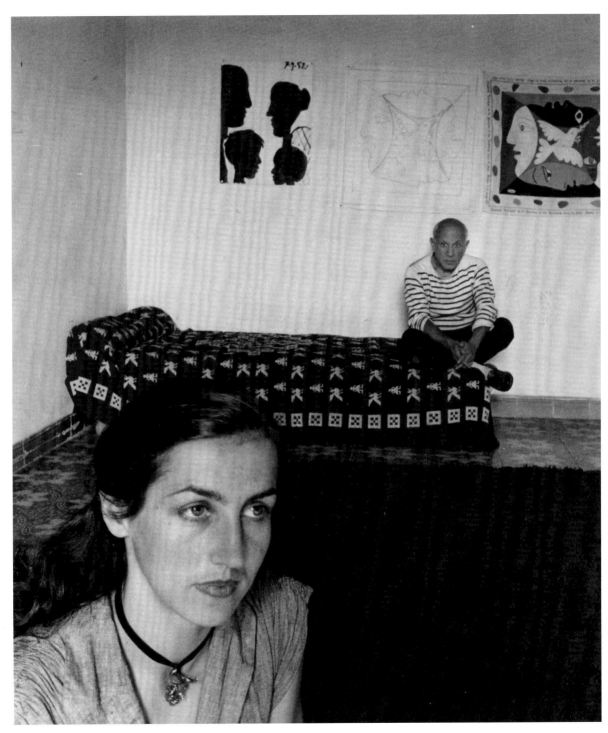

ROBERT DOISNEAU Picasso in Vallauris, in the foreground Françoise Gilot, 1952

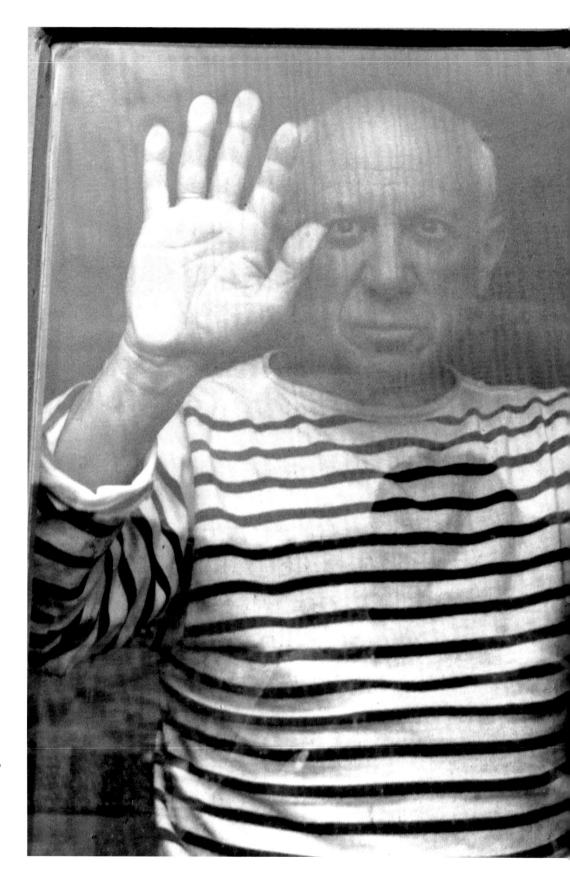

ROBERT DOISNEAU
Picasso—behind the window,
allauris, 1952

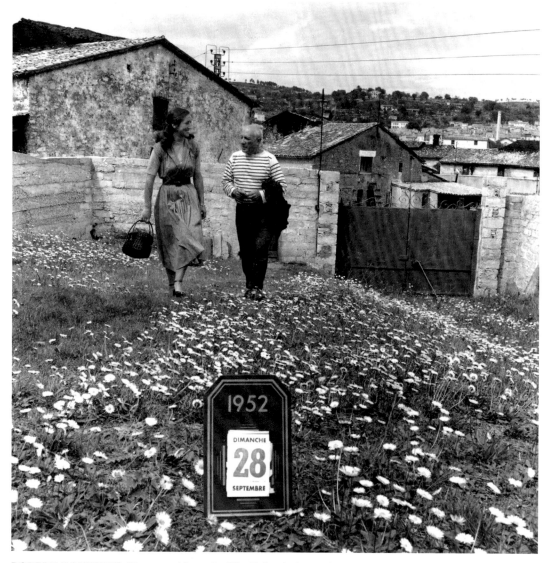

ROBERT DOISNEAU Picasso and Françoise Gilot, Vallauris, September 28, 1952

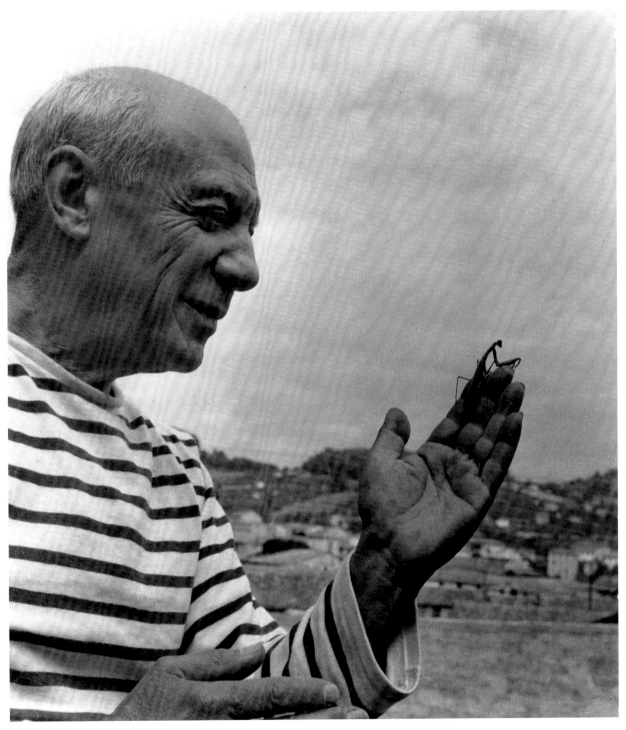

ROBERT DOISNEAU Picasso with praying mantis, Vallauris, 1952

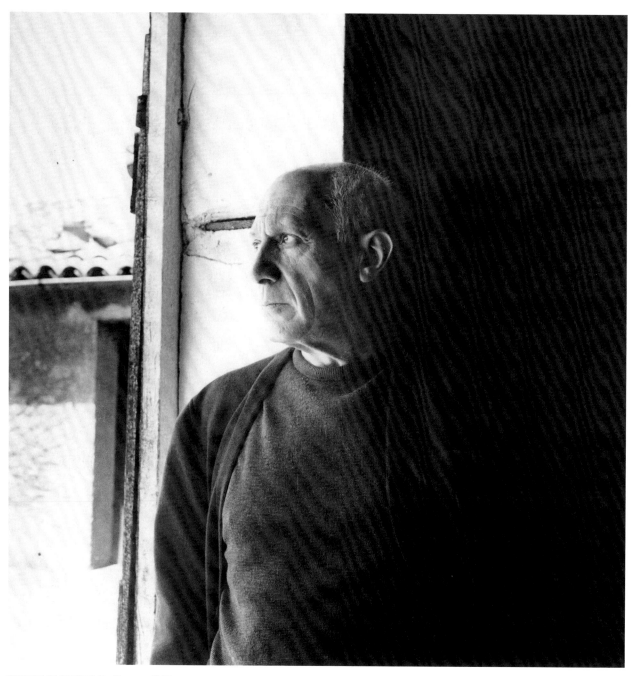

WILLY MAYWALD Picasso, 1948

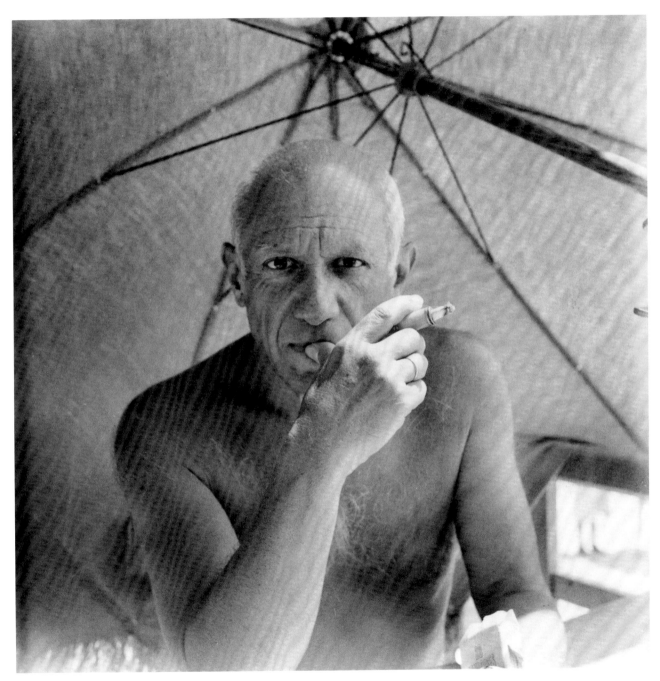

WILLY MAYWALD Picasso, 1947

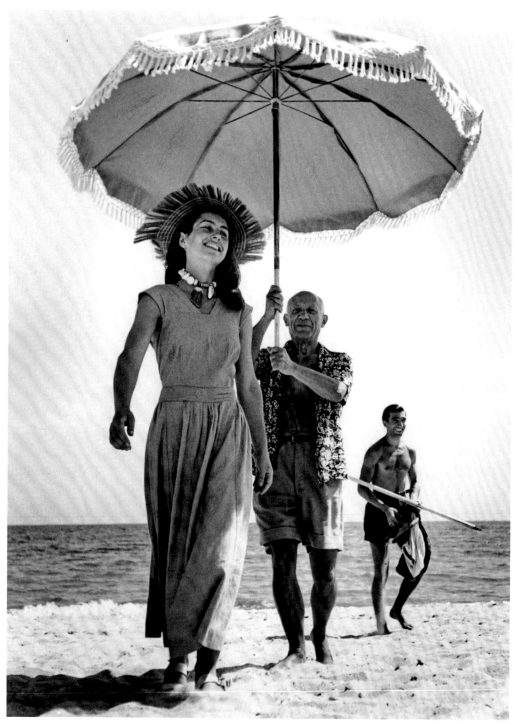

ROBERT CAPA Pablo Picasso and Françoise Gilot. In the background is Picasso's nephew Javier Vilato, August 1948

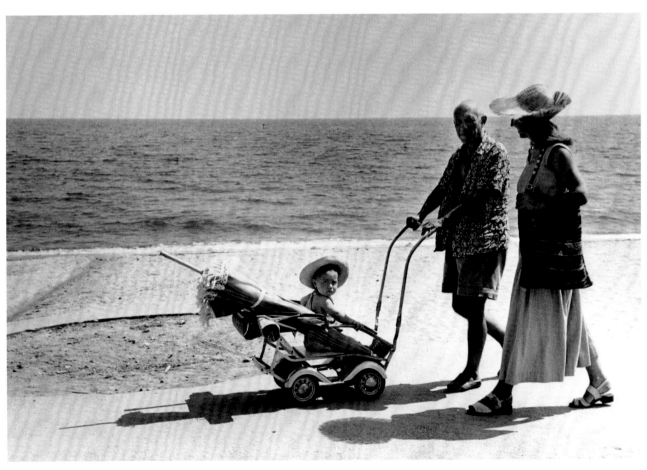

ROBERT CAPA Pablo Picasso on the beach with his son Claude and his partner Françoise Gilot, 1948

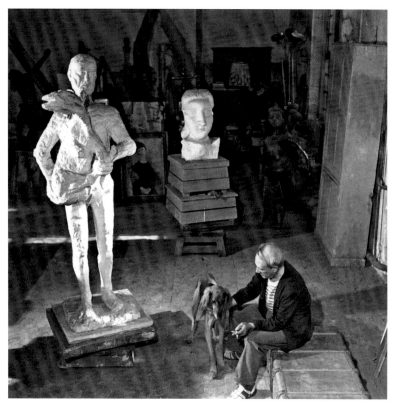

ROBERT CAPA Pablo Picasso in his studio at
the Rue des Grands Augustins, September 2, 1944

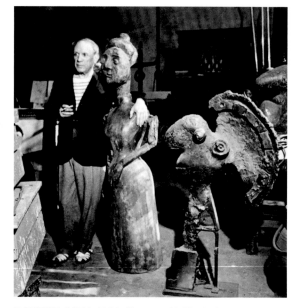

ROBERT CAPA Pablo Picasso with *The Artist-Painter*, 1944

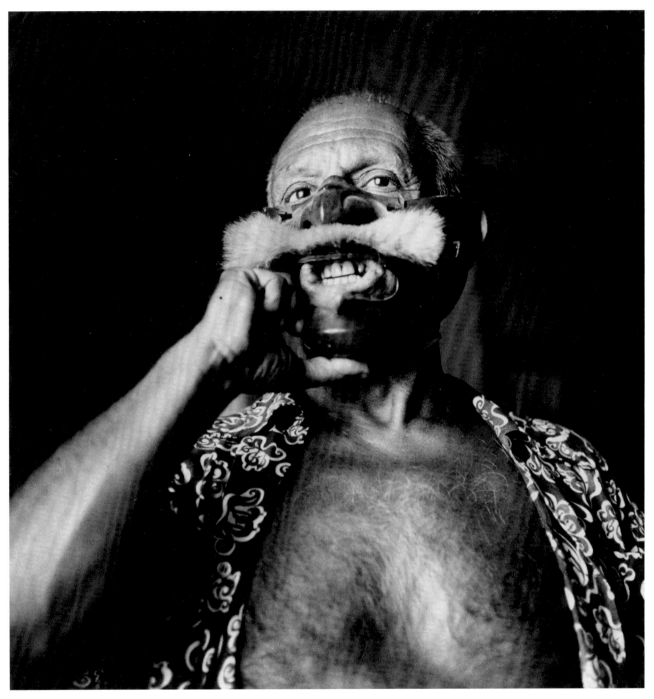

ROBERT CAPA Picasso as clown, 1946

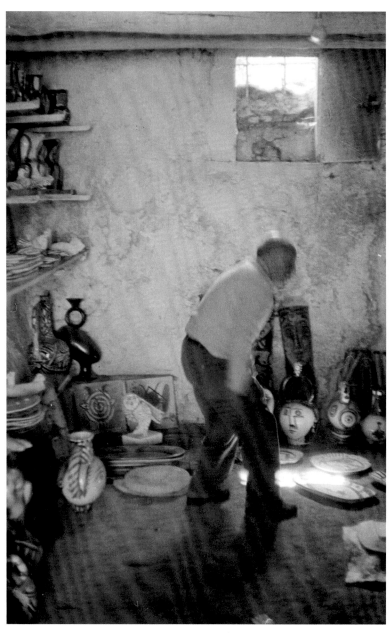

INGE MORATH Pablo Picasso, Vallauris, 1953

ROBERT PICAULT Picasso during the filming
of Fréderic Rossif's film, 1950

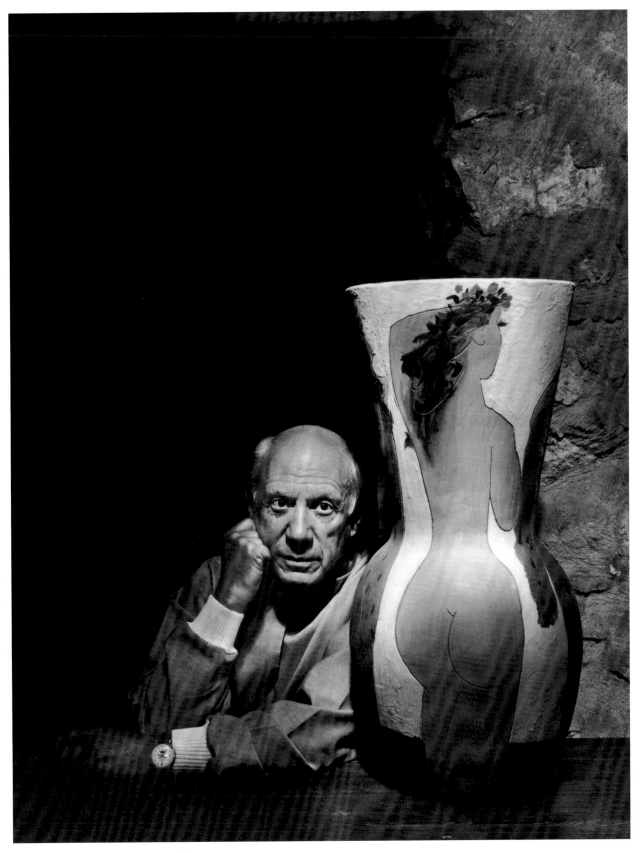

YOUSUF KARSH Pablo Picasso, 1954

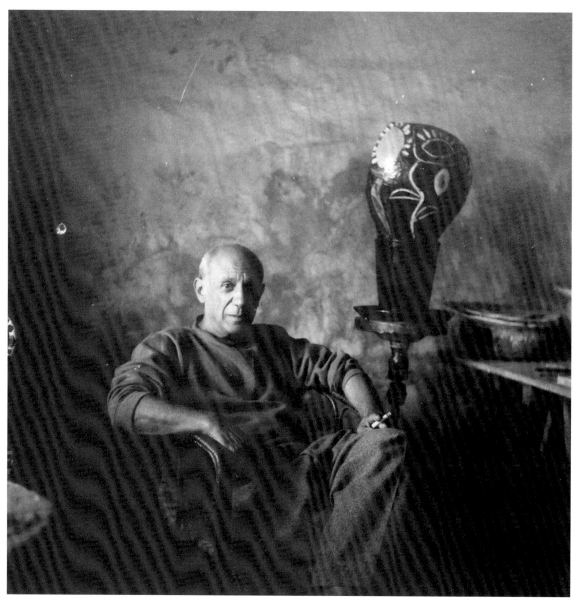

MICHEL SIMA Picasso in Vallauris, ca. 1950

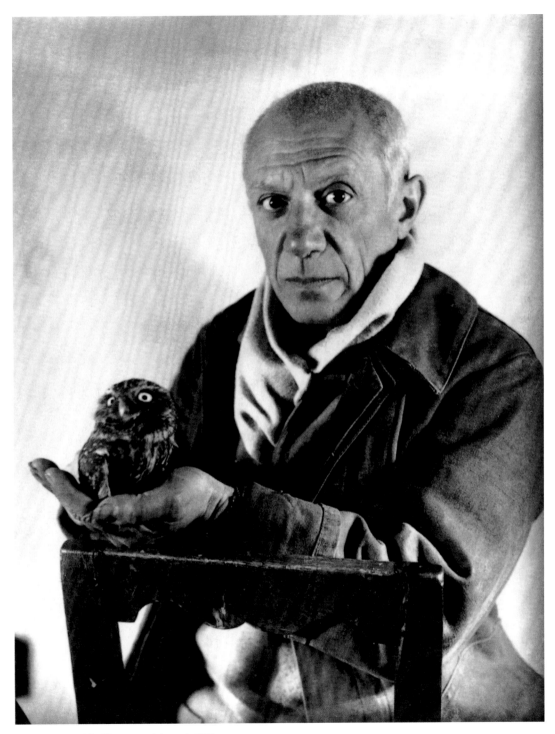

MICHEL SIMA Picasso and the owl, 1946

MICHEL SIMA Pablo Picasso, 1946

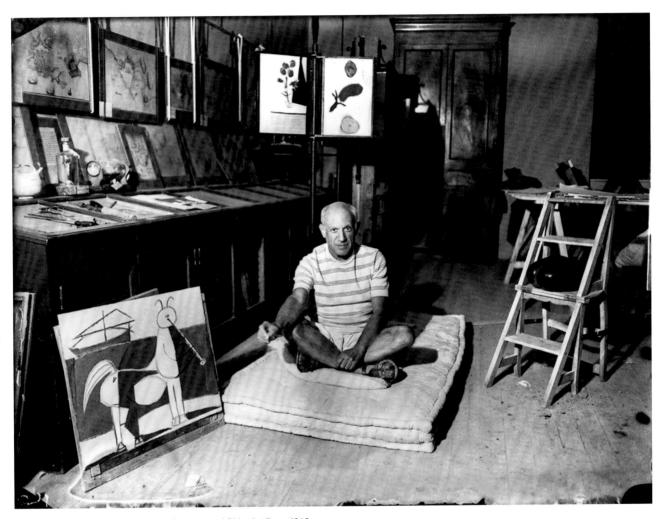

MICHEL SIMA Picasso next to *Centaur and Ship,* Antibes, 1946

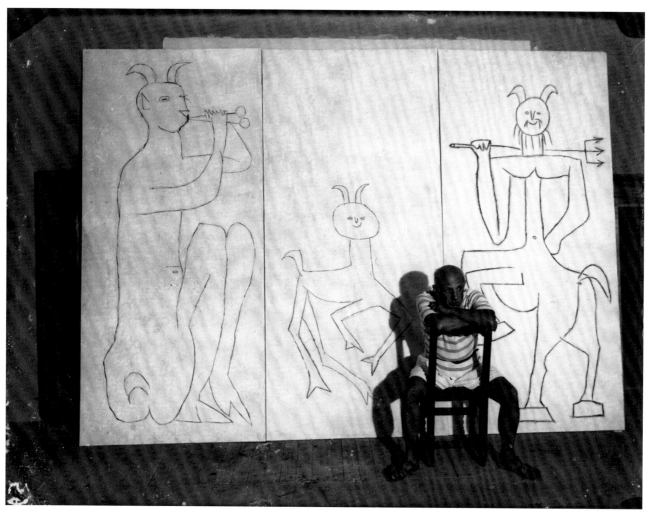

MICHEL SIMA Picasso in front of the triptych *Satyr, Faun, and Centaur with Trident,* Château Grimaldi, Antibes, 1946

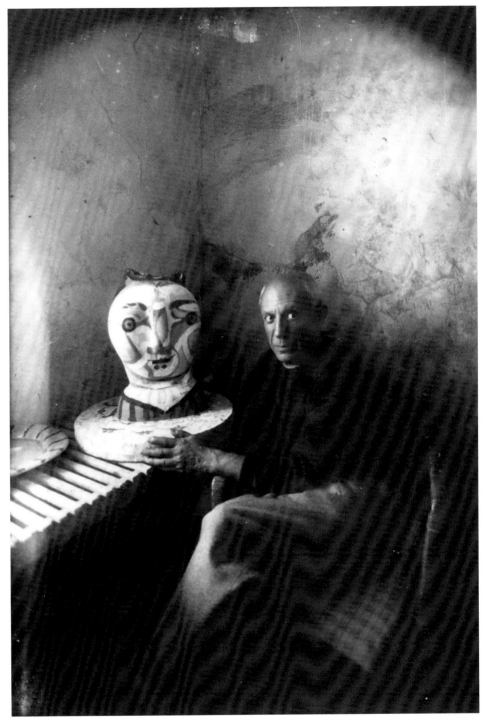

MICHEL SIMA Picasso in Vallauris, ca. 1950

RICHARD AVEDON Pablo Picasso, artist, Beaulieu, France, April 16, 1958

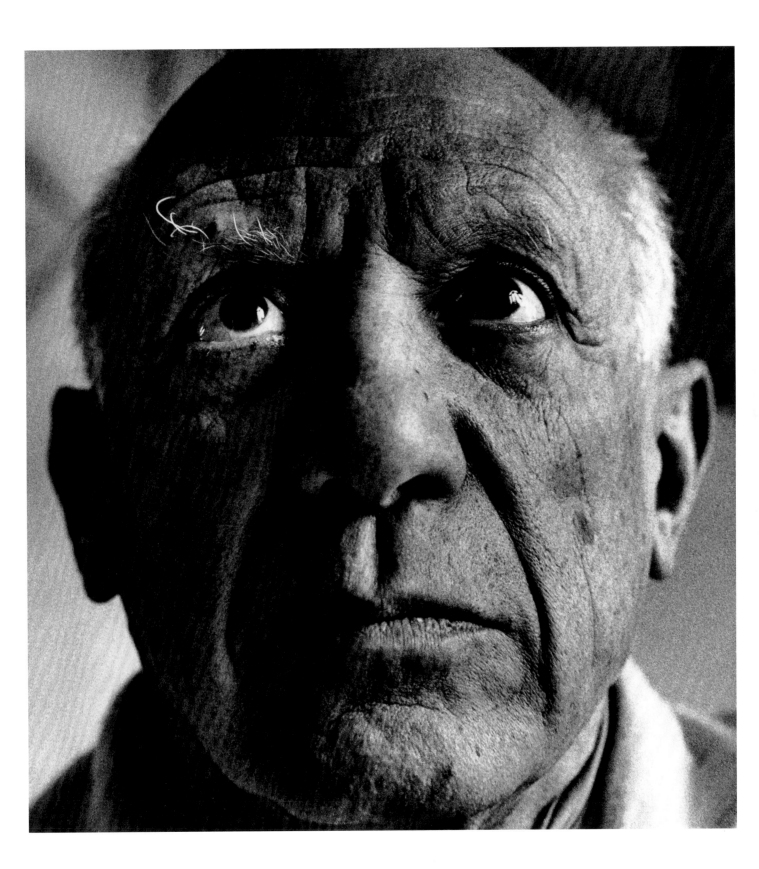

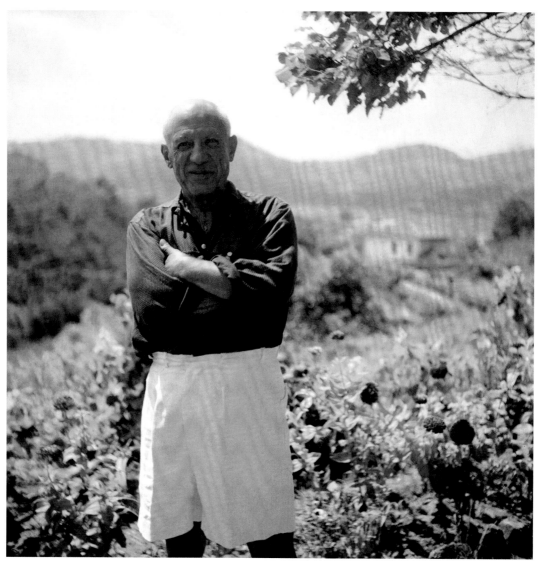

WILLY RIZZO Picasso landscape, Vallauris, 1952

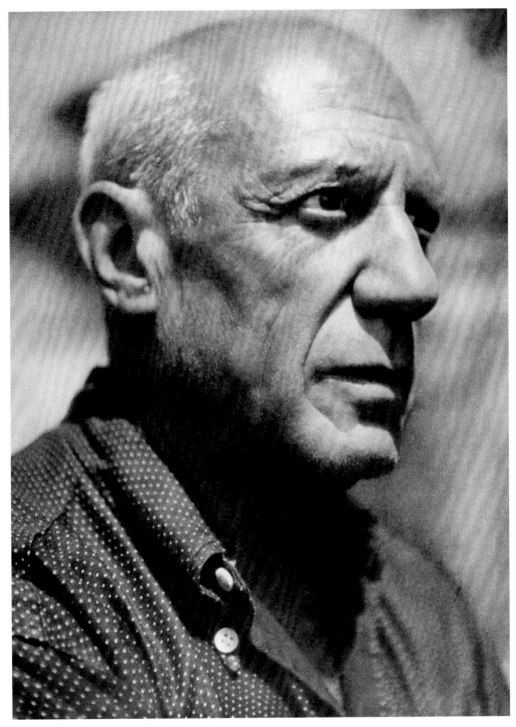

WILLY RIZZO Picasso, Vallauris, 1952

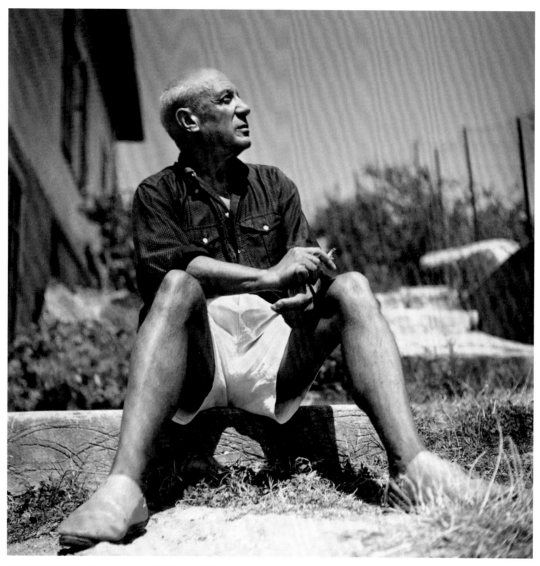

WILLY RIZZO Picasso seated, Vallauris, 1952

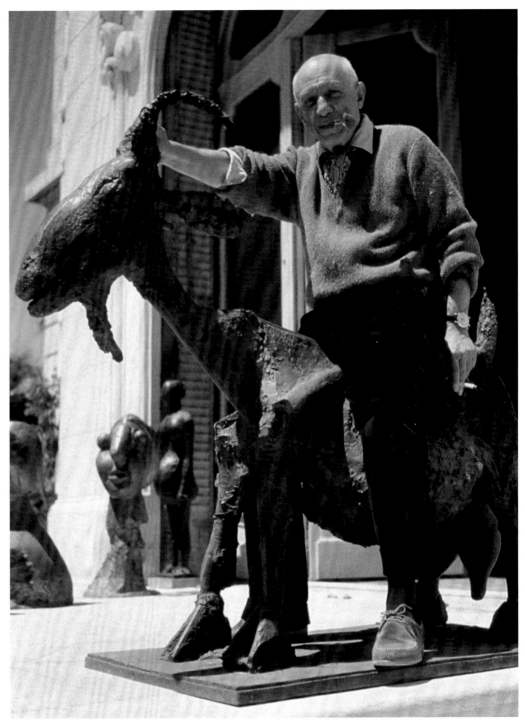

WILLY RIZZO Picasso and *The Goat*, Cannes, 1955

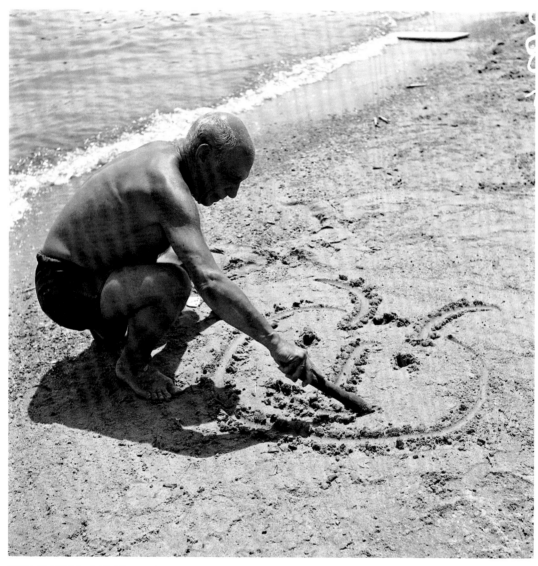

WILLY RIZZO Pablo Picasso, Cannes, 1952

1955.

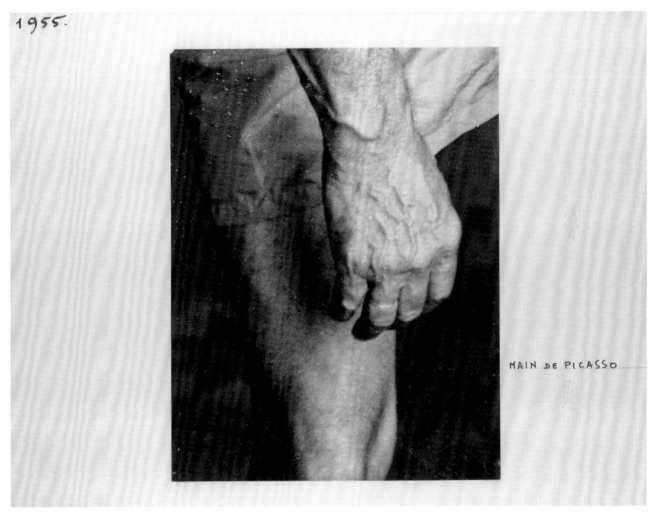

MAIN DE PICASSO

JACQUES-HENRI LARTIGUE Picasso's hand, 1955

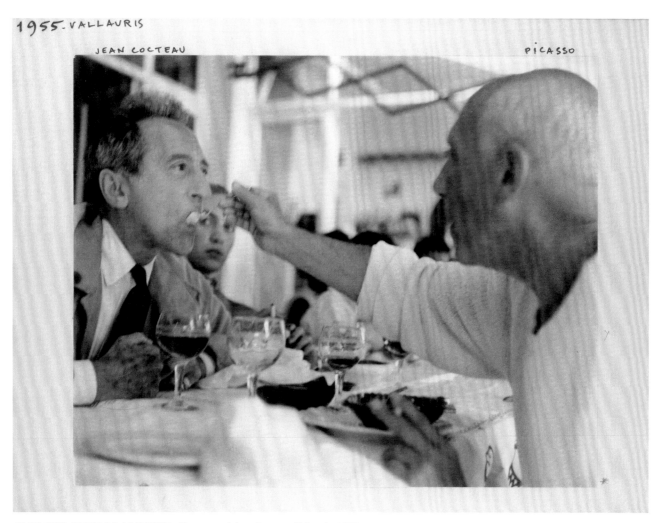

JACQUES-HENRI LARTIGUE Picasso and Jean Cocteau, Vallauris, 1955

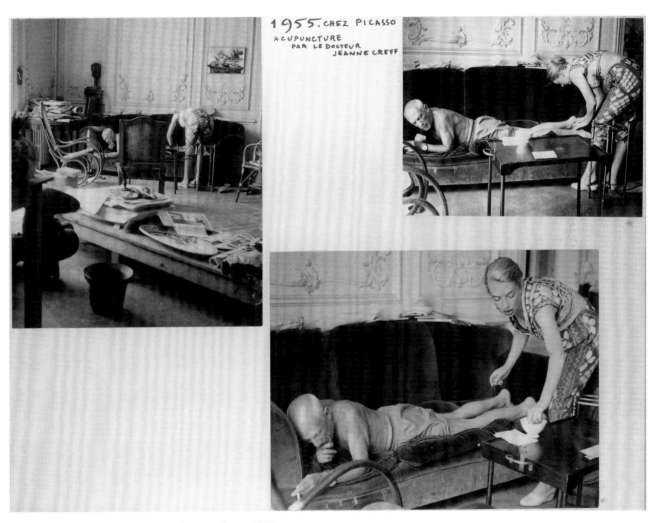

JACQUES-HENRI LARTIGUE Picasso at home, 1955

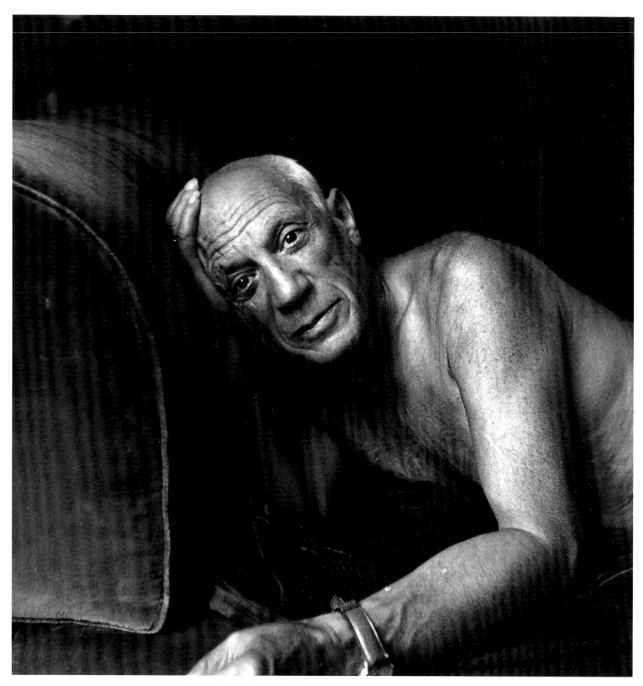

JACQUES-HENRI LARTIGUE Picasso, Cannes, August 1955

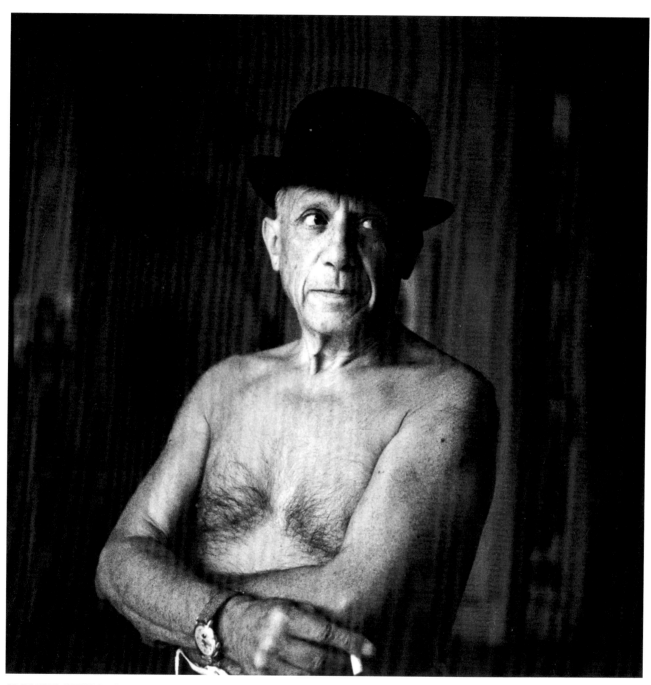

JACQUES-HENRI LARTIGUE Picasso, Cannes, 1955

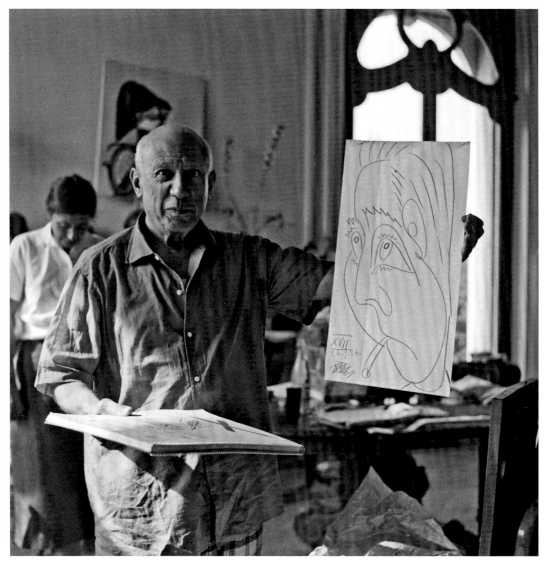

EDWARD QUINN Picasso with his drawing of Jacques Prévert, Villa La Californie, Cannes 1956

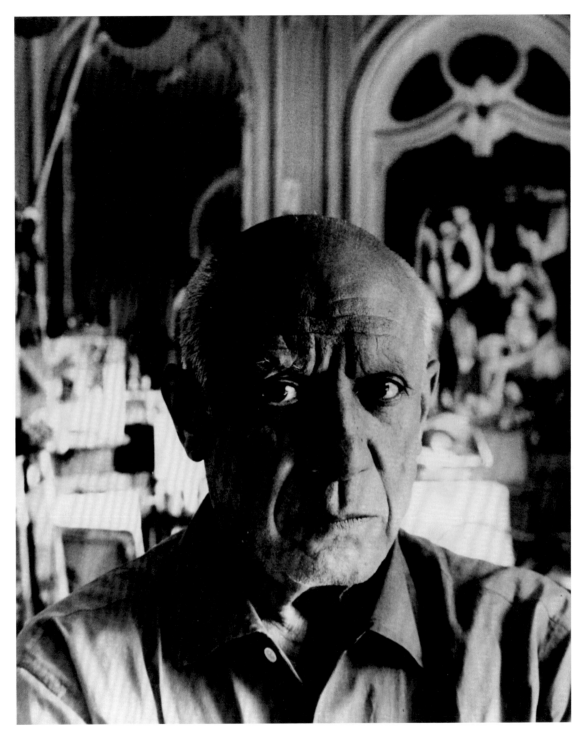

BILL BRANDT Pablo Picasso, 1956

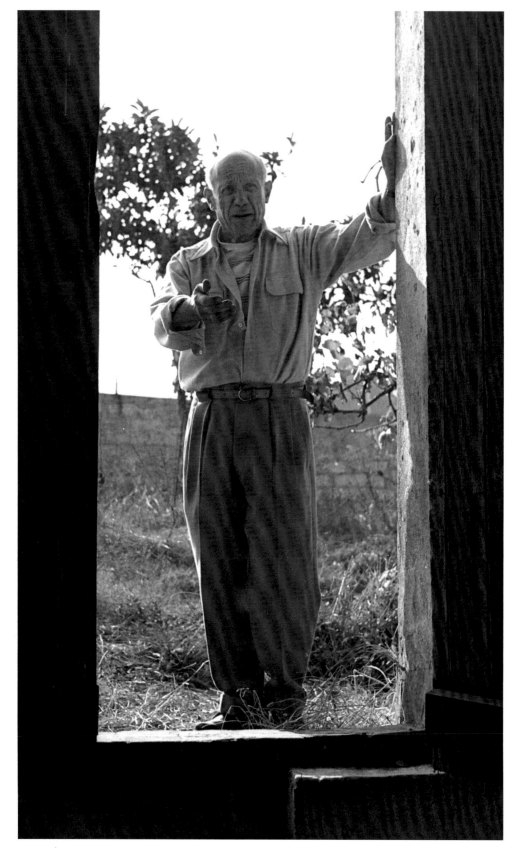

ANDRÉ VILLERS Vallauris, 1954

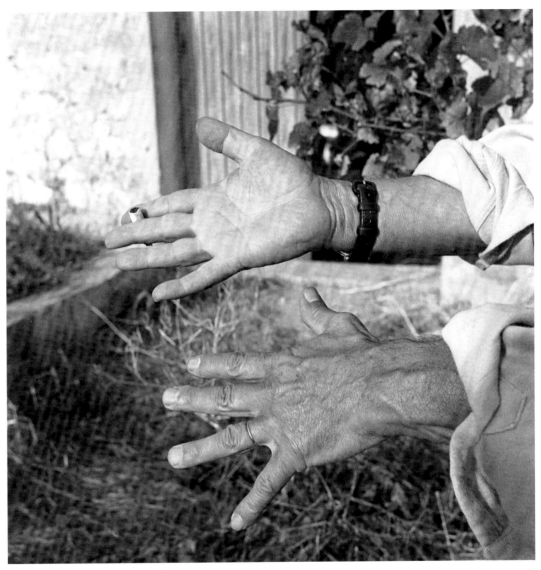

ANDRÉ VILLERS Picasso's hands, ca. 1960

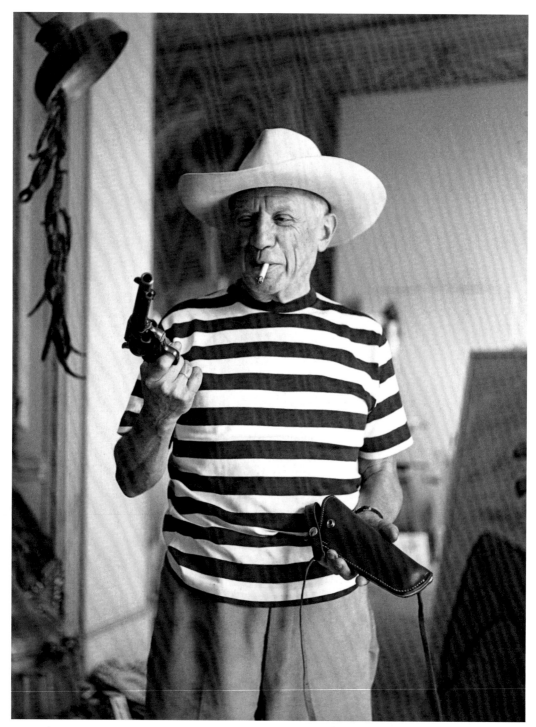

ANDRÉ VILLERS With revolver and hat given to him by Gary Cooper, Cannes, 1958

ANDRÉ VILLERS Cannes, 1958

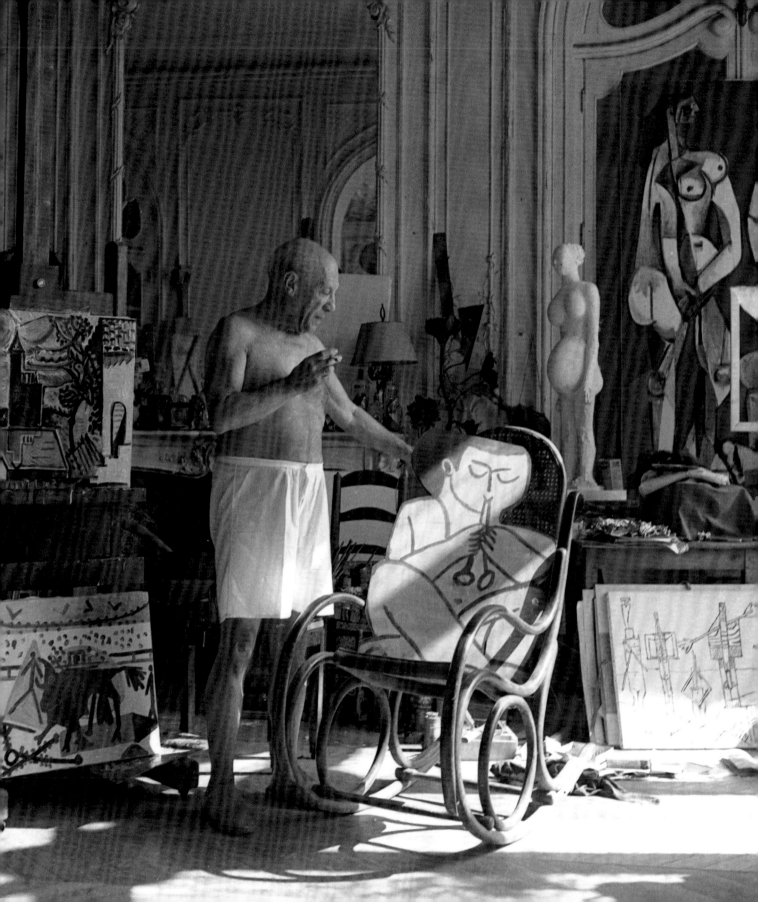

DAVID DOUGLAS DUNCAN Picasso with Indian chieftain headdress
given to him by Gary Cooper, Villa La Californie, Cannes 1960

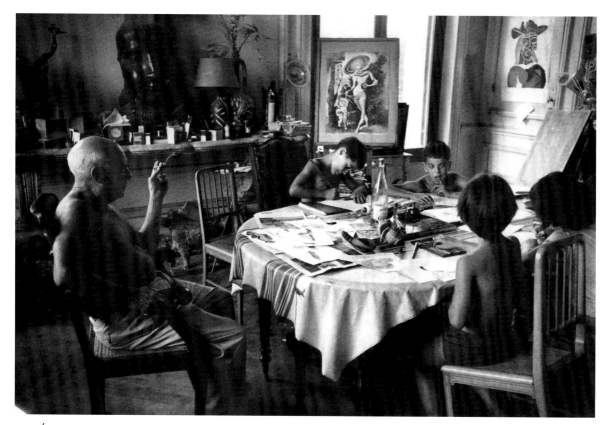

RENÉ BURRI Pablo Picasso with his children, 1957

Life Magazine, December 27, 1968

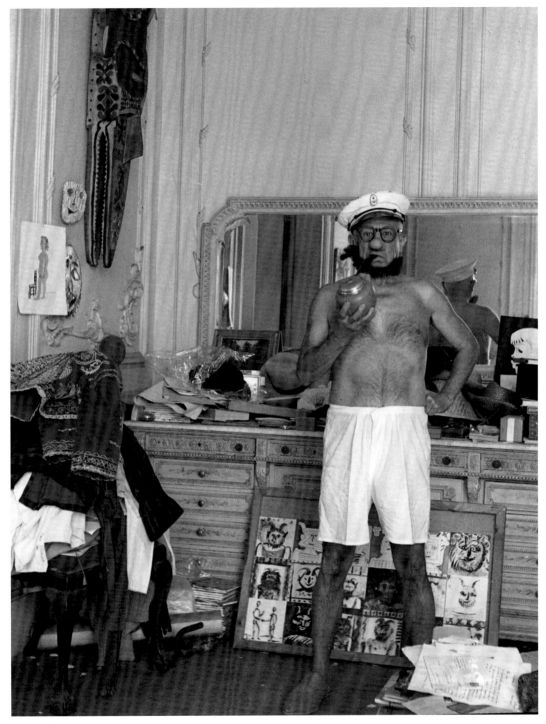

ANDRÉ VILLERS Picasso as Popeye, Cannes, 1957

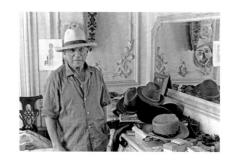

EDWARD QUINN
Hats and caps given as gifts
by Picasso's friends and visitors,
Villa La Californie, Cannes 1956

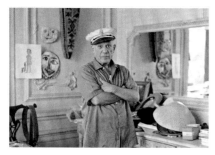

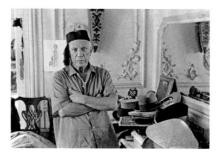

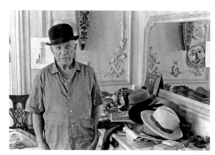

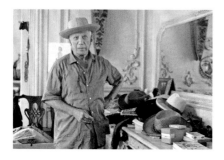

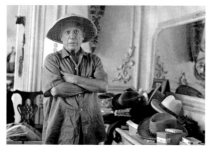

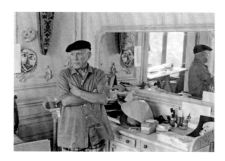

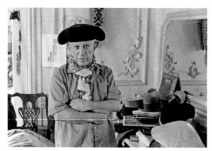

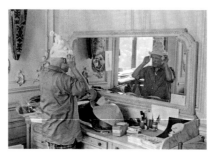

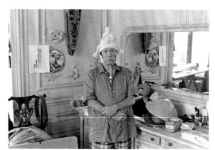

EDWARD QUINN Picasso posing with hats and caps from his collection, Villa La Californie, Cannes 1956

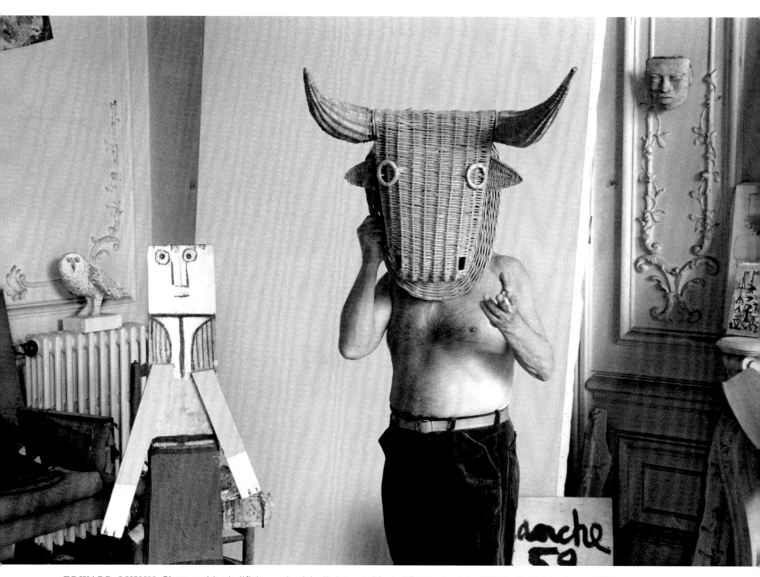

EDWARD QUINN Picasso with a bullfight mask originally intended for bullfighters' training, Villa La Californie, Cannes 1959

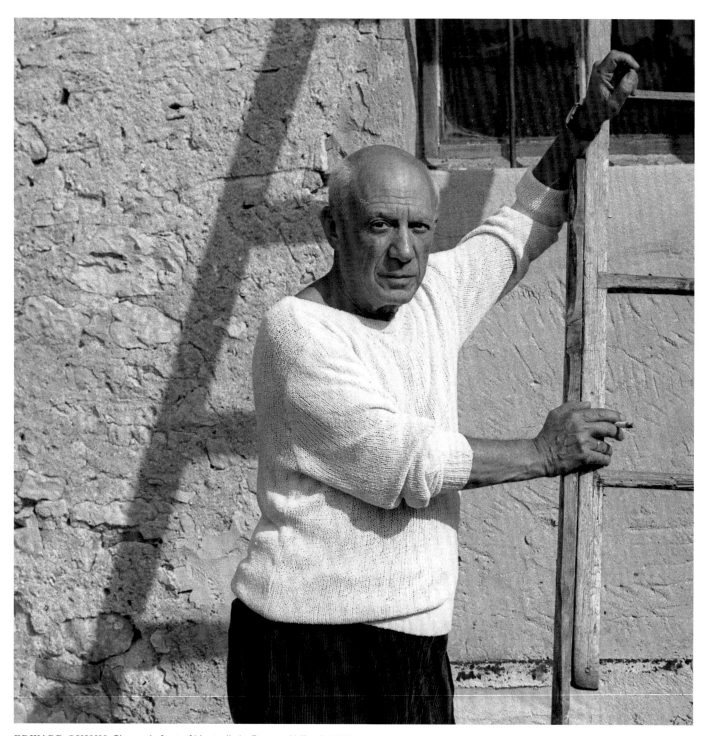

EDWARD QUINN Picasso in front of his studio Le Fournas, Vallauris 1953

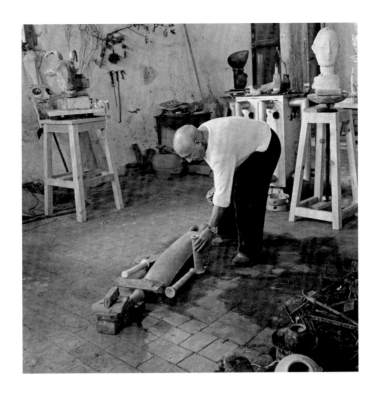

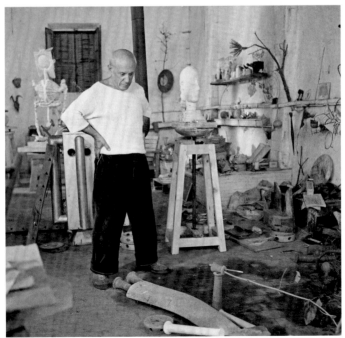

EDWARD QUINN Picasso working on the sculpture *Woman with Key*
(*"La Madame"*) in the studio Le Fournas, Vallauris 1953

EDWARD QUINN Picasso, Villa La Californie, Cannes 1961

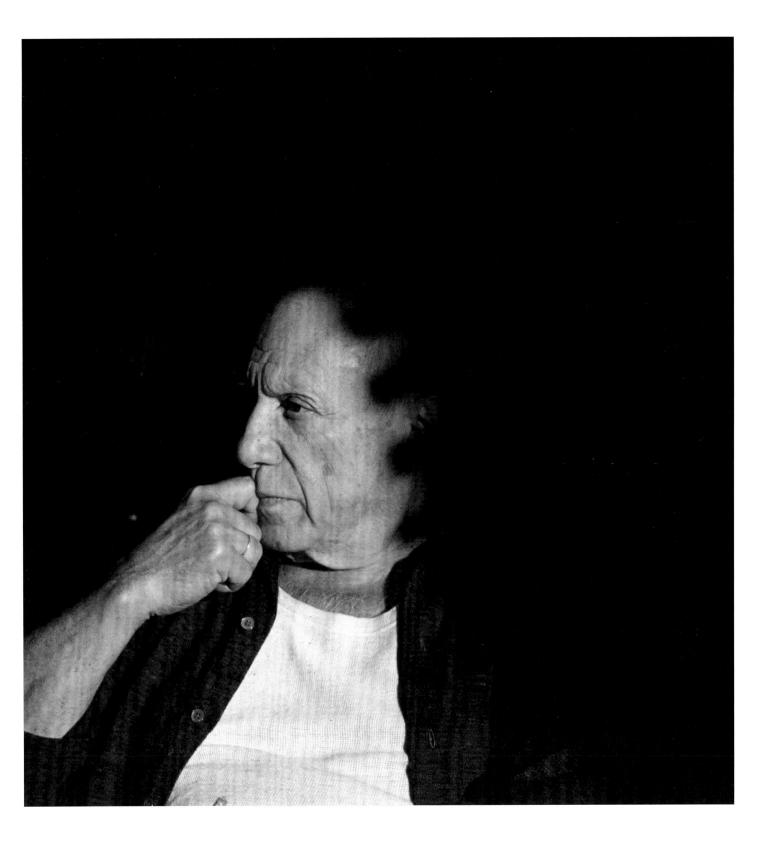

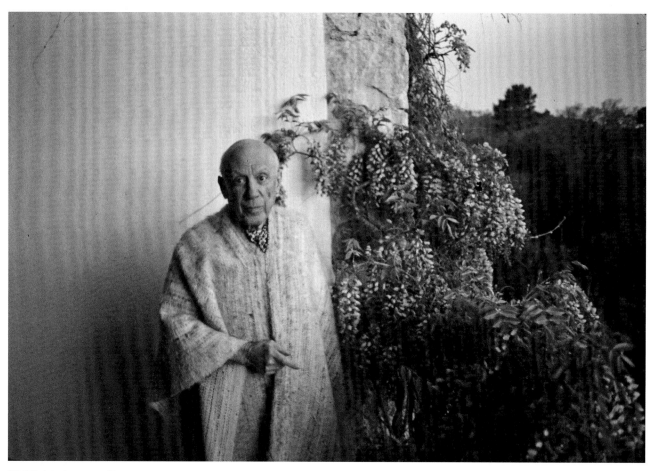

EDWARD QUINN Picasso wearing a South American poncho, Villa Notre-Dame de Vie, 1967

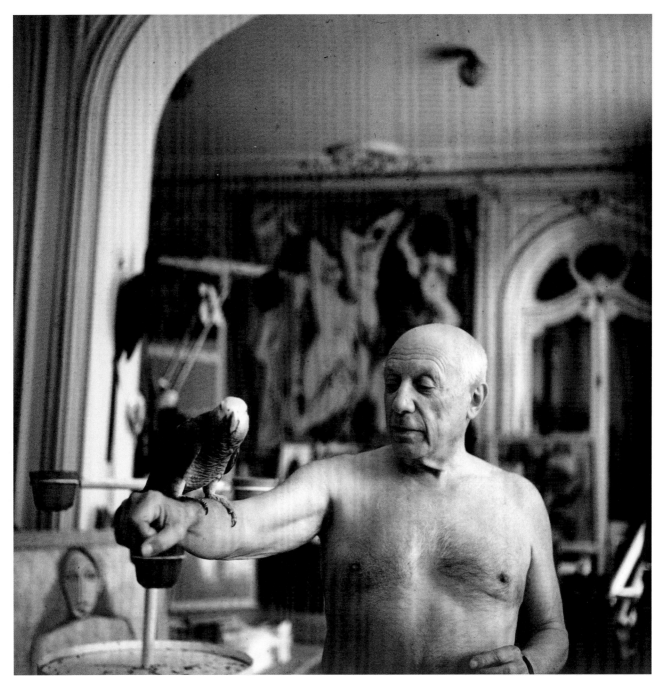

EDWARD QUINN Picasso with parrot, Villa La Californie, Cannes 1956

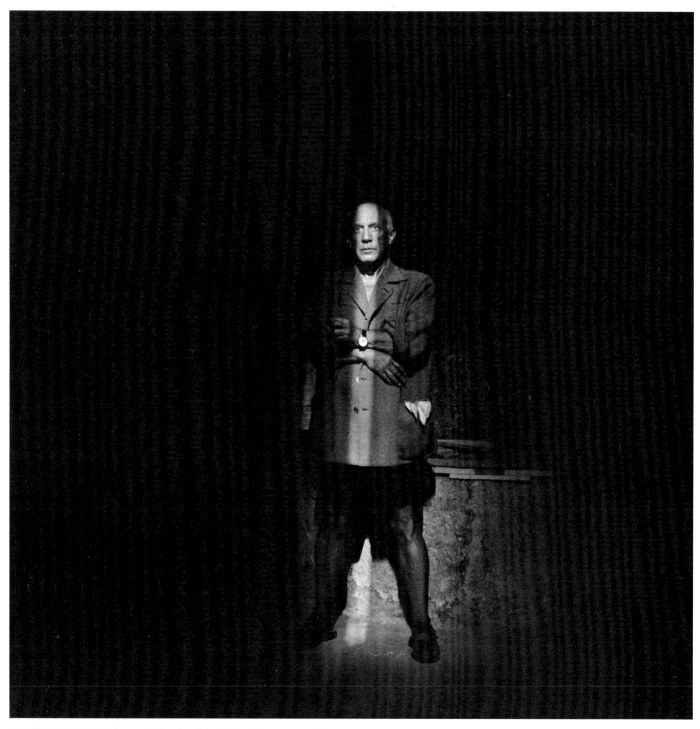

EDWARD QUINN Picasso in the abandoned chapel in Vallauris, before working on the mural *La guerre et la paix*, Vallauris 1953

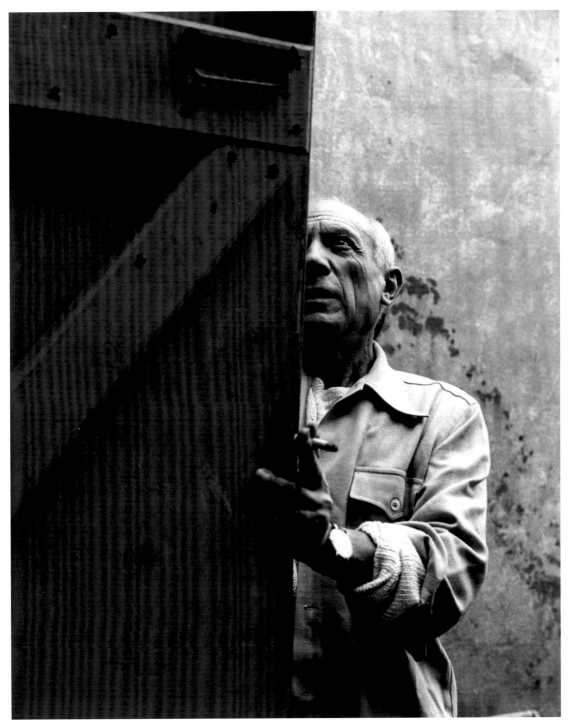

EDWARD QUINN Picasso at the door of his studio Le Fournas, Vallauris 1953

ROBERTO OTERO Pablo Picasso in the old bullring at Fréjus, August 7, 1966

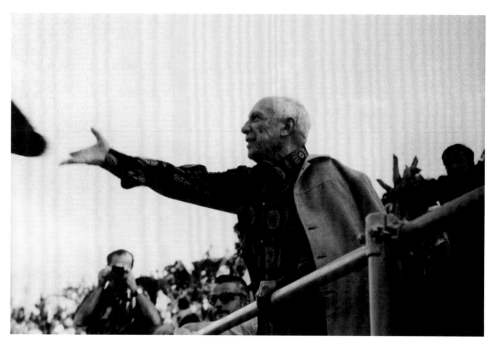

ROBERTO OTERO Pablo Picasso throws back the cap to the budding bullfighter, Fréjus, August 7, 1966

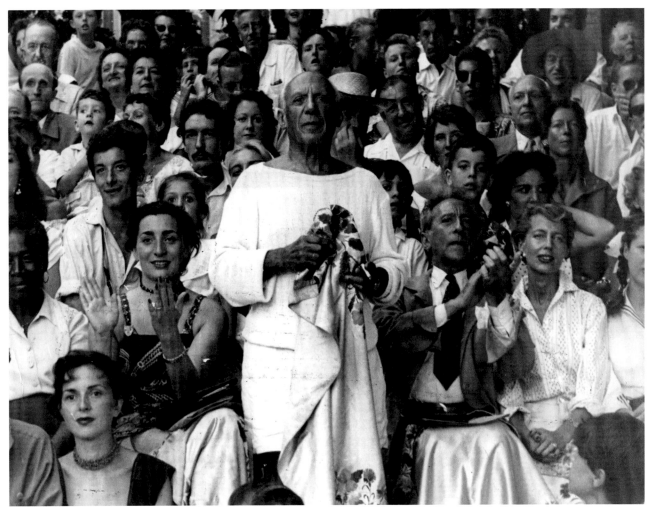

EDWARD QUINN Picasso at the bullfight put on in his honor (left: Jacqueline Roque, right: Jean Cocteau and Francine Weisweiller, behind Picasso, partly concealed: his children Paloma and Claude), Vallauris, 1955

EDWARD QUINN Picasso amused by a tourist
wearing a Picasso shirt, Vallauris, 1955

EDWARD QUINN Picasso pretending to get arrested at a
corrida in Vallauris (behind him: Jacqueline Roque and Jean Cocteau),
Vallauris, 1955

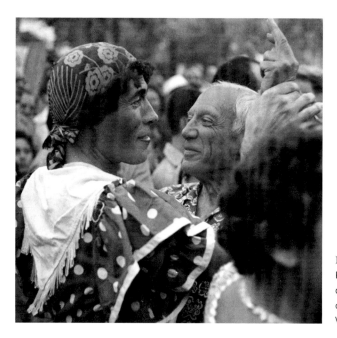

EDWARD QUINN
Picasso dancing with a man
dressed as a woman on the occasion
of a bullfight put on in his honor,
Vallauris, 1953

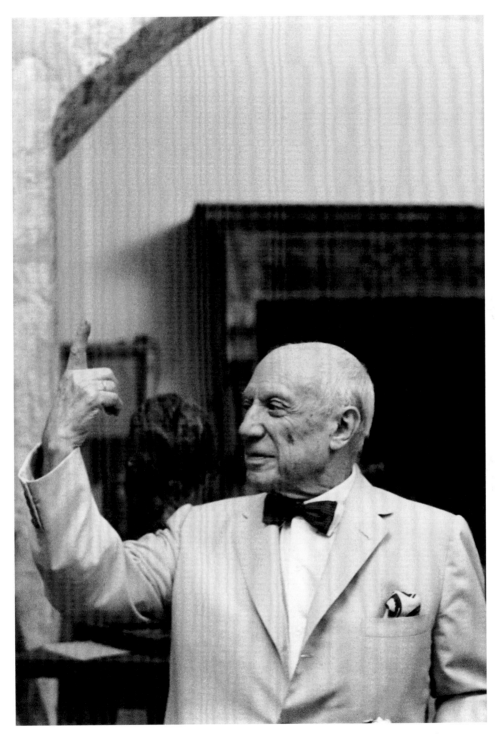

ROBERTO OTERO "I'm the most important Picasso collector in the world," Notre-Dame de Vie,
Mougins, August 6, 1966

IRVING PENN Pablo Picasso, 1957

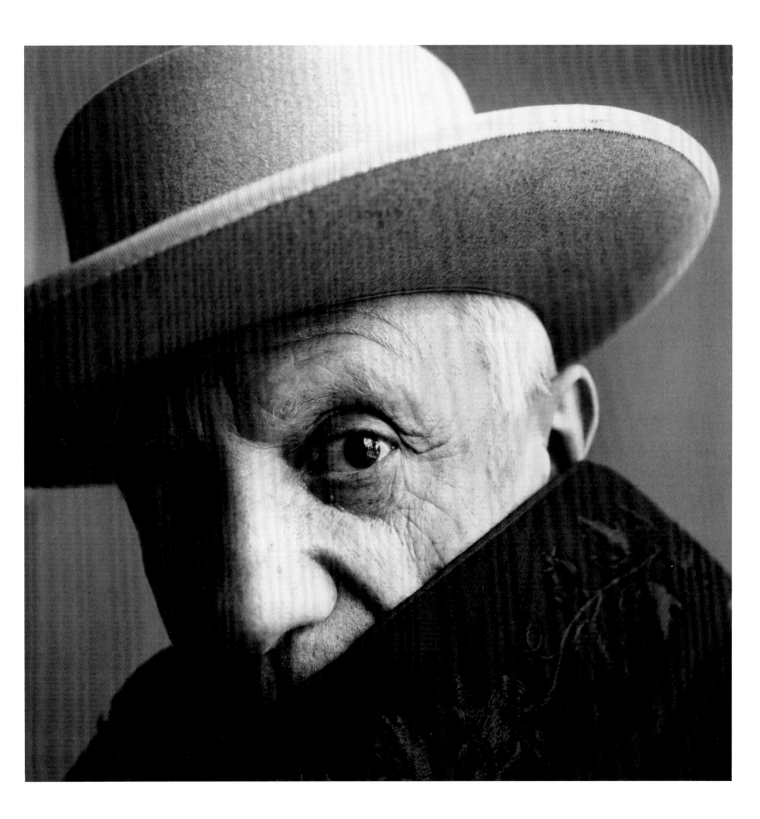

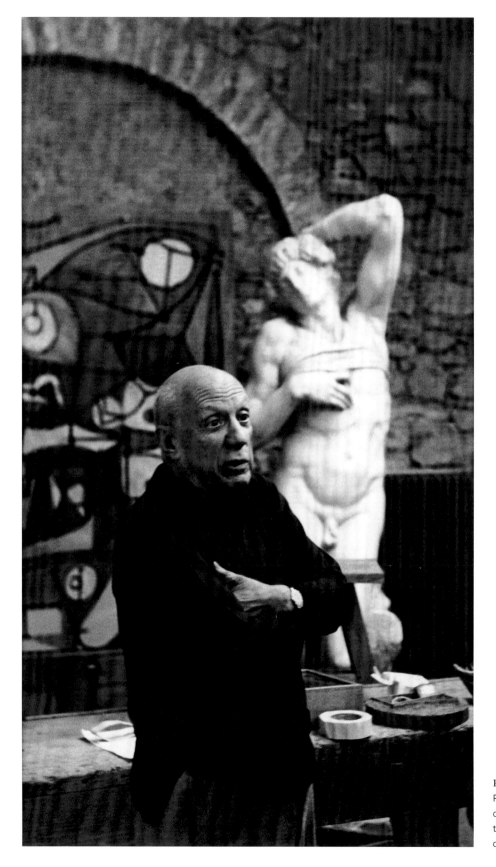

ROBERTO OTERO
Pablo Picasso with a plaster cast
of Michelangelo's *Dying Slave* in
the sculpture studio at Notre-Dame
de Vie, Mougins, October 1966

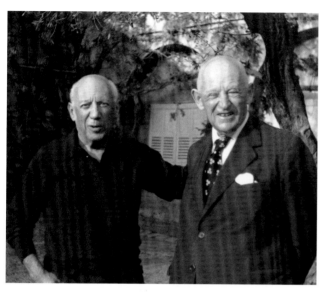

ROBERTO OTERO Pablo Picasso with Daniel-Henry Kahnweiler,
Notre-Dame de Vie, Mougins 1964

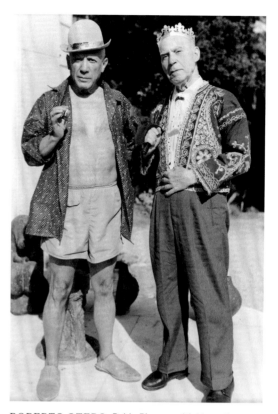

ROBERTO OTERO Pablo Picasso with Manuel
Pallarès in the garden at Villa La Californie, Cannes 1964

ROBERTO OTERO Pablo Picasso and Rafael Alberti, backlit,
Notre-Dame de Vie, Mougins 1965

ROBERTO OTERO Pablo Picasso heads for his Hispano Suiza, which he has owned since 1933, accompanied by Myriam Hepp,
Notre-Dame de Vie, Mougins, June 1966

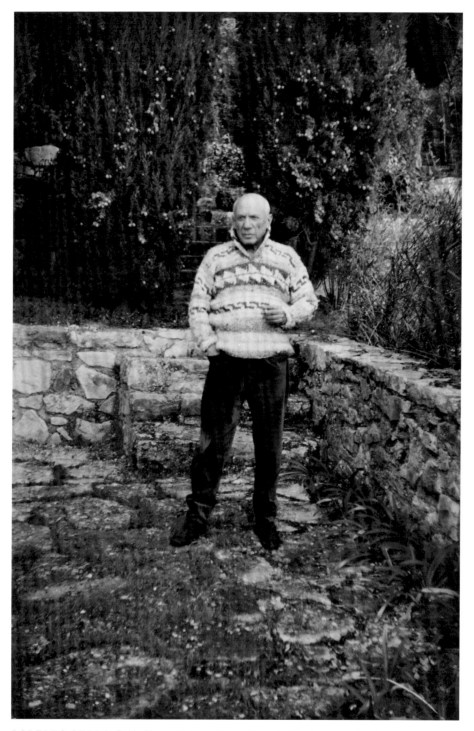

ROBERTO OTERO Pablo Picasso in a garden at Villa La Californie, Cannes 1970

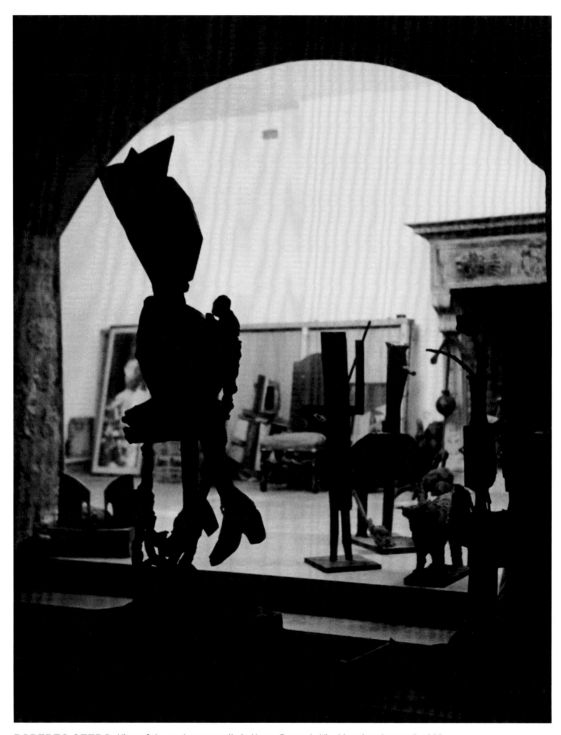

ROBERTO OTERO View of the sculpture studio in Notre-Dame de Vie, Mougins, August 6, 1966

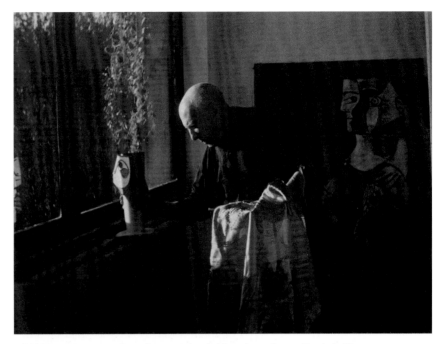

Pablo Picasso prepares for a photo session, holding the sculpture *Head of a Woman*,
Notre-Dame de Vie, Mougins, November 1965

Pablo Picasso, in costume for a photo session, with *Head of a Woman* on his head,
Notre-Dame de Vie, Mougins, November 1965

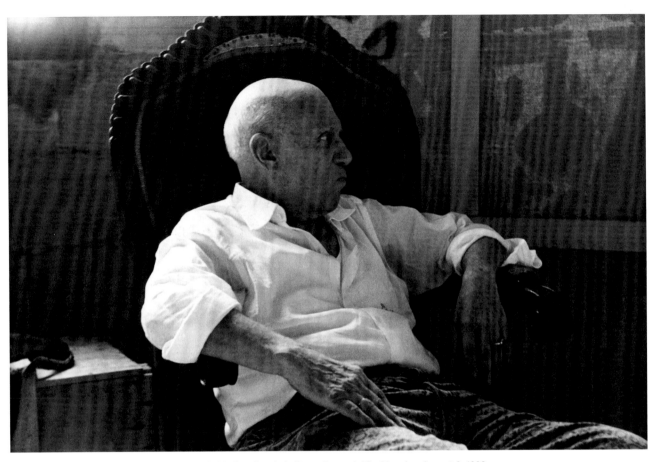

ROBERTO OTERO Pablo Picasso sitting in his favorite chair, Notre-Dame de Vie, Mougins, August 6, 1966

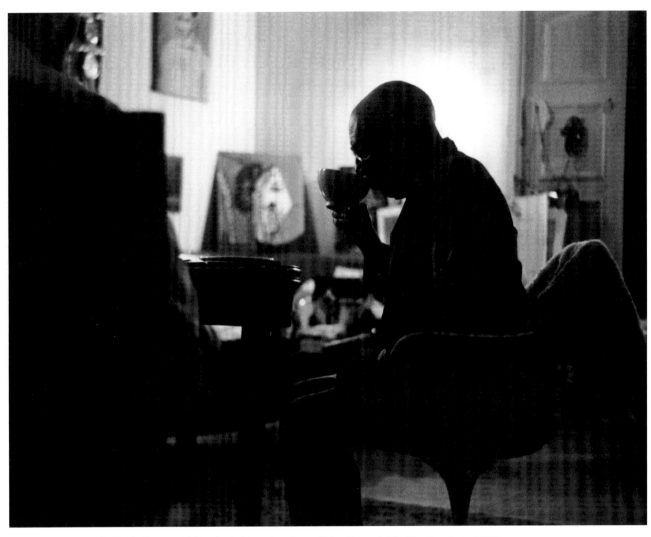

ROBERTO OTERO Pablo Picasso drinking herbal tea after dinner, Notre-Dame de Vie, Mougins, August 1964

LUCIEN CLERGUE Cover of the portfolio "Picasso," undated

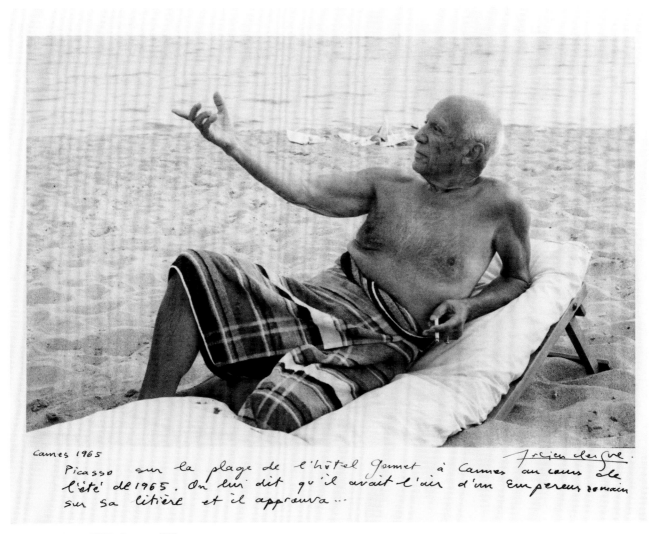

Cannes 1965

Picasso sur la plage de l'hôtel Gonnet à Cannes au cours de l'été de 1965. On lui dit qu'il avait l'air d'un Empereur romain sur sa litière et il approuva...

LUCIEN CLERGUE Cannes, 1965

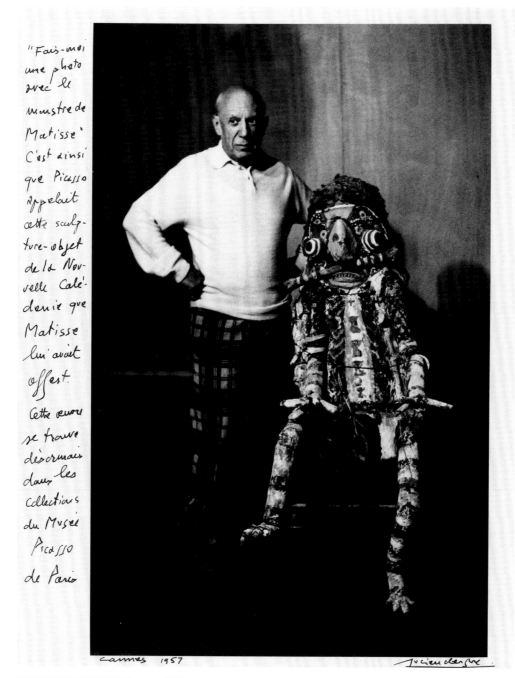

"Fais-moi une photo avec le monstre de Matisse" C'est ainsi que Picasso appelait cette sculpture-objet de la Nouvelle Calédonie que Matisse lui avait offert. Cette œuvre se trouve désormais dans les collections du Musée Picasso de Paris

Cannes 1957

LUCIEN CLERGUE Cannes, 1957

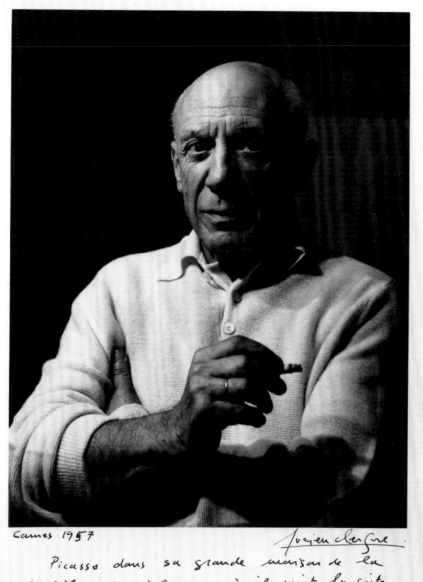

Cannes 1957

Lucien Clergue

Picasso dans sa grande maison de la "Californie" à Cannes où il peint la suite des ateliers et où il exécutera la série des Ménines, d'après Vélasquez. Décembre 1957.

LUCIEN CLERGUE Cannes, 1957

Picasso a toujours eu une passion pour les animaux. Au cours de l'été de 1968, pendant la visite d'amis, on lui signale un crapaud égaré sur un emballage vide. A 87 ans il garde la même réserve d'émerveillement.

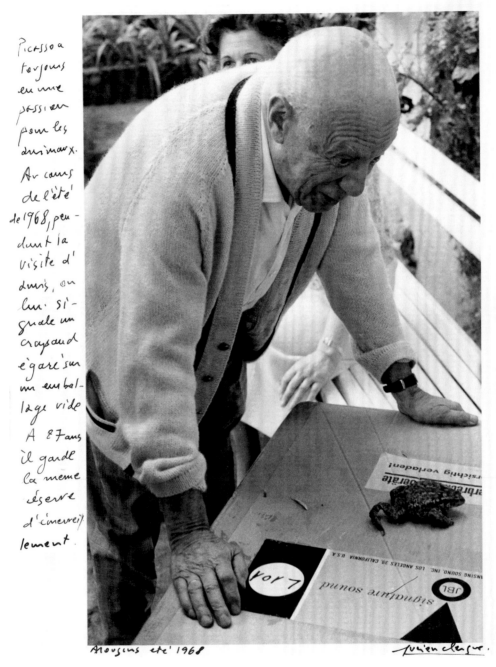

Mougins été 1968 lucien clergue

LUCIEN CLERGUE Mougins, summer 1968

la réserve
de Mougins
telle qu'elle
se présentait
en 1970
C'est là
que transi-
taient les
œuvres
entre deux
exposi-
tions.
C'est de-
vant l'en-
trée que
se tenait
la sculp-
ture de
"l'Homme
au
Mouton"

Mougins 1970

LUCIEN CLERGUE Mougins, 1970

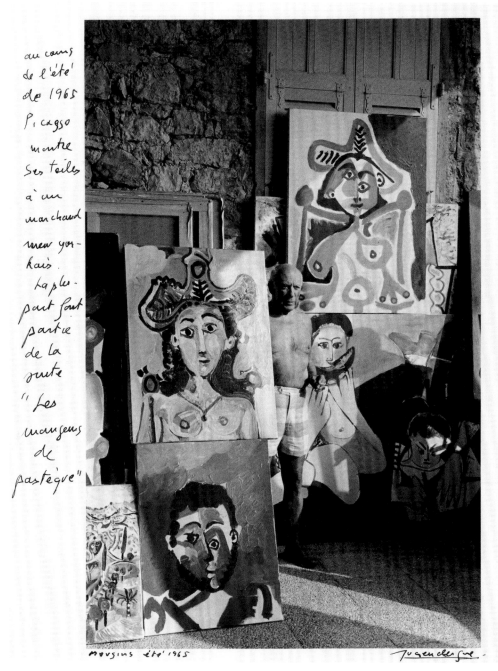

au cours
de l'été
de 1965
Picasso
montre
ses toiles
à un
marchand
new yor-
kais.
La plu-
part font
partie
de la
suite
" Les
mangeurs
de
pastègue"

Mougins été 1965 Lucien Clergue.

LUCIEN CLERGUE Mougins, summer 1965

216

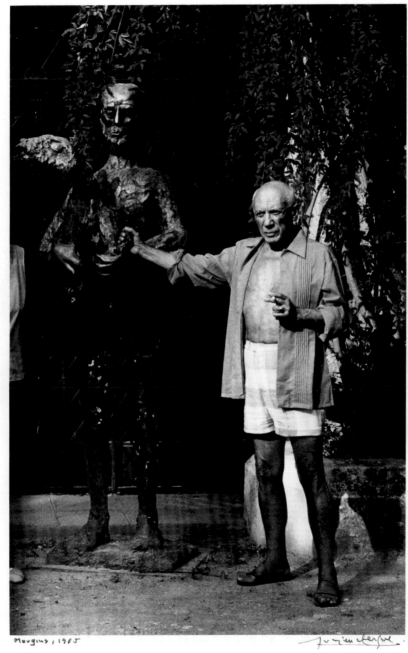

A Mougins devant les grilles de la réserve Picasso pose avec celui qui semble son frère "l'Homme au mouton" dont il a offert le premier tirage aux habitants de Vallauris

Mougins, 1965

LUCIEN CLERGUE Mougins, 1965

Arles Sept. 1959
 Vêtu en châtelain de Vauvenargues, Picasso entre chez un antiquaire face aux Arènes
d'Arles et achète une mandoline qui figurera dans une suite de tableaux peints à Vauve-
nargues. Avec le commerçant et son ami, Paco Muñoz, ils reconstituent le tableau "les 3 Musiciens"

LUCIEN CLERGUE Arles, September 1959

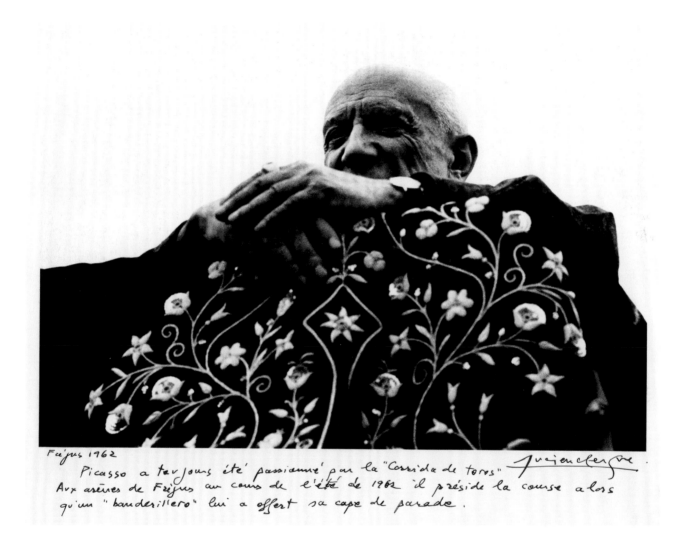

Fréjus 1962

Picasso a toujours été passionné par la "Corrida de toros"
Aux arènes de Fréjus au cours de l'été de 1962 il préside la course alors
qu'un "banderillero" lui a offert sa cape de parade.

LUCIEN CLERGUE Fréjus, 1962

HORST TAPPE Pablo Picasso, Cannes, 1963

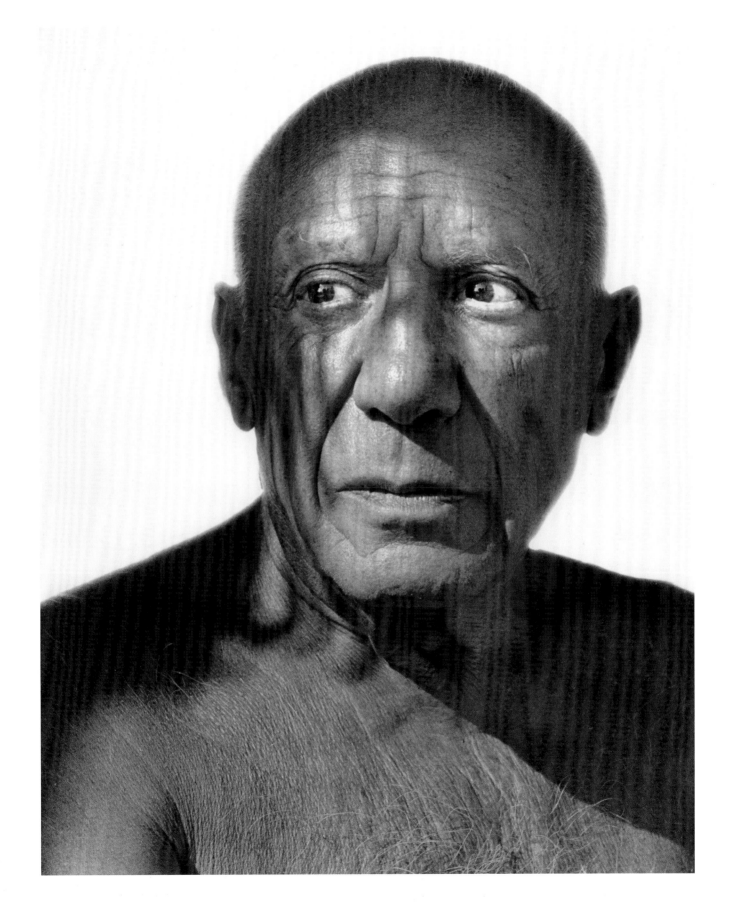

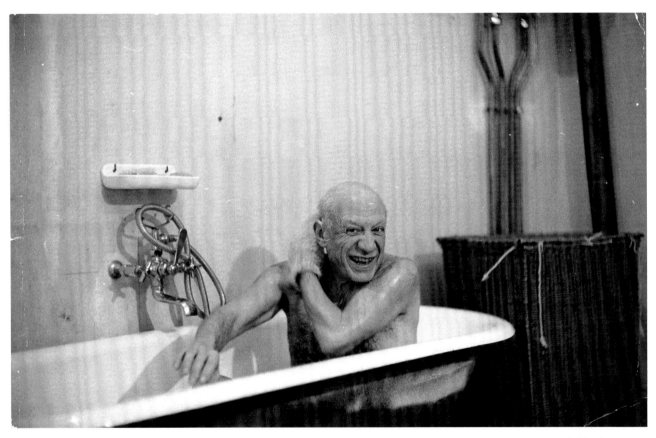

DAVID DOUGLAS DUNCAN Pablo Picasso in his bath on the first day of his meeting with David Douglas Duncan, Villa La Californie, Cannes 1956

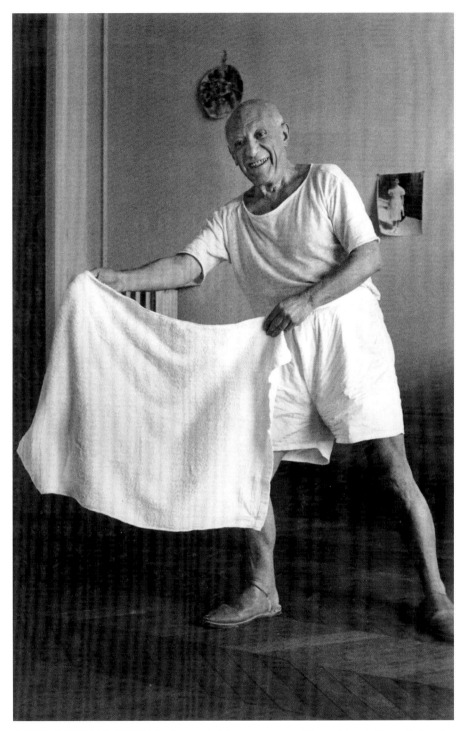

DAVID DOUGLAS DUNCAN Picasso imitating a toreador with a bath towel, Villa La Californie,
Cannes 1957

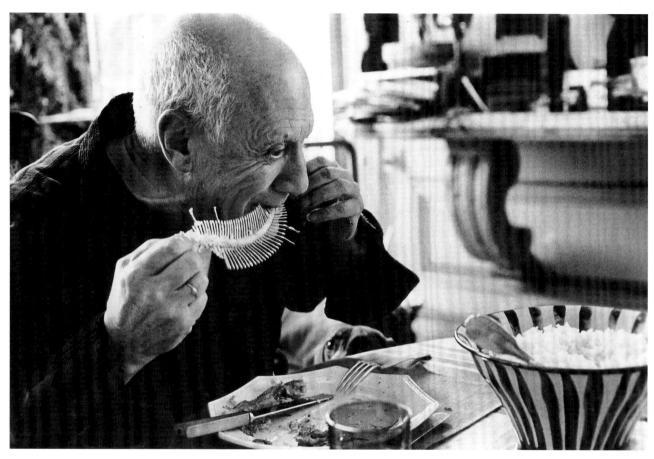

DAVID DOUGLAS DUNCAN Pablo Picasso preparing fish spine to be cast in clay, Villa La Californie, Cannes 1957

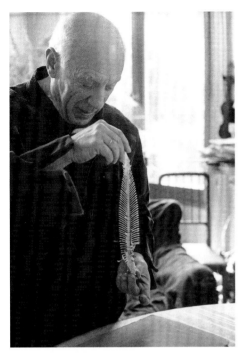

Pablo Picasso holding the fish spine over the clay

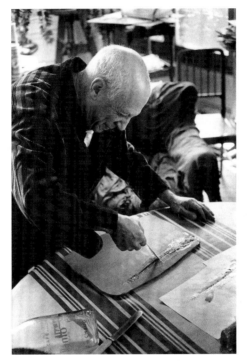

Pablo Picasso picking up the fish spine from
the clay

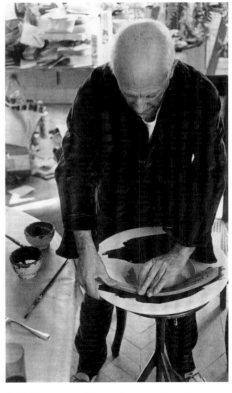

Pablo Picasso working on the ceramic sculpture

DAVID DOUGLAS DUNCAN
Villa La Californie, Cannes 1957

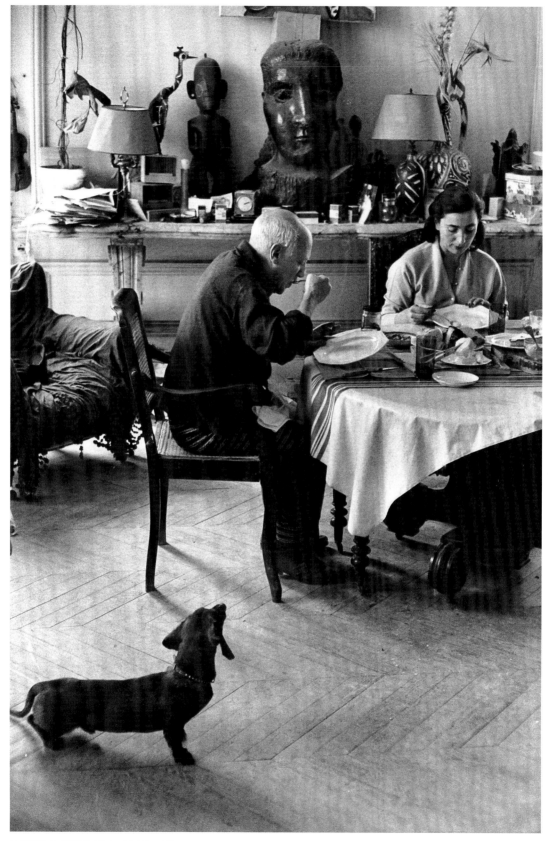

DAVID DOUGLAS DUNCAN Picasso and Jacqueline seated at a table, with Lump, Villa La Californie, Cannes 1957

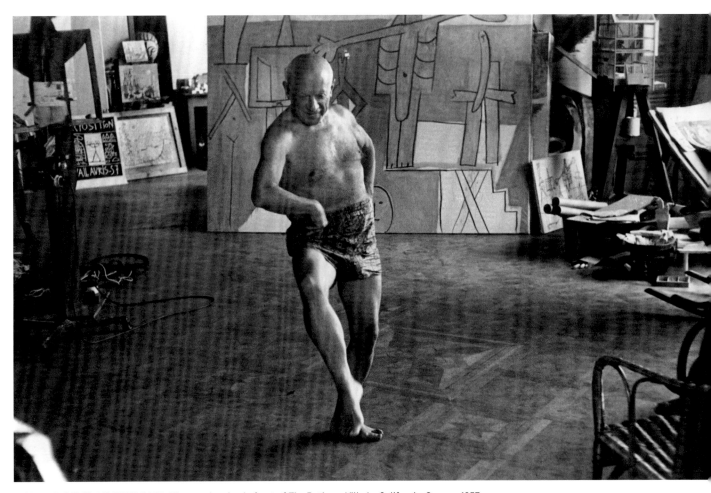

DAVID DOUGLAS DUNCAN Picasso dancing in front of *The Bathers*, Villa La Californie, Cannes 1957

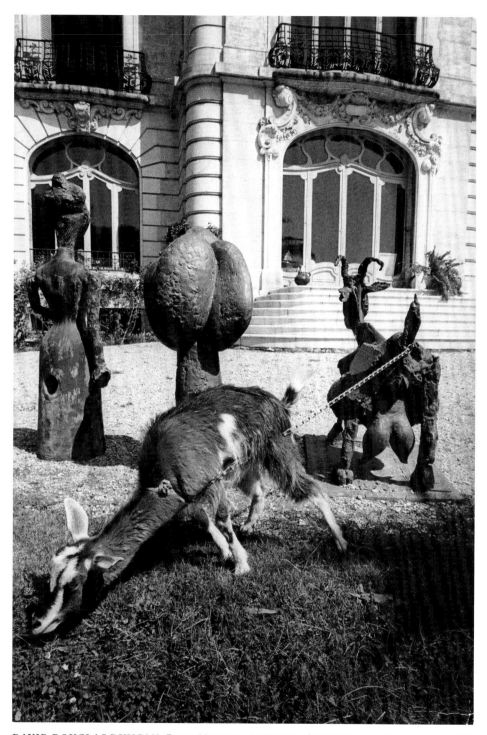

DAVID DOUGLAS DUNCAN Esmeralda attached to *The Goat* (1950), Villa La Californie, Cannes 1957

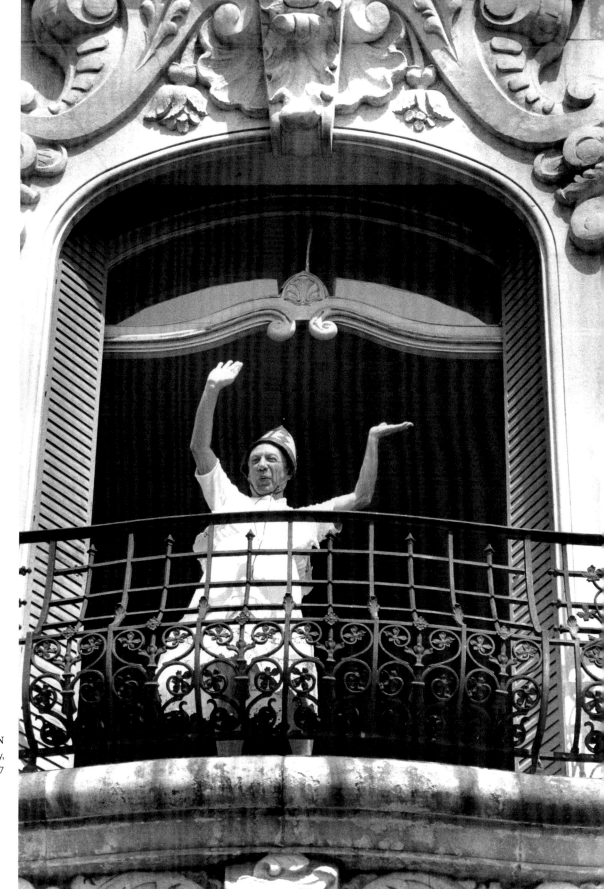

DAVID DOUGLAS DUNCAN
Picasso dancing on his balcony,
Villa La Californie, Cannes 1957

Pablo Picasso

EDWARD QUINN Picasso showing his children Claude and Paloma a photograph of himself as a child from 1888, Villa La Galloise, Vallauris 1953

1881	Pablo Ruíz y Picasso is born in Málaga. His father is the painter José Ruíz Blasco, his mother María Picasso Lopez
1891	Family moves to A Coruña in Galicia
1895	Family moves to Barcelona, where he attends the art school La Llotja
1897	Enrolls in the Real Academia de Bellas Artes de San Fernando in Madrid
1899	First exhibition in Barcelona. Friendship with Jaime Sabartés. First visit to Paris
1901	Second visit to Paris. Exhibition at the gallery of Ambroise Vollard. Beginning of friendship with Max Jacob. Beginning of Blue Period
1904	Picasso settles permanently in Paris. Moves into an atelier in the artists' tenement Bateau-Lavoir. Fernande Olivier becomes his lover
1905	First paintings of the Rose Period. Meets Leo and Gertrude Stein
1908	Beginning of close collaboration with Georges Braque: the Cubist period
1909	Moves to Montmartre, into the atelier on Boulevard de Clichy
1910–13	Exhibitions in Munich, Düsseldorf, Berlin, London, and New York
1911	Beginning of relationship with Éva Gouel
1915	Meets Jean Cocteau
1916	Moves with Guillaume Apollinaire to Montrouge, southwest of Paris
1917	Works for Sergei Diaghilev's Ballets Russes, designs stage sets and costumes for *Parade*. Meets the dancer Olga Khokhlova
1918	Marries Olga. They have a son, Paul (*1921). Settles on the Rue La Boëtie and bids farewell to his "bohemian life"
1919–	Beginning of the classical period
1927	Marie-Thérèse Walter becomes Picasso's model and lover. They have a daughter, Maya (*1935)
1932	First museum retrospective in Zurich
1936–37	Spanish Civil War. Creation of the famous painting *Guernica*. Beginning of relationship with Dora Maar. New atelier on the Rue des Grands Augustins
1939–40	Beginning of World War II. Occupation of Paris. Picasso is forbidden to show his work. Retrospective in New York
1941	Writes the play *Desire Caught by the Tail*. Creation of the sculpture *Head of a Woman (Dora Maar)*
1943	Beginning of relationship with Françoise Gilot. They have two children, Claude (*1947) and Paloma (*1949)
1944	Max Jacob dies in the internment camp at Drancy. Picasso joins the Communist Party of France
1945–	Visits the south of France more and more often. Begins working in lithography again
1948	In Vallauris, discovers ceramics as a new means of expression
1953	Françoise Gilot leaves Picasso. Beginning of relationship with Jacqueline Roque
1955	Acquires the villa La Californie in Cannes. Henri-Georges Clouzot's film *Le mystère Picasso* is released
1958	Acquires the Château de Vauvenargues near Aix-en-Provence, at the foot of Montagne Sainte-Victoire
1960	Retrospective in London, curated by Roland Penrose
1961	Marries Jacqueline Roque. Acquires the villa Notre-Dame de Vie in Mougins near Cannes
1964	Opening of the Museu Picasso in Barcelona
1973	Picasso dies in Mougins

Photographer
Biographies

by
Feride Akgün
Sonja Kruchen
Karin Schuller-Procopovici
Katherine Slusher
Kerstin Stremmel

Rogi André
Richard Avedon
Cecil Beaton
Bill Brandt
Brassaï
René Burri
Robert Capa
Henri Cartier-Bresson
Chim
Lucien Clergue
Jean Cocteau
Denise Colomb
Robert Doisneau
David Douglas Duncan
Yousuf Karsh
Jacques-Henri Lartigue
Herbert List
Dora Maar
Madame d'Ora
Man Ray
Willy Maywald
Gjon Mili
Lee Miller
Inge Morath
Arnold Newman
Roberto Otero
Irving Penn
Julia Pirotte
Edward Quinn
Willy Rizzo
Gotthard Schuh
Michel Sima
Horst Tappe
André Villers

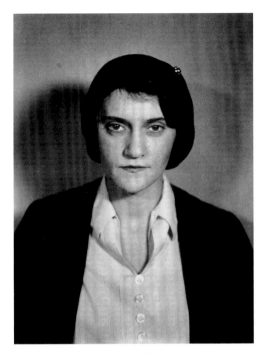

Rogi André, Self-portrait, ca. 1930

Rogi André (Rózsa Josephine Klein)

BUDAPEST 1900 — 1970 PARIS

Born Rozsa Josephine Klein, her Hungarian pet name, Rozsi, became part of her nom de plume. She studied the violin, and later art at the Hungarian Royal Drawing School, before moving to Paris in 1925; she learned photography from her neighbor (and later husband), André Kertész. Rogi André used a large-format plate Voigtländer Bergheil throughout her lifetime, and was known for her long exposure times as well as her lengthy darkroom work; she abhorred the snapshot aesthetic. Her altered portraits, created by etching and drawing on the negatives, served as precursor for a number of experimental photographers who manipulated their negatives. Emmanuel Sougez lauded her work in an article entitled "Deux femmes, quatre-vingts hommes," and her portraits were compared to those of Nadar in a 1936 article in *Photographie.* Early exhibitions of her photographs include: Rive Gauche, Paris, 1935; Pavillon de Marsan, Paris, 1936; Museum of Modern Art, New York, 1937; Galerie d'Art et d'Industrie, Paris, 1937; Galerie de la

Pléiade, Paris, 1937; and the London Gallery in 1949. From 1941 to 1962, Rogi André lived, with very limited means, in a small room at the Galerie Jeanne Bucher. She maintained a long friendship with the Hungarian sculptor Étienne Hadjú. Rogi André became isolated later in life, and dedicated her last twenty years to nonfigurative painting.

Richard Avedon

NEW YORK 1923 — 2004 SAN ANTONIO, TEXAS

With his first camera, a gift from his father, Richard Avedon photographed his comrades in the U.S. Merchant Marine for their service identification cards. After military service, he worked briefly as a department store photographer in New York, where he was discovered by Alexey Brodovitch, art director of the fashion magazine *Harper's Bazaar.* He was hired as staff photographer and quickly rose to the top of his field as a fashion photographer. Avedon was particularly known for leaving the studio and photographing haute couture models in

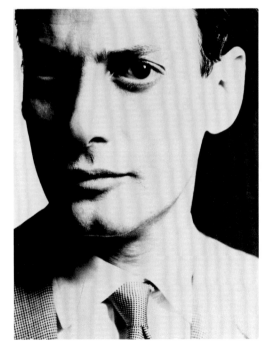

Richard Avedon photographed by Hiro, undated

everyday settings—most famously in the image *Dovima with Elephants, Evening Dress by Dior, Cirque d'Hiver, Paris 1955.* In a completely different vein, he also took photographs of the mentally ill and Vietnamese napalm victims, as well as an extraordinary series of images documenting the death of his father. In addition to his fashion photography, Avedon was also a portraitist, and created many images that have gone into the collective memory, including portraits of Ezra Pound, Marilyn Monroe, Charlie Chaplin, Igor Stravinsky, and Henry Kissinger. Avedon's portraiture is remarkable for its purist style and its ability to render visible both the strengths and the weaknesses of its subjects.

Cecil Beaton (Sir Cecil Walter Hardy Beaton)

LONDON 1904 — 1980 BROADCHALK, ENGLAND

Cecil Beaton initially began a course in business training to satisfy his father, but abandoned it in order to pursue his artistic interests and establish himself as a freelance portrait photographer. In the early 1930s he went to New York and Hollywood, where he sold his glamorous images to *Harper's Bazaar* and *Vogue.* In 1937, he was named court photographer to the English royal family. During World War II, he worked for the British Ministry of Information in Africa and the Near East, and after the war he photographed artists and writers including Picasso, Jean Cocteau, and Jean-Paul Sartre. In addition to his photography, he created costume designs for productions such as *My Fair Lady* and worked as an interior designer, illustrator, and writer. The "fanatical aesthete," as Beaton described himself, was a detail-obsessed master of dramatic staging, for whom beauty was the most important thing in the world.

Cecil Beaton photographed by Irving Penn, 1950

Bill Brandt (Hermann Wilhelm Brandt)

HAMBURG 1904 — 1983 LONDON)

After his childhood in Germany and a long stay at a sanatorium in Switzerland, in 1929 Bill Brandt went to Paris, where he met Man Ray. Through his contacts with André Breton, Marcel Duchamp, and Brassaï, he was introduced to Surrealism and developed a passion for the photographs of Eugène Atget and the films of Luis Buñuel. In 1931, Brandt began a career in London as a socially conscious documentary photographer; his first photojournalistic series focused on the streets of London's East End. He produced photo documentaries for the *Weekly Illustrated, Picture Post, Verve,* and *Lilliput,* and beginning in 1936 published numerous volumes of photographs. His abstracted images of nudes achieved particular fame. He photographed Picasso on several occasions, as well as other artists and writers, including Francis Bacon and Graham Greene.

Brassaï (Gyula Halász)

BRASSÓ, TRANSYLVANIA 1899 — 1984 NICE

From 1919 to 1922, Brassaï studied painting at the Academy of Fine Arts in Budapest and the Academy of Art in Berlin's Charlottenburg neighborhood, where he met László Moholy-Nagy, Oskar Kokoschka, and Wassily Kandinsky. In 1924 he moved to Paris, where he initially worked as a sculptor, painter, and journalist. He made his first photographs five years later, when a girlfriend loaned him a camera. His friends Henry Miller and André Kertész encouraged Brassaï to pursue photography, and in 1932 his famous collection *Paris de nuit* was published, with images of the streets of Paris as he experienced them on his nightly walks. His photographs of Picasso's sculptures were published in the magazine *Minotaure* in 1933, and the book *Les sculptures de Picasso* came out in 1949; it was these images that made Picasso popular as a sculptor. Brassaï's important literary works include his book *Conversations avec Picasso,* published in 1964.

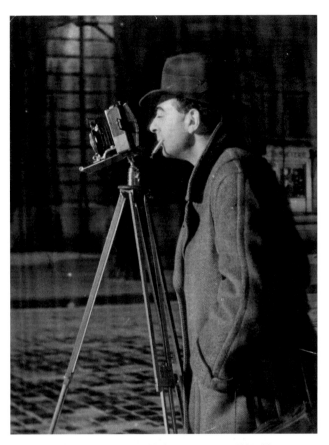

Brassaï, Self-portrait, Boulevard Saint-Jacques, ca. 1931–32

René Burri

ZURICH 1933

René Burri made his first successful photograph of a prominent person—Winston Churchill—at the age of thirteen. After attending school in Zurich, he studied photography at the School of Applied Arts there with teachers including Hans Finsler. Through his acquaintance with Werner Bischof, he was introduced to the Magnum photo agency in 1955; four years later, he became a member. Burri's photojournalistic work was published in magazines including *Life, Look, Paris Match, Stern,* and *Du,* and his journalistic travels took him to Egypt and South America, Cyprus, and Iran. His book *Die Deutschen (The Germans)* was published in the early 1960s: its images of reconstruction, the early signs of a consumer society, and the

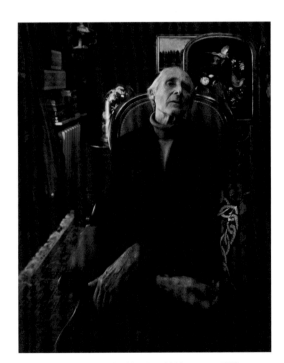

Bill **Brandt** photographed by Arnold Newman, 1978

René Burri on the cover of the periodical *Du, Jubiläum-sausgabe 70 Jahre Du – René Burri* 3, 2011

German economic miracle constitute a sociological document. Throughout his career, Burri's photographic interest has gravitated toward the architecture of Europe as well as important painters and poets; particularly well-known is his portrait of the cigar-smoking Che Guevara, as well as his photographs of Picasso and Le Corbusier.

Robert Capa (Endre Ernő Friedmann)
BUDAPEST 1913 — 1954 THAI-BINH,
FRENCH INDOCHINA

Due to his political activities, Endre Friedmann was forced to emigrate from Hungary in 1931. He settled in Berlin, where he studied journalism and worked as a laboratory assistant at Ullstein publishers, and later for the Deutscher Photodienst (Dephot). When the Nazis seized power in 1933, Friedmann fled first to Vienna and then to Paris. Since it was difficult to sell his pictures, he and his companion, Gerta Pohorylle, invented the

figure of a famous American photographer, Robert Capa. The hoax was exposed and Friedmann himself assumed this name, while his lover called herself Gerda Taro. Together with Capa and David Seymour, she documented the struggle of the Republican troops in the Spanish Civil War and was fatally injured in an accident. At the outbreak of World War II, Capa moved to New York; as a war reporter, he photographed events including the American landing in Normandy in 1944. In 1947, he co-founded the Magnum photo agency in New York and directed the Paris office from 1950 to 1953. One of the most famous artist portraits is his iconic image of Picasso and Françoise Gilot on the beach at Golfe-Juan in 1948. Capa, who by that time was working only rarely as a war reporter, died in 1954 when he stepped on a land mine in the First Indochina War.

Robert Capa, Self-portrait, 1954

Henri Cartier-Bresson photographed by George Platt Lynes, ca. 1930

Henri Cartier-Bresson

CHANTELOUP-EN-BRIE 1908 — 2004 CÉRESTE

Henri Cartier-Bresson first studied painting in Paris; in 1930, however, he turned his attention to photography because he "felt obligated to document the horrors of the world with a faster instrument than the brush." He also worked as an assistant to director Jean Renoir and made documentary films himself. During World War II, he served as a corporal in a news reporting unit. After the war—three years of which he spent as a German POW—he worked as a photographer in Paris and New York. In 1947, together with Robert Capa, David Seymour, and George Rodger, he founded the Magnum agency, which soon became the most famous photo agency in the world. He rejected posed photography and artificial lighting and refused to crop his photographs. In 1955, he was the first photographer al-

lowed to exhibit in the Louvre in Paris. His photographic oeuvre includes portraits of famous artists, actors, and writers, including Picasso, Henri Matisse, Alberto Giacometti, Samuel Beckett, and Marilyn Monroe. In the early 1970s, he gave up photography and returned to drawing and painting.

Chim or David Seymour (David Robert Szymin)

WARSAW 1911 — 1956 SUEZ, EGYPT

From 1929 to 1931, David Seymour attended the Royal Academy of Graphic Arts and Bookmaking in Leipzig and subsequently spent two years at the Sorbonne in Paris. In 1933 he made his first photographs, which were published in the communist magazine *Regards.* During this time he also met Robert Capa and Gerda Taro, with whom he shared a small studio. In 1936, they traveled to Spain to document the Republican struggle against Franco's Fascists; the photographs were published in *Vu, Regards,* and *Life.* When World War II broke out, Seymour went to the United States, where he remained, acquiring Amer-

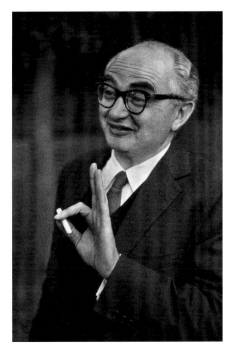

Chim photographed by Elliott Erwitt, ca. 1954

ican citizenship in 1942. In 1947 he became a founding member of the Magnum photo agency. His anti-war book *The Children of Europe,* with its empathetic photos of young victims of war, achieved worldwide fame. In 1937, he photographed Picasso in Paris in front of his famous painting *Guernica,* which was exhibited the same year at the Paris World Exposition. In 1956, Seymour was shot during the Suez crisis by Egyptian soldiers while crossing the front lines.

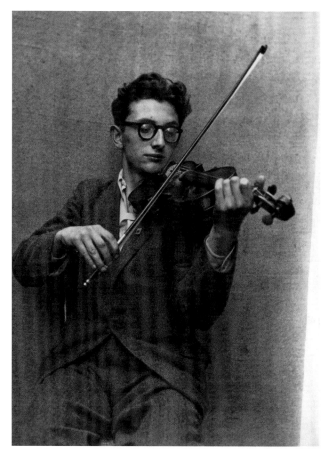

Lucien Clergue, Self-portrait, 1959

Lucien Clergue
ARLES 1934

Since his parents could not afford to send their violin-playing son to a conservatory, Lucien Clergue turned to photography. He took pictures of bullfights, which is where he met Picasso in 1953. The latter was impressed by the young man's work, especially the nudes with which Clergue made a name for himself and which in France at that time were considered pornographic. In the postwar period, Clergue took photographs documenting the bombed-out city of Arles and produced his series *Saltimbanque,* capturing the lives of Gypsies in southern France. In 1955 he encountered Picasso again and developed a close friendship with him, recounted in Clergue's book *Picasso mon ami* (1993). In 1968, together with his friend Michel Tournier, Clergue founded the Rencontres internationales de la photographie, an annual photography festival in Arles. He was a staunch advocate for the recognition of photography as an art, and was the first photographer to become a member of the French Académie des Beaux-Arts.

Jean Cocteau
MAISONS-LAFFITTE NEAR PARIS 1889 —
1963 MILLY-LA-FORÊT

Poet, screenwriter, and director Jean Cocteau published his first volume of poetry at the age of nineteen. He frequented the literary salons of Paris and began cultivating contacts with renowned writers, musicians, and artists, in particular with Picasso; the friendship between the two was documented in many photographs. His first collaboration with Picasso was the experimental ballet *Parade* (1917) for Sergei Diaghilev's Ballets Russes, for which Cocteau wrote the libretto and Erik Satie composed the music, while Picasso designed the stage sets and costumes. In 1919, Cocteau met the writer Raymond Radiguet and became his companion and mentor. When Radiguet died in 1923, Cocteau succumbed to an opium addiction which he was never able to overcome, though it did not inhibit his career. Presumably, it was his drug dependency as well as his divergent political views that caused Picasso to distance himself from Cocteau in later years. Cocteau's photographs of Picasso

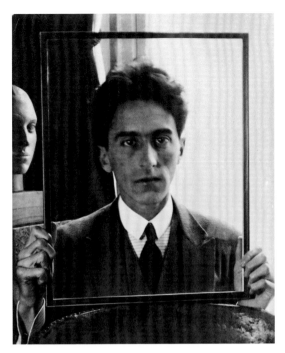

Jean Cocteau photographed by Man Ray, 1922

Staël, Alexander Calder, Marc Chagall, Zao Wou-Ki, Jean Arp, César, Le Corbusier, Joan Miró, Pierre Soulages, Victor Vasarely, Max Ernst, Georges Braque, Roberto Matta, and Jean Dubuffet; they were exhibited at the Galerie Pierre (run by her brother Pierre Loeb) in 1957. The next year, she was once again commissioned to photograph in the Antilles. A book of her photographs, *Portraits d'artistes: les années 50–60,* was published in 1986. Retrospectives of her work were mounted at the Palais de Tokyo, Paris (1992) and in the Antibes (1993). Toward the end of her life, Denise Colomb donated her entire photographic archive to the Association Patrimoine photographique in Paris.

from 1916 document their early bohemian period, during which their friendship was as yet untroubled.

Denise Colomb (Denise Loeb)
PARIS 1902 — 2004 PARIS

Denise Colomb began working in photography in the mid-1930s, during her travels with her husband, Gilbert Cahen, a marine engineer who worked in French colonial Indochina. Born Denise Loeb, she adopted the surname Colomb in 1940 in order to escape the Gestapo. In 1948, Colomb was invited by Aimé Césaire, politician from Martinique, to photograph the Antilles—Guadeloupe, Martinique, and Haiti; her documentary photographs were shown the following year at the gallery Le Minotaure in Paris. She began her best-known body of work in 1947 with a photograph of Antonin Artaud shortly before his death. This series included portraits of numerous painters and sculptors, among them Picasso, Alberto Giacometti, Nicolas de

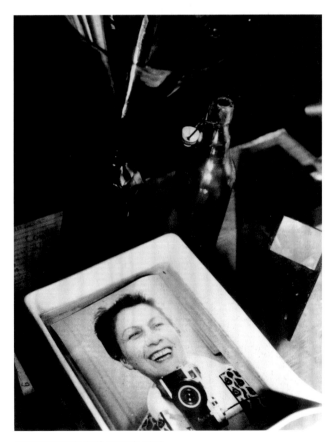

Denise Colomb, Self-portrait, 1952

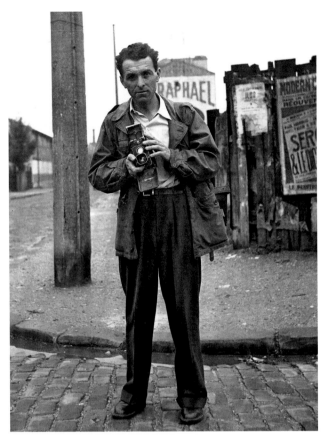

Robert Doisneau, Self-portrait at Villejuif, 1949

The Kiss by the Hotel de Ville (1950) achieved fame as an expression of Parisian *joie de vivre,* and his portrait of Picasso with bread-loaf fingers has become one of the most famous images of the painter.

David Douglas Duncan

KANSAS CITY, MISSOURI 1916

Using a camera he received for his twenty-second birthday, David Douglas Duncan photographed a hotel fire in Tucson, Arizona. In the process, he happened to capture an image of bank robber John Dillinger—at that time "Public Enemy No. 1"—attempting to escape from the burning hotel; this photograph became the cornerstone of his career. After his university studies, Duncan became an officer in the United States Marine Corps, where he worked as a war photographer. His pictures impressed J. R. Eyerman of *Life Magazine,* who hired him. In addition to his reputation as a war photographer—whose reporting of such conflicts as the Korean War and the Vietnam War grew increasingly critical over time—he also became famous for his memorable photo series of Picasso, whom he had met through their mutual friend Robert Capa. Duncan's photographs frequently include the dachshund Lump, a gift from the photographer to the animal-lover Picasso.

Robert Doisneau

GENTILLY, SEINE 1912 — 1994 PARIS

Robert Doisneau completed studies in lithography at the École Estienne in Chantilly before beginning his career as a photographer in 1929. He sold his first photojournalistic work, a series of images of Parisian flea markets, to the magazine *Excelsior* in 1932, and in 1934 was hired as an industrial photographer for the Renault factory in Billancourt. In 1940 he began work as a freelance photographer, first for the agency Alliance Photo, and then, beginning in 1946, for the Rapho photo agency. From 1949 to 1952 he photographed for the fashion magazine *Vogue*. Doisneau was well-known for his humorously enigmatic images of people; Parisian street life and the charm of the everyday occupied the center of his interest. His allegedly unposed photo

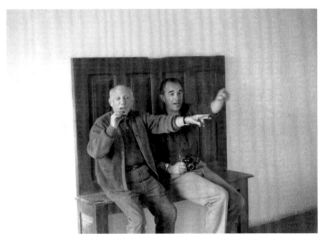

Picasso and **David Douglas Duncan** at Vauvenargues, photographed by Roland Penrose, 1956

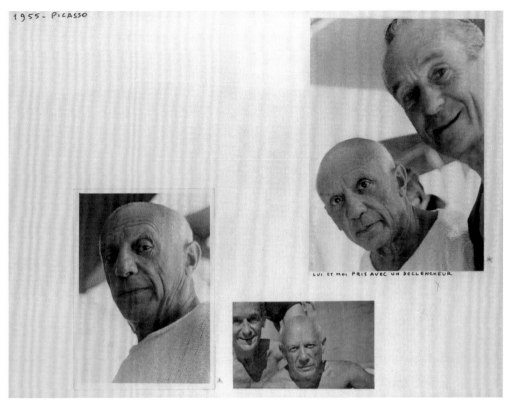

1955 - PICASSO

LUI ET MOI PRIS AVEC UN DÉCLENCHEUR

Jacques-Henri Lartigue, Picasso 1955 (Double portrait Picasso/Lartigue with self-timer)

Yousuf Karsh (Howsep Karshian)
MARDIN, TURKEY 1908 — 2002 BOSTON, MASSACHUSETTS

The persecution of Armenians in Turkey drove Yousuf Karsh and his family to Syria when he was fourteen. Two years later, his parents sent him to his uncle George Nakash in Canada, a photographer in the province of Quebec. The latter took note of his nephew's talent and apprenticed him to the portrait photographer John H. Garo in Boston. Upon his return, Karsh founded his own studio in Ottawa and photographed numerous dignitaries at the recommendation of the Canadian prime minister. His 1941 portrait of Winston Churchill brought him international fame and was followed by countless portraits of world-famous personalities, including Picasso, whom Karsh called "old lion" and portrayed with subtle irony.

Jacques-Henri Lartigue (Jacques Haguet Henri Lartigue)
COURBEVOIE 1894 — 1986 NICE

As a small boy, Jacques-Henri Lartigue received a camera as a gift from his father, and it became his constant companion. At first he photographed his family, documenting his untroubled bourgeois childhood during the Belle Epoque. In 1899, he and his family moved to Paris, where he studied painting at the Académie Julian in 1914–15; photography, however, remained his primary area of creative activity. Lartigue is famous for his assured style and love of experimentation; his favorite motifs included auto races and early attempts at flight. His photographs are remarkable for their vitality, a quality that also characterizes his portraits of Picasso, Kees van Dongen, and Jean Cocteau.

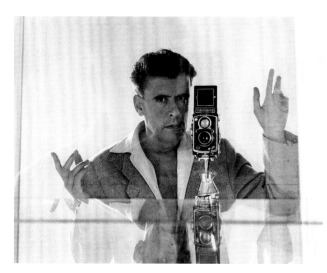

Herbert List, Self-portrait in mirror, Rome, 1955

Herbert List

HAMBURG 1903 — 1975 MUNICH

While working as a manager in his father's coffee company, Herbert List began to take photographs at the instigation of Andreas Feininger. Strongly influenced by artists such as Man Ray and Giorgio de Chirico, he went to Paris in 1935 and London in 1936 to devote himself entirely to photography. There he worked as a fashion photographer for *Harper's Bazaar, Life, The Studio,* and *Vogue.* In 1937, his first exhibition took place in Paris, and he began work on his book project *Licht über Hellas* (published in English as *Hellas*). When World War II broke out, List was in Athens, and from June 1944 to March 1945 he was called up for military service in Norway. Returning to Munich after the war, he documented the ruins of the destroyed city and produced photographic series for *Epoca, Picture Post,* and *Du.* From 1951 to 1956 he was a member of the Magnum photo agency. List photographed Picasso multiple times in the mid- to late 1940s, both in the latter's villa in Vallauris and at his atelier in Paris.

Dora Maar (Henriette Theodora Markovitch)

PARIS 1907 — 1997 PARIS

Dora Maar (née Henriette Theodora Markovitch) was born in Paris in 1907 and grew up in Argentina, where her father worked as an architect. The family returned to Paris and Dora Maar studied painting in the atelier of André Lhote, where many of the artists of the time went for training, then later at the École de Photographie de la Ville de Paris. Among her mentors were the photographers Emmanuel Sougez, and, to a lesser degree, Man Ray. Maar set up her first photo studio with Pierre Kéfer, and her work in the early 1930s bears their joint stamp. She continued to work in different areas of photography; at the time, portraiture was the most available option for

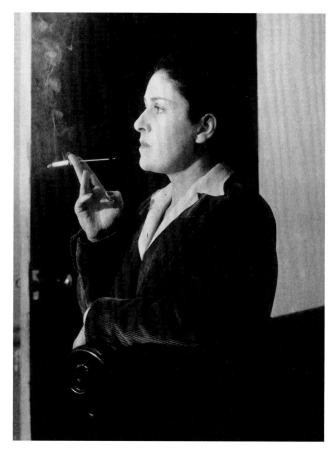

Dora Maar in her apartment on Rue de Savoie, photographed by Brassaï, 1944

women photographers. Her street work was published in *Photographie* in 1932, and she contributed to the book *Le Mont St. Michel*. She exhibited her advertising photography at the Galerie de la Pléiade in 1935. Dora Maar served as the set photographer for the Groupe Octobre (which performed works by Jacques Prévert and Jean Renoir). Her most personal work was strongly Surrealist in nature, creating strange environments inhabited by Ubu and other creatures. Maar experimented with rayographs, which led to a collaboration with Picasso in 1937. Her photographs documenting Picasso at work on *Guernica* date from the same year. After 1938, Dora Maar concentrated largely on her paintings, which were exhibited at various galleries in Paris: Jeanne Bucher, 1944; René Drouin, 1945; Pierre Loeb, 1946; Berggruen, 1957; and Galerie 1900–2000, 1990.

Madame d'Ora (Dora Philippine Kallmus)
VIENNA 1881 — 1963 FROHNLEITEN, AUSTRIA

Dora Philippine Kallmus opened her Atelier d'Ora after having completed a five-month apprenticeship in Berlin with Nicola Perscheid. She hired Arthur Benda as her technician; he took care of the technical equipment and processing; they formed a team, she organized, and Benda did the rest. Her work was printed in gum and silver, and in a straight color-printing process known as Pinatype, a forerunner of dye-transfer printing invented in France in 1903. Madame d'Ora was born into a distinguished family, which gave her broad social access; she photographed the emperor Karl of Austria with his family in 1917 and much of the royalty and high society that were in attendance during his coronation as king of Hungary. She also photographed notable artists, among them Hermann Bahr, Gustav and Alma Mahler, Alban Berg, Gustav Klimt, and Anna Pavlova.

Madame d'Ora moved to Paris in 1925 after selling her Vienna studio to Benda. She changed the signature on her work from the stamp "Atelier d'Ora" to simply the signature "d'Ora," with the word *Paris* stamped underneath. Besides portraiture, she did fashion work for the Berlin magazine *Die Dame* and photographed for many of the well-known couturiers, including Nina Ricci, Jeanne Lanvin, Jean Patou, Balenciaga, Chanel, and Hermès. She was a favorite photographer of the successful

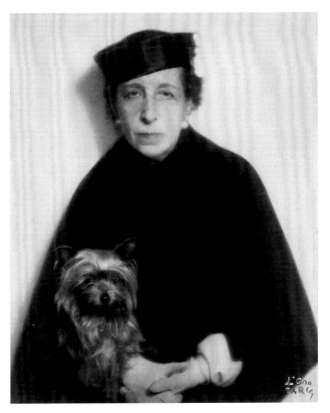

Madame d'Ora, Self-portrait, 1927

Austrian modiste Agnès Rittener, and took numerous portraits of Rittener wearing her extravagant hats, often created out of unusual materials such as Plexiglas. After World War II, Madame d'Ora's work changed drastically: instead of kings and fashion designers, she photographed orphans and an Austrian refugee camp, and began a series of photographs of slaughterhouses with her assistant Jan de Vries. In 1958, Madame d'Ora exhibited her work at the Galerie Montaigne in Paris in a show entitled *Portraits et Recherches: 60 ans d'art photographique,* presented by Jean Cocteau. Her health declined after she was hit by a motorcycle, and she returned to her family's summer house in Austria, recovered after the Nazi occupation, and lived there until her death.

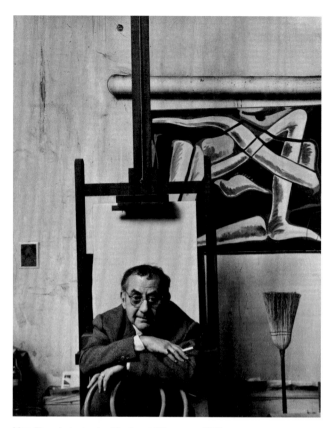

Man Ray photographed by Arnold Newman, 1960

Man Ray (Emmanuel Rudnitzky)

PHILADELPHIA, PENNSYLVANIA 1890 — 1976 PARIS

After studying at the National Academy of Design, the Art Students League, and the Modern School of New York's Ferrer Center, Man Ray worked as a commercial artist and illustrator from 1913 to 1919. In 1915, he bought a camera to document the works in his first exhibition in New York. Through his friendship with Alfred Stieglitz, he came into contact with members of the European avant garde, including Francis Picabia and Marcel Duchamp. In 1921, he went to Paris and made numerous portraits of artists such as Picasso, Henri Matisse, and Georges Braque, documenting the peak of Parisian cultural life in the 1920s. Photographs by Man Ray were shown in numerous exhibitions in New York, Paris, and London in the 1920s and 30s. During the German occupation of Paris, he fled to New York and worked as a fashion photographer; for a time he also taught art in Hollywood. In 1951 he returned to Paris. Man Ray is one of the most significant artists of Dada and Surrealism and played a decisive role in the development of modern photography and film.

Willy Maywald

CLEVES 1907 — 1985 PARIS

After attending the art school Kunstschule des Westens in Berlin from 1928 to 1931, Willy Maywald went to Paris, where he discovered fashion photography and embarked upon an international career. After several years of exile in Switzerland, after World War II he returned to Paris and in the early 1960s opened a gallery. Early on, he cultivated close contacts with artists such as Marc Chagall, Henri Matisse, and Jean Cocteau. According to Maywald, his first encounter with Picasso was a disaster: his camera broke during the photo shoot and he had to resort to a child's camera. The unique images created on the

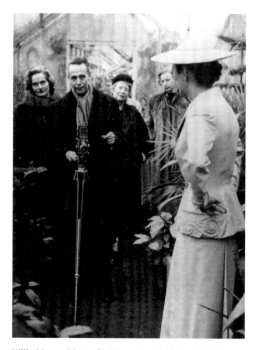

Willy Maywald at a fashion shoot in Düsseldorf, photographed by Fritz Gerlinger, 1953

beach at Golfe-Juan, however, reveal nothing of this mishap. Maywald's work as a photographer was esteemed by such eminent fashion designers as Christian Dior and Pierre Balmain, and he was described as a "master of the pose." His photographs were published in magazines including *Vogue* and *Harper's Bazaar.*

Gjon Mili

KORÇA, ALBANIA 1904 — 1984 STAMFORD, CONNECTICUT

Gjon Mili came to the United States in 1923. After studying at the Massachusetts Institute of Technology, he worked for ten years as an engineer in Cambridge, Massachusetts. A technically accomplished self-taught photographer, he began working freelance for various magazines, including *Life.* His oeuvre includes portraits of Paul Newman, Jean-Paul Sartre, and Edith Piaf. He met Picasso for the first time in 1949 in Vallauris, when he created the photo series *Drawing the Centaur with a Light Pencil.*

Lee Miller (Elizabeth Miller)

POUGHKEEPSIE, NEW YORK 1907 —
1977 EAST SUSSEX, ENGLAND

Elizabeth Miller was first exposed to photography by her father, who frequently used her as his model. After a trip to Paris and drawing courses at the Artists League in New York, as well as a theater production class at Vassar College, Miller was hired by Condé Nast and soon landed on the cover of *Vogue.* She adopted the name Lee and continued to model, and was photographed by Edward Steichen, Arnold Genthe, and Nickolas Muray. In 1929, with an introduction by Steichen, she returned to Paris, where she met Man Ray and began a professional and personal relationship with him. Lee Miller became part of the Surrealist beau monde and began photographing in that vein. She left for New York in 1932, exhibited at the Julien Levy Gallery, and opened her own successful photo studio with her brother Erik, which she ran until her marriage to Aziz Eloui Bey and subsequent move to Egypt in 1934. In Egypt, Miller continued to work, photographing the desert and remote villages. On a trip to France in 1937, she began a relationship with Roland

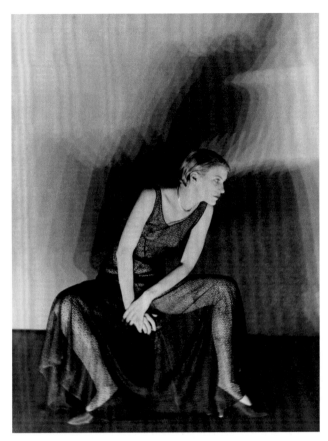

Lee Miller photographed by Man Ray, 1929

Penrose and met Picasso and Dora Maar. In 1939, Lee Miller left Egypt and joined Penrose in London, where she did fashion photography for *Vogue* and took Surrealist images of the Blitz bombings. In 1942, she became an accredited U.S. war correspondent and spent the next three years following the war through France and Germany, photographing the bombing at Saint-Malo and the liberation of Dachau and Buchenwald, along with writing copy for *Vogue.* After the war, Miller and Penrose, with their son Antony, moved to the English countryside. She continued to photograph intermittently, largely photographs of Picasso and the illustrious visitors that came from around the world to visit Farley Farm.

Inge Morath (Ingeborg Mörath)

GRAZ, AUSTRIA 1923 — 2002 NEW YORK

Born Ingeborg Mörath, she moved with her family to Germany as a child. There she studied languages, and was a gifted linguist as well as translator and writer, working in Salzburg after the war. In 1951 Morath moved to London, where she was briefly married; her first photographic work appeared there under the pseudonymn "Egni Tarom." Returning to Paris, Morath began working at the photo agency Magnum as a photo editor and then as a photojournalist; at the invitation of Robert Capa, she joined as a full member in 1955. She traveled widely, her fluency in German, French, English, Spanish, Romanian, Russian, and Chinese an enormous asset. She published numerous monographs of her work, ranging from her 1955 photographs of Spain, *Guerre à la Tristesse,* to collaborations with her husband, the playwright Arthur Miller, on their travels together in Russia and China. Inge Morath also worked exten-

sively in portraiture throughout her lifetime, photographing Alberto Giacometti, Jean Arp, Philip Roth, and a series of masked portraits in collaboration with Saul Steinberg. She also worked as a set photographer, capturing such film stars as Audrey Hepburn, Marilyn Monroe, Montgomery Clift, Clark Gable, Burt Lancaster, and Dustin Hoffman on location. Inge Morath first exhibited her work at the Art Institute of Chicago in 1964, and has continued to elicit interest as awareness of her wide-ranging photographic repertoire has grown. In 1992 she was awarded the Austrian State Prize, the first photographer to be so honored.

Inge Morath, Self-portrait, Jerusalem 1958

Arnold Newman

NEW YORK 1918 — 2006 NEW YORK

After two years of art study at the University of Miami, Arnold Newman took a position in a portrait studio in Philadelphia. In 1939 he met Alfred Stieglitz, who began to promote him, as did Beaumont Newhall, then curator of the Department of Photography at the Museum of Modern Art in New York. Newman established himself as a photographer, mounted exhibitions, and opened his first photo studio in New York; he met Picasso while traveling in Europe in the 1950s. Newman was one of the most sought-after photographers of his time, his work appearing in publications including *Harper's Bazaar, Vanity Fair, Look, Holiday,* and the *New York Times Magazine*. His portrait photos often show the subject's surroundings, which earned him the nickname "father of the environmental portrait"; yet he pursued other experimental approaches to photography, as well, as manifested in his collages.

Roberto Otero

TRENQUE LAUQUEN, BUENOS AIRES 1931 — 2004 PALMA DE MALLORCA

The Argentine documentary filmmaker and photographer Roberto Otero earned a degree from La Sorbonne (Paris, 1955) and studied at the Institut des hautes études cinématographiques (IDHE, Paris). He was the founder and former director of the press agencies Presse Mondiale (Paris, 1956) and Intern Press Service (Rome, 1963), and is well-known as the director

Arnold Newman, Self-portrait, 1979

Irving Penn

PLAINFIELD, NEW JERSEY 1917 — 2009 NEW YORK

Irving Penn was trained as a designer at the Philadelphia Museum School of Industrial Art and worked as creative director for a number of magazines. His initial desire to become a painter yielded to a passion for photography, and in 1942 he made his first cover image for *Vogue*. During his time as staff photographer for that fashion magazine, Penn met the model Lisa Fonssagrives, who became his wife and appears in many dazzling photos. He soon became one of the most popular fashion photographers of the 1950s. Far from the world of glamour, he also created portrait series of aboriginals in Papua New Guinea and the highland Indians of Peru. His still lifes, created from the 1970s on, consist of aesthetically sensitive arrangements of objects including cigarette butts and trash. He also made portraits of famous personalities such as Marcel Duchamp, Marlene Dietrich, Georgia O'Keeffe, and Picasso. His image of the latter with hat and turned-up collar is among the most famous photos of the artist.

and scriptwriter of the documentary film *Federico García Lorca, vida y muerte de un poeta* (1965), about the murder of the Spanish poet, shot underground. He was the photographer who portrayed Pablo Picasso's private life during the last ten years of the artist's life, when he was living in Mougins, France. Otero's relations with the great painter, whom he met through the art critic Ricardo Baeza and the writer José Bergamín, were further strengthened by his family ties with Rafael Alberti. This close contact enabled him to build up a large photographic archive of more than 2,000 negatives, which provides an extraordinary record of the artist's daily life. He is the author of, among other books, *Forever Picasso: An Intimate Look at His Last Years* (New York, 1974) and *Lejos de España: Encuentros y conversaciones con Picasso* (Barcelona, 1975).

Irving Penn photographed by Bert Stern, 1962

Julia Pirotte (Julia Djament)

KOŃSKOWOLA, POLAND 1907 — 2000 WARSAW

Born Julia Djament, Pirotte was a political activist who was incarcerated in her native Poland. She took refuge in Belgium in 1934 and married Jean Pirotte the following year, which gave her Belgian nationality. She studied journalism and then photography at the suggestion of Suzanne Spaak, who worked for the resistance in Paris and who gave her her first camera, a Leica Elmar 3, which she treasured throughout her long life. She volunteered to work in an aircraft factory in Marseilles, and then as a photojournalist, which gave her great mobility—essential for her work in the resistance. Her sister, Mindla Maria Djament, was guillotined by the Nazis for her role in the resistance. After the war, Pirotte continued to do documentary work; she photographed throughout Eastern Europe, the Soviet Union, and Israel. In 1958 she met a Polish economist, Jefim Sokolski, who had been imprisoned in Soviet camps for over twenty years, and they lived together until his death in 1974. In 1984, Pirotte exhibited thirty of her works at the International Center of Photography. A review of the exhibition in *Artnews* stated: "Although this modest show was primarily of historical interest, it was a worthy tribute to the freedom fighters of Marseilles and to Pirotte herself, who so ably and bravely immortalized their struggle." The Musée de la Photographie in Charleroi, Belgium, held a large show of her work in 1994. She died in 2000 and was buried in Poland.

Edward Quinn

DUBLIN 1920 — 1997 ALTENDORF, SWITZERLAND

Edward Quinn began his career as a guitarist and radio navigator; it was not until the mid-1940s, when he went to the Côte d'Azur, that he began taking photographs. In subsequent years, the Mediterranean coast of France became a popular resort area for film stars, musicians, and the nobility; Quinn captured these celebrities in sensitive, insightful photos and published his images of high society in various magazines. In 1951, Quinn met Picasso, and a friendship developed between them. In the years that followed, Quinn's photographic oeuvre consisted chiefly of portraits of artists and writers, including Max Ernst,

Julia Pirotte, Self-portrait, Marseille, 1943

Edward Quinn in Hans Hartung's house in Saint-Paul-de-Vence, photographed by Hans Hartung, 1961

included stories on Gregory Peck, Gary Cooper, and Anne Baxter, he returned to France in 1949 and was hired by *Paris Match.* His reportage on Maria Callas published in that magazine inspired Hergé to enshrine him as Walter Rizzoto, the photographer from *Paris Flash,* in the *Tintin* comic *Les bijoux de Castafiore (The Castafiore Emerald).* Among the many famous persons he captured with wit and charm as a fashion and society photographer was Picasso, whom he photographed in 1952 in Vallauris and in 1955 at his villa La Californie.

Alexander Calder, Alberto Giacometti, and Francis Bacon; Picasso, however, long remained his primary motif. Quinn is the author of numerous books on the artist, including *Picasso at Work* (1965) and *The Private Picasso* (1976).

Willy Rizzo

NAPLES 1928

As early as his school days in Paris, Willy Rizzo used an Agfa Box camera to photograph his classmates. When he acquired his first Rolleiflex on the black market in 1944, he set out on his bicycle to take his first photographs of the stars and starlets of French cinema. These he sold to *Ciné mondial, Point de vue,* and *Images du monde,* but as a photojournalist he also reported on the Nuremberg trials and the Mareth Line in Tunisia. After a stay in the United States, where his photojournalistic activity

Willy Rizzo with his model, Milan 1962

Picasso and **Gotthard Schuh** photographed by
Hanns Robert Welti, 1932

Gotthard Schuh

SCHÖNEBERG NEAR BERLIN 1897 —
1969 KÜSNACHT, SWITZERLAND

After attending vocational school in Basel and traveling to Italy,
Gotthard Schuh settled in Munich as a painter. In 1926, he re-
turned to Switzerland and joined the Basel painters' group Rot-
Blau (Red-Blue). At the same time, he was working as an ama-
teur photographer, and first published his images in 1931 in the
magazine *Zürcher Illustrierte.* At an exhibition of his paintings
in Paris in 1932, he met Picasso, Fernand Léger, and Georges
Braque. From 1933 to 1937, he published photojournalistic se-
ries from around the world, producing reportages in Belgium,
Italy, and England, and traveling to Sumatra, Java, and Bali in
1938–39. Schuh's book *Insel der Götter (Island of the Gods),*
consisting of both text and photographs, was published in 1940
after a trip to Indonesia and constitutes one of the pioneering
photo books of its kind. In 1941 he worked for the magazine *Du,*
then joined the photo editing staff of the newspaper *Neue
Zürcher Zeitung,* which he directed until 1960.

Michel Sima (Michael Smajewski)

SLONIM, POLAND 1912 — 1987 ARDÈCHE, FRANCE

Michael Smaievski, known as Michel Sima, came from an afflu-
ent Jewish family. At age seventeen, he went to Paris to become
a sculptor and enrolled in the Académie de la Grande Chau-
mière, earning part of his livelihood photographing daily events
for newspapers and magazines. In 1933 he joined the group
around the painter Francis Gruber. In 1936, after three years of
contact with Jean Cocteau, Max Ernst, and Constantin Bran-
cusi, he also met Picasso and Gertrude Stein. In 1942, during
preparations for a joint exhibition with Francis Picabia, he was
arrested and deported to the Blechhammer concentration
camp. In 1945, he returned to France, seriously ill, and was ad-
mitted to a clinic in Grasse for convalescence; after this stay it
became clear that Sima could no longer pursue his activity as
a sculptor. Shortly thereafter, he encountered Picasso again in
Golfe-Juan; the latter offered his support and helped restart
Sima's career as a photographer, providing him with numerous
contacts to fellow artists, but also allowing him to document
the creation of the painting *La joie de vivre.* Sima's striking pho-
tos show his sense of space and light.

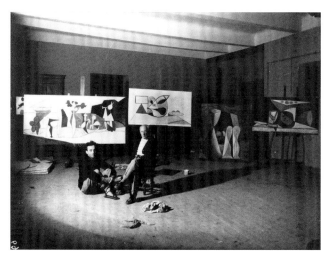

Michel Sima, Double portrait Sima / Picasso with self-timer, 1946

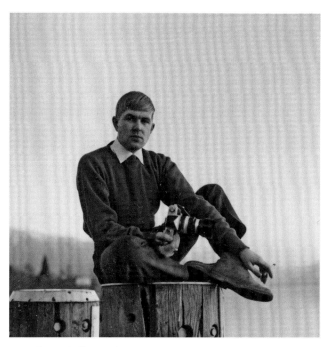

Horst Tappe, Self-portrait, ca. 1961

Horst Tappe

GÜTERSLOH, GERMANY 1938 — 2005 VEVEY, SWITZERLAND

Following an apprenticeship in a traditional photo studio, Horst Tappe attended the private photography school of Marta Hoepffner in Hofheim am Taunus and continued his training at the photography school in Vevey, Switzerland. Tappe was particularly known for his photographs of writers and artists. His portrait of Picasso in half-shadow is famous, but he also produced photographs of Salvador Dalí as well as Oskar Kokoschka and Vladimir Nabokov, with whom he had a friendly relationship. Tappe's photographs appeared in numerous magazines and daily newspapers, and in 1979 the American Society of Magazine Photographers made him an honorary member.

André Villers

BEAUCOURT 1930

Suffering from tuberculosis at the age of seventeen, André Villers went to a sanatorium in Vallauris, where he was to spend the next eight years of his life. He began to take photographs there, and when he met Picasso in 1953 the artist gave him his first Rolleiflex camera. That was the beginning of Villers's career as a photographer, which remained closely connected to the person of Picasso. In 1962, they collaborated on *Diurnes,* a portfolio of reproduced photograms with text by Jacques Prévert. In addition to Picasso, Villers photographed many other artists, including Alberto Magnelli and Hans Hartung. In 1966, Villers's photographs of shadows from the sculptures of Alberto Giacometti were used by Louis Aragon to illustrate *Lautréamont et nous.*

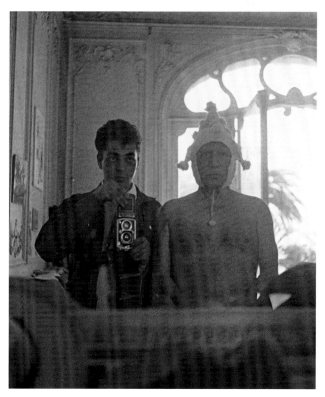

André Villers and Pablo Picasso, Self-portraits in mirror, Cannes, 1955

List of Illustrations

Most of the images listed here originally had no titles. In many case, titles were first assigned in publications or by the rights holders. As such, they are mostly descriptive and should not be understood as official titles.

Images without dimension information are not part of the exhibition.

ROGI ANDRÉ

Picasso, ca. 1936
Silver gelatin print, 40 × 30 cm
Centre national d'art et de culture
Georges Pompidou, Paris
© RMN
Fig. p. 98

Picasso, ca. 1936
Silver gelatin print, 40 × 30 cm
Centre national d'art et de culture
Georges Pompidou, Paris
© RMN
Fig. p. 99

Self-portrait, ca. 1930
Silver gelatin print, 40 × 30.1 cm
Centre national d'art et de culture
Georges Pompidou, Paris
© RMN
Fig. p. 233 top

RICHARD AVEDON

Pablo Picasso, artist, Beaulieu, France,
April 16, 1958
Silver gelatin print, 40.7 × 38.2 cm
The Richard Avedon Foundation, New York
© The Richard Avedon Foundation
Fig. p. 165

CECIL BEATON

Pablo Picasso, 1933
Silver gelatin print, 24 × 22.7 cm
Museum Ludwig, Cologne/Gruber Collection
© Cecil Beaton Archive, Sotheby's, London/
RBA
Fig. p. 75

HUBERT BECKER

after Picasso/Brassaï
Skull, 2008
Barite print, 21 × 16 cm
Peter und Irene Ludwig Stiftung, Aachen
© Hubert Becker/RBA
Fig. p. 104 left

BILL BRANDT

Pablo Picasso, 1956
Silver gelatin print, 35.7 × 29 cm
Museum Ludwig, Cologne/Gruber Collection
© Bill Brandt Archive, London/RBA
Fig. p. 177

BRASSAÏ

Picasso plays *artiste-peintre,*
Jean Marais mimics the model, Paris, 1944
Silver gelatin print, 23.9 × 30.5 cm
Estate Brassaï, Paris
© RMN/Estate Brassaï
Fig. p. 26 top

The actors of *Desire Caught by the Tail,* June
16, 1944 (Picasso at center; to his right, Zanie
de Campan, Louise Leiris, Pierre Reverdy,
Cécile Éluard, Jacques Lacan; to his left,
Valentine Hugo, Simone de Beauvoir; on the
floor, Jean-Paul Sartre, Michel Leiris, Jean
Aubier, Albert Camus)
© RMN/Estate Brassaï
Fig. p. 46

The studio on Rue La Boëtie, 1932
Silver gelatin print, 29.3 × 22.5 cm
Estate Brassaï, Paris
© RMN/Estate Brassaï
Fig. p. 76

The apartment on Rue La Boëtie, 1932
Silver gelatin print, 24 × 18.3 cm
Estate Brassaï, Paris
© RMN/Estate Brassaï
Fig. p. 77

The Bateau-Lavoir by night, 1946
Silver gelatin print, 22.9 × 29 cm
Estate Brassaï, Paris
© RMN/Estate Brassaï/RBA
Fig. p. 78 top

The studio on Rue des Grands Augustins
with easel and canvases, 1945
© RMN/Estate Brassaï
Fig. p. 78 bottom

Picasso next to the oven in the studio
on Rue des Grands Augustins, 1939
Silver gelatin print, 27.6 × 19.5 cm
Estate Brassaï, Paris
© RMN/Estate Brassaï
Fig. p. 79

The Woman with the Palette in the studio
on Rue des Grands Augustins, 1946
Silver gelatin print, 29.1 × 22 cm
Peter und Irene Ludwig Stiftung, Aachen
© RMN/Estate Brassaï
Fig. p. 80

Bust of Dora Maar for the Apollinaire
memorial, Rue des Grands Augustins,
Paris 1943–44
Silver gelatin print, 30 × 20.8 cm
Estate Brassaï, Paris
© RMN/Estate Brassaï/RBA
Fig. p. 81

The dove, 1944
Silver gelatin print, 23.3 × 16.7 cm
Estate Brassaï, Paris
© RMN/Estate Brassaï
Fig. p. 82

The dog Kazbek in the studio on Rue
des Grands Augustins, Paris, May 2, 1944
Silver gelatin print, 29.7 × 22 cm
Estate Brassaï, Paris
© RMN/Estate Brassaï
Fig. p. 83

The paint pots in the studio
on Rue La Boëtie, 1932
Silver gelatin print, 17.9 × 23.3 cm
Peter und Irene Ludwig Stiftung, Aachen
© RMN/Estate Brassaï
Fig. p. 84 bottom

The slippers, 1943
Silver gelatin print, 22.9 × 17.3 cm
Estate Brassaï, Paris
© RMN/Estate Brassaï
Fig. p. 85

Corner of the studio, chair with hat, 1932
Silver gelatin print, 28.5 × 22 cm
Estate Brassaï, Paris
© RMN/Estate Brassaï/RBA
Fig. p. 86

Picasso holding the sculpture The Orator,
1939
Silver gelatin print, 30.4 × 23.8 cm
Estate Brassaï, Paris
© RMN/Estate Brassaï
Fig. p. 87

Untitled (Picasso with paintbrush
on newspaper base), 1944–45
Silver gelatin print, 20.7 × 16.7 cm
Estate Brassaï, Paris
© RMN/Estate Brassaï
Fig. p. 88

Cast of Picasso's right hand, 1944
Silver gelatin print, 22.6 × 29.6 cm
Estate Brassaï, Paris
© RMN/Estate Brassaï
Fig. p. 89 top left

The closed fist, 1944
© RMN/Estate Brassaï
Fig. p. 89 bottom

Studio in Boisgeloup with sculptures
by night, 1932
Silver gelatin print, 28.8 × 20.8 cm
Estate Brassaï, Paris
© RMN/Estate Brassaï/RBA
Fig. p. 90

Studio door in Boisgeloup with
two dogs and Tériade, 1932
Silver gelatin print, 29.3 × 23 cm
Estate Brassaï, Paris
© RMN/Estate Brassaï
Fig. p. 91

Picasso at Café Flore, 1939
Silver gelatin print, 22.5 × 29.2 cm
Estate Brassaï, Paris
© RMN/Estate Brassaï
Fig. p. 92 top

Picasso at Café Flore, 1939
Silver gelatin print, 29.2 × 23.5 cm
Estate Brassaï, Paris
© RMN/Estate Brassaï/RBA
Fig. p. 92 bottom left

Picasso at Brasserie Lipp with Pierre Matisse
and Jaime Sabartés, 1939
Silver gelatin print, 22.8 × 28.5 cm
Estate Brassaï, Paris
© RMN/Estate Brassaï/RBA
Fig. p. 92 bottom right

The group in the studio on Rue des Grands
Augustins (left to right: Apel les Fenosa,
Jean Marais, Pierre Reverdy, Pablo Picasso,
Françoise Gilot, Jaime Sabartés, Brassaï),
1944
Silver gelatin print, 17 × 23.4 cm
Estate Brassaï, Paris
© RMN/Estate Brassaï/RBA
Fig. p. 93 top left

Dora Maar in her studio, 1945
Silver gelatin print, 22.7 × 28.1 cm
Estate Brassaï, Paris
© RMN/Estate Brassaï
Fig. p. 93 top right

The group in the studio on Rue des Grands
Augustins (left to right: Manuel Ortiz de
Zárate, Françoise Gilot, Apel les Fenosa,
Jean Marais, Pierre Reverdy, Pablo Picasso,
Jean Cocteau, Brassaï), 1944
Silver gelatin print, 29.7 × 23.4 cm
Estate Brassaï, Paris
© RMN/Estate Brassaï
Fig. p. 93 bottom

Picasso in front of Henri Rousseau's
portrait of "Jadwiga," 1932
Silver gelatin print, 29.1 × 22.4 cm
Peter und Irene Ludwig Stiftung, Aachen
© RMN/Estate Brassaï
Fig. p. 95

Tête de mort, 1944
Silver gelatin print, 22 × 17.2 cm
Estate Brassaï, Paris
© RMN/Estate Brassaï
Fig. p. 105

Self-portrait, Boulevard Saint-Jacques,
ca. 1931–32
Silver gelatin print, 29.5 × 22.8 cm
Estate Brassaï, Paris
© RMN/Estate Brassaï
Fig. p. 235 top

Dora Maar in her apartment on
Rue de Savoie, 1944
Silver gelatin print, 18 × 12.7 cm
Estate Brassaï, Paris
© RMN/Estate Brassaï
Fig. p. 242 bottom

CHRIS BUCK

Steve Martin on the cover of Pdn, 2006
© Chris Buck
Fig. p. 24 lower right

GELETT BURGESS

Picasso, 1908
Silver gelatin print
© RMN
Fig. p. 23

RENÉ BURRI

Pablo Picasso, La Californie, Cannes,
Provence–Alpes–Côte d'Azur region 1957
Series of 3 photographs
© Rene Burri/Magnum Photos/
Agentur Focus
Fig. p. 37

Pablo Picasso with his children, 1957
Silver gelatin print (from the 1980s),
40 × 26.4 cm
Fotostiftung Schweiz, Winterthur
© René Burri/Magnum Photos/
Agentur Focus
Fig. p. 184 top

ROBERT CAPA

Pablo Picasso and Françoise Gilot.
In the background is Picasso's nephew
Javier Vilato, August 1948
Silver gelatin print, 40.4 × 51 cm
International Center of Photography, New
York
© Robert Capa, © International Center of
Photography/Magnum Photos/Agentur Focus
Fig. p. 152

Pablo Picasso on the beach with his son
Claude and his partner Françoise Gilot, 1948
Silver gelatin print, 40.4 × 51 cm
International Center of Photography,
New York
© Robert Capa, © International Center of
Photography/Magnum Photos/Agentur Focus
Fig. p. 153

Pablo Picasso in his studio at the Rue
des Grands Augustins, September 2, 1944
Silver gelatin print, 33.6 × 27.3 cm
International Center of Photography,
New York
© Robert Capa, © International Center of
Photography/Magnum Photos/Agentur Focus
Fig. p. 154 top

Pablo Picasso with *The Artist-Painter,* 1944
Silver gelatin print, 22.2 × 20.3 cm
International Center of Photography,
New York
© Robert Capa, © International Center of
Photography/Magnum Photos/Agentur Focus
Fig. p. 154 bottom

Picasso as clown, 1946
Silver gelatin print, 18 × 24 cm
Museu Picasso, Barcelona
© Robert Capa, © International Center of
Photography/Magnum Photos/Agentur Focus
Fig. p. 155

Self-portrait, 1954
Silver gelatin print, 34.1 × 26.9 cm
Museum Ludwig, Cologne/Gruber Collection
© Robert Capa/Magnum Photos/
Agentur Focus/RBA
Fig. p. 236 bottom

HENRI CARTIER-BRESSON

Pablo Picasso's studio, Rue des
Grands Augustins, Paris 1944
Silver gelatin print, 23.2 × 34.4 cm
Fondation Henri Cartier-Bresson, Paris
© Henri Cartier-Bresson/
Magnum Photos/Agentur Focus
Fig. p. 118 top

Pablo Picasso's studio, Rue des
Grands Augustins, Paris 1944
Silver gelatin print, 24.8 × 35.3 cm
Fondation Henri Cartier-Bresson, Paris
© Henri Cartier-Bresson/
Magnum Photos/Agentur Focus
Fig. p. 118 bottom

Pablo Picasso's studio, Rue des
Grands Augustins, Paris 1944
Silver gelatin print, 28 × 35.3 cm
Fondation Henri Cartier-Bresson, Paris
© Henri Cartier-Bresson/
Magnum Photos/Agentur Focus
Fig. p. 119 top

Paul Éluard and Pablo Picasso in the studio,
Rue des Grands Augustins, Paris 1944
Silver gelatin print, 29.2 × 19.2 cm
Fondation Henri Cartier-Bresson, Paris
© Henri Cartier-Bresson/Magnum
Photos/Agentur Focus
Fig. p. 119 bottom

Picasso at home, Rue des Grands Augustins,
Paris 1944
Silver gelatin print, 15.4 × 22.8 cm
Fondation Henri Cartier-Bresson, Paris
© Henri Cartier-Bresson/Magnum
Photos/Agentur Focus
Fig. p. 120

Picasso in the ceramist Ramié's studio,
Vallauris, 1953
Silver gelatin print, 29.4 × 19.9 cm
Fondation Henri Cartier-Bresson, Paris
© Henri Cartier-Bresson/Magnum
Photos/Agentur Focus
Fig. p. 121

CHIM (DAVID SEYMOUR)

Picasso in front of his painting *Guernica*
at its unveiling at the Spanish Pavilion
of the World's Fair, Paris, 1937
Silver gelatin print, 23 × 8 × 15.2 cm
International Center of Photography,
New York
© Magnum Photos
Fig. p. 97

LUCIEN CLERGUE

Cannes, 1965
Silver gelatin print, 22.7 × 30.2 cm
Museum Ludwig, Cologne/Gruber Collection
© Lucien Clergue/RBA
Fig. p. 211

Cannes, 1957
Silver gelatin print, 29.8 × 22.9 cm
Museum Ludwig, Cologne/Gruber Collection
© Lucien Clergue/RBA
Fig. p. 212

Cannes, 1957
Silver gelatin print, 29.5 × 20.3 cm
Museum Ludwig, Cologne/Gruber Collection
© Lucien Clergue/RBA
Fig. p. 213

Mougins, summer 1968
Silver gelatin print, 28.7 × 22.9 cm
Museum Ludwig, Cologne/Gruber Collection
© Lucien Clergue/RBA
Fig. p. 214

Mougins, 1970
Silver gelatin print, 30.2 × 23.4 cm
Museum Ludwig, Cologne/Gruber Collection
© Lucien Clergue/RBA
Fig. p. 215

Mougins, summer 1965
Silver gelatin print, 29.9 × 22.9 cm
Museum Ludwig, Cologne/Gruber Collection
© Lucien Clergue/RBA
Fig. p. 216

Mougins, 1965
Silver gelatin print, 30.2 × 23.4 cm
Museum Ludwig, Cologne/Gruber Collection
© Lucien Clergue/RBA
Fig. p. 217

Arles, September 1959
Silver gelatin print, 22.2 × 30.2 cm
Museum Ludwig, Cologne/Gruber Collection
© Lucien Clergue/RBA
Fig. p. 218

Fréjus, 1962
Silver gelatin print, 22.3 × 30.2 cm
Museum Ludwig, Cologne/Gruber Collection
© Lucien Clergue/RBA
Fig. p. 219

Self-portrait, 1959
© Lucien Clergue/RBA
Fig. p. 238

JEAN COCTEAU

Manuel Ortiz de Zárate, Max Jacob,
Henri-Pierre Roché, Pablo Picasso,
Paris, August 12, 1916
Silver gelatin print, 17.6 × 25.4 cm
Musée Carnavalet, Paris
© VG Bild-Kunst, Bonn
Fig. p. 72 top

Pâquerette, Marie Vassilieff, Pablo
Picasso in front of Café La Rotonde,
Paris, August 12, 1916
Silver gelatin print, 17.6 × 25.8 cm
Musée Carnavalet, Paris
© VG Bild-Kunst, Bonn
Fig. p. 72 center

Manuel Ortiz de Zárate, Moïse Kisling,
Max Jacob, Pablo Picasso, Pâquerette,
Paris, August 12, 1916
Silver gelatin print, 17.6 × 21.8 cm
Musée Carnavalet, Paris
© VG Bild-Kunst, Bonn
Fig. p. 72 bottom

Moïse Kisling, Manuel Ortiz de Zárate,
Max Jacob, Pablo Picasso, Pâquerette,
Paris, August 12, 1916
Silver gelatin print, 16 × 22 cm
Musée Carnavalet, Paris
© VG Bild-Kunst, Bonn
Fig. p. 73 top

Amedeo Modigliani, Pablo Picasso,
André Salmon, Paris, August 12, 1916
Silver gelatin print, 17.4 × 23.9 cm
Musée Carnavalet, Paris
© VG Bild-Kunst, Bonn
Fig. p. 73 bottom left

Amedeo Modigliani, Pablo Picasso,
André Salmon, Paris, August 12, 1916
Silver gelatin print, 5.2 × 6.7 cm
Musée Carnavalet, Paris
© VG Bild-Kunst, Bonn
Fig. p. 73 bottom right

DENISE COLOMB

Picasso in Antibes, 1952
Silver gelatin print, 38.5 × 30 cm
Médiathèque de l'architecture et
du patrimoine, Fort de Saint-Cyr
© Ministère de la Culture, France –
Médiathèque du patrimoine, Dist. RMN
Fig. p. 42

Picasso's studio, Rue des Grands Augustins,
Paris 1952
Silver gelatin print, 37.1 × 30.1 cm
Médiathèque de l'architecture et
du patrimoine, Fort de Saint-Cyr
© Ministère de la Culture, France –
Médiathèque du patrimoine, Dist. RMN
Fig. p. 116

Picasso in the Rue des Grands Augustins,
Paris 1952
Silver gelatin print, 41 × 30.3 cm
Médiathèque de l'architecture et
du patrimoine, Fort de Saint-Cyr
© Ministère de la Culture, France –
Médiathèque du patrimoine, Dist. RMN
Fig. p. 117

Self-portrait, 1952
Silver gelatin print, 39 × 29 cm
Médiathèque de l'architecture et
du patrimoine, Fort de Saint-Cyr
© Ministère de la Culture, France –
Médiathèque du patrimoine, Dist. RMN
Fig. p. 239 bottom

ROBERT DOISNEAU

Picasso in the studio in Vallauris, 1952
Silver gelatin print, 15.8 × 21.8 cm
Atelier Robert Doisneau
© Atelier Robert Doisneau
Fig. p. 38

The studio in Rue des Grands Augustins,
1956
Silver gelatin print, 22.2 × 17 cm
Atelier Robert Doisneau
© Atelier Robert Doisneau
Fig. p. 39

Picasso under the lamps, Rue des
Grands Augustins, Paris 1959/1
Silver gelatin print, 15.7 × 15.8 cm
Atelier Robert Doisneau
© Atelier Robert Doisneau
Fig. p. 138

Picasso under the lamps, Rue des
Grands Augustins, Paris 1959/2
Silver gelatin print, 15.7 × 15.8 cm
Atelier Robert Doisneau
© Atelier Robert Doisneau
Fig. p. 139

Glued-on contact sheet "fleur volante,"
undated
Overall 14 × 20 cm
Atelier Robert Doisneau
© Atelier Robert Doisneau
Fig. p. 140

Picasso and "la fleur volante," Vallauris,
1952
Silver gelatin print, 16.8 × 17 cm
Atelier Robert Doisneau
© Atelier Robert Doisneau
Fig. p. 141

Glued-on contact sheet "déjeuner,"
undated
Overall 14 × 20 cm
Atelier Robert Doisneau
© Atelier Robert Doisneau
Fig. p. 142

Pablo Picasso with bread fingers,
Vallauris, 1952
Silver gelatin print, 15.5 × 18.2 cm
Atelier Robert Doisneau
© Atelier Robert Doisneau
Fig. p. 143

Picasso eating lunch with Françoise Gilot,
Vallauris, 1952
Silver gelatin print, 15.7 × 15.8 cm
Atelier Robert Doisneau
© Atelier Robert Doisneau
Fig. p. 144

Picasso in Vallauris, in the foreground
Françoise Gilot, 1952
Silver gelatin print, 21.9 × 18.9 cm
Museum Ludwig, Cologne/Gruber Collection
© Atelier Robert Doisneau
Fig. p. 145

Picasso—behind the window, Vallauris, 1952
Silver gelatin print, 22 × 28.4 cm
Atelier Robert Doisneau
© Atelier Robert Doisneau
Fig. pp. 146–147

Picasso and Françoise Gilot, Vallauris,
September 28, 1952
Silver gelatin print, 18 × 18 cm
Atelier Robert Doisneau
© Atelier Robert Doisneau
Fig. p. 148

Picasso with praying mantis, Vallauris, 1952
Silver gelatin print, 18 × 20 cm
Atelier Robert Doisneau
© Atelier Robert Doisneau
Fig. p. 149

Self-portrait in Villejuif, 1949
Silver gelatin print, 24.5 × 18 cm
Atelier Robert Doisneau
© Atelier Robert Doisneau
Fig. p. 240 top

DAVID DOUGLAS DUNCAN

Pablo Picasso seated at a table with
Yves Montand, Simone Signoret,
Georges Tabaraud and his wife,
Villa La Californie, Cannes 1956
Silver gelatin print, 23.9 × 34.6 cm
Private collection
© Harry Ransom Humanities Research
Center, The University of Texas at Austin
Fig. p. 29 bottom

Jacques Frélaut, Jaime Sabartés, Pablo
Picasso, Jacqueline Picasso, La Californie,
ca. 1957
© Harry Ransom Humanities Research
Center, The University of Texas at Austin
Fig. p. 49

Small Snow Owl (1-I), 1957
Silver gelatin print, 21 × 30 cm
Lars Netopil and David Pitzer, Wetzlar
©Harry Ransom Humanities Research
Center, The University of Texas at Austin
Fig. p. 34

Making of *Large Snow Owl* (1-II), 1957
Silver gelatin print, 24 × 30 cm
Lars Netopil and David Pitzer, Wetzlar
© Harry Ransom Humanities Research
Center, The University of Texas at Austin
Fig. p. 35 top left

Making of *Large Snow Owl* (1-IV), 1957
Silver gelatin print, 19.3 × 30 cm
Lars Netopil and David Pitzer, Wetzlar
© Harry Ransom Humanities Research
Center, The University of Texas at Austin
Fig. p. 35 top right

Picasso drawing *Self-Portrait as Owl,*
Villa La Californie, Cannes 1957
Silver gelatin print, 29.7 × 19.5 cm
Private collection
© Harry Ransom Humanities Research
Center, The University of Texas at Austin
Fig. p. 35 bottom left

Making of *Small Snow Owl* (2-IV), 1957
Silver gelatin print, 28 × 35.5 cm
Lars Netopil and David Pitzer, Wetzlar
© Harry Ransom Humanities Research
Center, The University of Texas at Austin
Fig. p. 35 bottom right

Picasso hanging *Self-Portrait as Owl* on
the wall, Villa La Californie, Cannes 1957
Silver gelatin print, 35.5 × 24.2 cm
Private collection
© Harry Ransom Humanities Research
Center, The University of Texas at Austin
Fig. p. 36 top

Picasso with *Self-Portrait as Owl,*
Villa La Californie, Cannes 1957
Silver gelatin print, 20.4 × 30 cm
Private collection
© Harry Ransom Humanities Research
Center, The University of Texas at Austin
Fig. p. 36 bottom

Picasso with Indian chieftain headdress given
to him by Gary Cooper, Villa La Californie,
Cannes 1960
C-print, 126 × 90.5 cm
Private collection
© Harry Ransom Humanities Research
Center, The University of Texas at Austin
Fig. p. 183

Pablo Picasso in his bath on the first day
of his meeting with David Douglas Duncan,
Villa La Californie, Cannes 1956
Silver gelatin print, 17 × 26.8 cm
Private collection
© Harry Ransom Humanities Research
Center, The University of Texas at Austin
Fig. p. 222

Picasso imitating a toreador with a bath
towel, Villa La Californie, Cannes 1957
Silver gelatin print, 38 × 25.3 cm
Private collection
© Harry Ransom Humanities Research
Center, The University of Texas at Austin
Fig. p. 223

Pablo Picasso preparing fish spine to be cast
in clay, Villa La Californie, Cannes 1957
Silver gelatin print, 25.2 × 20.3 cm
Private collection
© Harry Ransom Humanities Research
Center, The University of Texas at Austin
Fig. p. 224

Pablo Picasso holding the fish spine over the clay, Villa La Californie, Cannes 1957
Silver gelatin print, 25.3 × 17.5 cm
Private collection
© Harry Ransom Humanities Research Center, The University of Texas at Austin
Fig. p. 225 top

Pablo Picasso picking up the fish spine from the clay, Villa La Californie, Cannes 1957
Silver gelatin print, 25.3 × 17.5 cm
Private collection
© Harry Ransom Humanities Research Center, The University of Texas at Austin
Fig. p. 225 center

Pablo Picasso working on the ceramic sculpture, Villa La Californie, Cannes 1957
Silver gelatin print, 38 × 25.5 cm
Private collection
© Harry Ransom Humanities Research Center, The University of Texas at Austin
Fig. p. 225 bottom

Picasso and Jacqueline seated at a table, with Lump, Villa La Californie, Cannes 1957
Silver gelatin print, 25.4 × 17.5 cm
Private collection
© Harry Ransom Humanities Research Center, The University of Texas at Austin
Fig. p. 226

Picasso dancing in front of *The Bathers,* Villa La Californie, Cannes 1957
Silver gelatin print, 24.2 × 35.2 cm
Private collection
© Harry Ransom Humanities Research Center, The University of Texas at Austin
Fig. p. 227

Esmeralda attached to *The Goat* (1950), Villa La Californie, Cannes 1957
Silver gelatin print, 34.6 × 23.5 cm
Private collection
© Harry Ransom Humanities Research Center, The University of Texas at Austin
Fig. p. 228

Picasso dancing on his balcony, Villa La Californie, Cannes 1957
Silver gelatin print, 35.5 × 28 cm
Private collection
© Harry Ransom Humanities Research Center, The University of Texas at Austin
Fig. p. 229

ELLIOTT ERWITT

Portrait of Chim (David Seymour), ca. 1954
© Magnum Photos
Fig. p. 237 bottom

MAURICE FERRIER

Pablo Picasso with his left hand in his pocket, Vallauris, undated
Silver gelatin print, 12.8 × 8.7 cm
Peter und Irene Ludwig Stiftung, Aachen
© Maurice Ferrier/RBA
Fig. p. 17 top

Pablo Picasso signing his book, Vallauris, undated
Silver gelatin print, 12.9 × 8.6 cm
Peter und Irene Stiftung Ludwig, Aachen
© Maurice Ferrier/RBA
Fig. p. 17 center

Pablo Picasso with a cigarette in his mouth signing his book, Vallauris, undated
Silver gelatin print, 14.1 × 9.5 cm
Peter und Irene Stiftung Ludwig, Aachen
©Maurice Ferrier/RBA
Fig. p. 17 bottom

FRITZ GERLINGER

Willy Maywald at a fashion shoot in Düsseldorf, 1953
© Fritz Gerlinger/RBA
Fig. p. 244 bottom

HANS HARTUNG

Edward Quinn in Hans Hartung's house in Saint-Paul-de-Vence, 1961
Barite paper, 30 × 40 cm
Edward Quinn Archive, Uerikon
© edwardquinn.com
Fig. p. 249 top

HIRO

Richard Avedon, undated
Silver gelatin print, 26.5 × 20.6 cm
Museum Ludwig, Cologne/Gruber Collection
© Hiro/RBA
Fig. p. 233 bottom

YOUSUF KARSH

Pablo Picasso, 1954
Silver gelatin print, 27 × 34 cm
Camera Press, London
© Camera Press
Fig. p. 157

JACQUES-HENRI LARTIGUE

Picasso's hand, 1955
Album page, 40 × 50 cm
L'Association des Amis de Jacques Henri Lartigue (AAJHL), Charenton-Le Pont
© Ministère de la Culture – France/AAJHL
Fig. p. 171

Picasso and Jean Cocteau, Vallauris 1955
Album page, 40 × 50 cm
L'Association des Amis de Jacques Henri Lartigue (AAJHL), Charenton-Le Pont
© Ministère de la Culture – France/AAJHL
Fig. p. 172

Picasso at home, 1955
Album page, 40 × 50 cm
L'Association des Amis de Jacques Henri Lartigue (AAJHL), Charenton-Le Pont
© Ministère de la Culture – France/AAJHL
Fig. p. 173

Picasso, Cannes, August 1955
Silver gelatin print, 30 × 30 cm
L'Association des Amis de Jacques Henri Lartigue (AAJHL), Charenton-Le Pont
© Ministère de la Culture – France/AAJHL
Fig. p. 174

Picasso, Cannes, 1955
Silver gelatin print, 30 × 30 cm
L'Association des Amis de Jacques Henri Lartigue (AAJHL), Charenton-Le Pont
© Ministère de la Culture – France/AAJHL
Fig. p. 175

MAN RAY

Pablo Picasso, 1933
Silver gelatin print, 8.1 × 5.4 cm
Museum Ludwig, Cologne/Gruber Collection
© VG Bild-Kunst, Bonn/RBA
Fig. p. 50

Picasso with Yvonne Zervos and another woman, 1930s

Untitled (hands of Picasso and Yvonne Zervos), 1930s (1967)

Untitled (from: Paul Éluard and Man Ray, *Les mains libres)*, 1956

3 vintage pictures in a frame,
frame 43 × 78 × 3 cm
Man Ray Trust, New York
© Man Ray Trust/ADAGP/
VG Bild-Kunst, Bonn
Fig. pp. 52–53

Picasso, Juan les Pins, 1926
Silver gelatin print, 23 × 18 cm
Centre national d'art et de culture
Georges Pompidou, Paris
© VG Bild-Kunst, Bonn
Fig. p. 54

Pablo Picasso, 1933
Silver gelatin print, 29.9 × 23.9 cm
Museum Ludwig, Cologne/Gruber Collection
© VG Bild-Kunst, Bonn/RBA
Fig. p. 55

Pablo Picasso, 1933
Silver gelatin print, 29.8 × 23.1 cm
Museum Ludwig, Cologne/Gruber Collection
© VG Bild-Kunst, Bonn/RBA
Fig. p. 56 top

Pablo Picasso, 1932
Silver gelatin print, 22.8 × 17.9 cm
Museum Ludwig, Cologne/Gruber Collection
© VG Bild-Kunst, Bonn/RBA
Fig. p. 56 bottom

Pablo Picasso, 1955
Silver gelatin print, 22.8 × 13.7 cm
Museum Ludwig, Cologne/Gruber Collection
© VG Bild-Kunst, Bonn
Fig. p. 57

Picasso between Mme. De Erraguyen and Olga as toreador at the Comte de Beaumont costume ball, 1924
Silver gelatin print, 21 × 16 cm
Museo National Centro de Arte Reina Sofía, Madrid
© VG Bild-Kunst, Bonn
Fig. p. 74 top

Ricardo Viñes, Olga Picasso, Pablo Picasso, and Manuel Ángeles Ortiz, 1924
Silver gelatin print, 31 × 23.8 cm
Museo National Centro de Arte Reina Sofía, Madrid
© VG Bild-Kunst, Bonn
Fig. p. 74 bottom

Jean Cocteau, 1922
Silver gelatin print, 36.5 × 30 cm
Museum Ludwig, Cologne/Gruber Collection
© VG Bild-Kunst, Bonn/RBA
Fig. p. 239 top

Lee Miller, 1929
Silver gelatin print, 28.9 × 22.2 cm
Museum Ludwig, Cologne/Gruber Collection
© VG Bild-Kunst, Bonn/RBA
Fig. p. 245

WILLY MAYWALD

Picasso, 1948
Silver gelatin print, 40 × 50 cm
Peter und Irene Ludwig Stiftung, Aachen
© Association Willy Maywald/
VG Bild-Kunst, Bonn
Fig. p. 150

Picasso, 1947
Silver gelatin print, 40 × 50 cm
Peter und Irene Ludwig Stiftung, Aachen
© Association Willy Maywald/
VG Bild-Kunst, Bonn
Fig. p. 151

GJON MILI

A centaur drawn with light—Pablo Picasso in the Madoura pottery workshop, Vallauris 1949
Silver gelatin print, 46 × 35.5 cm
Münchner Stadtmuseum
© Getty Images, all rights reserved
Fig. p. 137

LEE MILLER

Roland Penrose, Lee Miller, and Picasso, Villa La Californie, Cannes 1956
Vintage print, 15.3 × 20.3 cm
Lee Miller Archives
© Lee Miller Archives, England
Fig. p. 65

Lee Miller, Jacqueline Roque, Roland Penrose, and Picasso next to the painting *Three Dancers* (1925), Villa Notre-Dame de Vie, Mougins 1965
© Lee Miller Archives, England
Fig. p. 67 left

Picasso and Lee Miller
(after the liberation of Paris), 1944
Silver gelatin print, 21.3 × 16.1 cm
Lee Miller Archive
© Lee Miller Archives, England
Fig. p. 124 top

Picasso in his studio
(Robert Capa holding flash), 1944
Silver gelatin print, 10.4 × 10.1 cm
Lee Miller Archives
© Lee Miller Archives, England
Fig. p. 125

Picasso and Roland Penrose, Mougins, 1937
Silver gelatin print, 16.9 × 16.6 cm
Lee Miller Archives
© Lee Miller Archives, England
Fig. p. 126

Picasso and sculpture of Jacqueline, 1963
Silver gelatin print, 11.3 × 11.3 cm
Lee Miller Archives
© Lee Miller Archives, England
Fig. p. 127

"Pottery baby series" (contact sheet), 1954
Contact print, digital print, 40 × 47.7 cm
Lee Miller Archives
© Lee Miller Archives, England
Fig. p. 128

INGE MORATH

Pablo Picasso seated next to Maurice Thorez
(former French politician and member of
the Communist Party) at the inauguration
of a Picasso mural at the UNESCO Building
in Paris, 1958
The Inge Morath Foundation, New York
Contact sheet
© The Inge Morath Foundation/
Magnum Photos
Fig. p. 70

Pablo Picasso, Vallauris, 1953
Silver gelatin print, 28 × 35.5 cm
The Inge Morath Foundation, New York
Contact sheet
© The Inge Morath Foundation/
Magnum Photos
Fig. p. 156 left

Self-portrait, Jerusalem 1958
Silver gelatin print, 28 × 35.5 cm
The Inge Morath Foundation, New York
© The Inge Morath Foundation/
Magnum Photos
Fig. p. 246

ARNOLD NEWMAN

Pablo Picasso, Vallauris, 1954
Silver gelatin print, 31.7 × 25.2 cm
Sammlung Ludwig, Cologne
© Getty Images, all rights reserved/RBA
Fig. p. 32

Picasso's eye, 1954
Silver gelatin print, 24.2 × 19.2 cm
Sammlung Ludwig, Cologne, gift of
the Gesellschaft für Moderne Kunst
© Getty Images, all rights reserved/RBA
Fig. p. 33

Bill Brandt, 1978
Polaroid, 24 × 19 cm
Museum Ludwig, Cologne/Gruber Collection
© Getty Images, all rights reserved/RBA
Fig. p. 235 bottom

Man Ray, 1960
Silver gelatin print, 24.5 × 19.6 cm
Museum Ludwig, Cologne/Gruber Collection
© Getty Images, all rights reserved/RBA
Fig. p. 244 top

Self-portrait, 1979
© Getty Images, all rights reserved
Fig. p. 247 top

ROBERTO OTERO

Pablo Picasso and Edward Steichen,
Notre-Dame de Vie, Mougins 1966
Silver gelatin print, 40.6 × 30.3 cm
Sammlung Ludwig, Cologne
© VG Bild-Kunst, Bonn/RBA
Fig. p. 45

Pablo Picasso in the old bullring at Fréjus,
August 7, 1966
C-print, 30.3 × 40.7 cm
Sammlung Ludwig, Cologne
© VG Bild-Kunst, Bonn/RBA
Fig. p. 196 top

Pablo Picasso throws back the cap to the
budding bullfighter, Fréjus, August 7, 1966
C-print, 30.3 × 40.6 cm
Sammlung Ludwig, Cologne
© VG Bild-Kunst, Bonn/RBA
Fig. p. 196 bottom

"I'm the most important Picasso
collector in the world," Notre-Dame de Vie,
Mougins, August 6, 1966
Silver gelatin print, 40 × 30 cm
Sammlung Ludwig, Cologne
© VG Bild-Kunst, Bonn/RBA
Fig. p. 199

Pablo Picasso with a plaster cast of Michel-
angelo's *Dying Slave* in the sculpture studio at
Notre-Dame de Vie, Mougins, October 1966
Silver gelatin print, 40.5 × 30.3 cm
Sammlung Ludwig, Cologne
© VG Bild-Kunst, Bonn/RBA
Fig. p. 202

Pablo Picasso with Daniel-Henry Kahnweiler,
Notre-Dame de Vie, Mougins 1964
Silver gelatin print, 28 × 33 cm
Sammlung Ludwig, Cologne
© VG Bild-Kunst, Bonn/RBA
Fig. p. 203 top left

Pablo Picasso with Manuel Pallarès in the
garden at Villa La Californie, Cannes 1964
Silver gelatin print, 26 × 37.5 cm
Sammlung Ludwig, Cologne
© VG Bild-Kunst, Bonn/RBA
Fig. p. 203 top right

Pablo Picasso and Rafael Alberti, backlit,
Notre-Dame de Vie, Mougins 1965
Silver gelatin print, 30 × 40 cm
Sammlung Ludwig, Cologne
© VG Bild-Kunst, Bonn/RBA
Fig. p. 203 bottom

Pablo Picasso heads for his Hispano Suiza,
which he has owned since 1933, accompanied
by Myriam Hepp, Notre-Dame de Vie,
Mougins, June 1966
C-print, 30.3 × 40.8 cm
Sammlung Ludwig, Cologne
© VG Bild-Kunst, Bonn/RBA
Fig. p. 204

Pablo Picasso in a garden at
Villa La Californie, Cannes 1970
C-print, 45 × 30 cm
Sammlung Ludwig, Cologne
© VG Bild-Kunst, Bonn/RBA
Fig. p. 205

View of the sculpture studio in Notre-Dame
de Vie, Mougins, August 6, 1966
Silver gelatin print, 30 × 40 cm
Sammlung Ludwig, Cologne
© VG Bild-Kunst, Bonn/RBA
Fig. p. 206

Pablo Picasso prepares for a photo session, holding the sculpture *Head of a Woman,* Notre-Dame de Vie, Mougins, November 1965
C-print, 29 × 39 cm
Sammlung Ludwig, Cologne
© VG Bild-Kunst, Bonn/RBA
Fig. p. 207 top

Pablo Picasso, in costume for a photo session, with *Head of a Woman* on his head, Notre-Dame de Vie, Mougins, November 1965
C-print, 29 × 39 cm
Sammlung Ludwig, Cologne
© VG Bild-Kunst, Bonn/RBA
Fig. p. 207 bottom

Pablo Picasso sitting in his favorite chair, Notre-Dame de Vie, Mougins, August 6, 1966
Silver gelatin print, 30.3 × 40.4 cm
Sammlung Ludwig, Cologne
© VG Bild-Kunst, Bonn/RBA
Fig. p. 208

Pablo Picasso drinking herbal tea after dinner, Notre-Dame de Vie, Mougins, August 1964
Silver gelatin print, 30.3 × 40.5 cm
Sammlung Ludwig, Cologne
© VG Bild-Kunst, Bonn/RBA
Fig. p. 209

IRVING PENN

Pablo Picasso, 1957
Silver gelatin print, 34.1 × 34.1 cm
Museum Ludwig, Cologne/Gruber Collection
© Condé Nast Publications/RBA
Fig. p. 201

Cecil Beaton, 1950
Silver gelatin print, 33.9 × 32.9 cm
Museum Ludwig, Cologne/Gruber Collection
© Condé Nast Publications/RBA
Fig. p. 234

ROLAND PENROSE

Picasso and David Douglas Duncan at Vauvenargues, 1956
Digital print, 12.8 × 19 cm
Lee Miller Archives
© Roland Penrose Estate, England
Fig. p. 240 bottom

Album page assembled by Roland Penrose. Dora Maar photographed by Lee Miller; Lee Miller photographed by Roland Penrose; Picasso photographed by Man Ray, undated
Album page: 22 × 29.5 cm, Dora Maar print: 13 × 12 cm, Lee Miller print: 6.5 × 8.7 cm, Picasso print: 12.6 × 8.6 cm
Lee Miller Archive
© Lee Miller Archives, England
Fig. p. 122

PABLO PICASSO

Self-portrait with Fernande Olivier, Paris, ca. 1910
Silver gelatin print, 20.2 × 25.2 cm
Jeanine Warnod Archive, Paris
© Succession Picasso/VG Bild-Kunst, Bonn/RBA
Fig. p. 18 left

Self-portrait in the studio on Boulevard de Clichy, December 1910
© Succession Picasso/VG Bild-Kunst, Bonn
Fig. p. 18 right

Self-portrait with bare torso and in boxer shorts in front of *Homme assis au verre* in the studio on Rue Schoelcher, 1915–16
© Succession Picasso/VG Bild-Kunst, Bonn
Fig. p. 19 top

Self-portrait in profile, Paris, 1927
Print from original negative
Musée Picasso, Paris, Archives Picasso
© Succession Picasso/VG Bild-Kunst, Bonn
Fig. p. 19 bottom

Lee Miller, 1960
Lee Miller Archives
© Succession Picasso/VG Bild-Kunst, Bonn
Fig. p. 67 right

ROBERT PICAULT

Picasso during the filming of Fréderic Rossif's film, 1950
© RMN/Robert Picault
Fig. p. 156 right

JULIA PIROTTE

World Congress of Intellectuals for Peace in Wrocław, Poland, 1948
Silver gelatin print, 27.5 × 38.1 cm
Collection Musée de la Photographie à Charleroi, Centre d'art contemporain de la Communauté française Wallonie-Bruxelles
© All rights reserved
Fig. p. 69

Self-portrait, Marseille 1943
Silver gelatin print, 17.8 × 24.3 cm
Collection Musée de la Photographie à Charleroi, Centre d'art contemporain de la Communauté française Wallonie-Bruxelles
© All rights reserved
Fig. p. 248

GEORGE PLATT LYNES

Henri Cartier-Bresson, ca. 1930
Silver gelatin print, 23.2 × 18.7 cm
Museum Ludwig, Cologne/Gruber Collection
© Estate of George Platt Lynes/RBA
Fig. p. 237 top

EDWARD QUINN

Picasso in front of his signature for the film *Le mystère Picasso,* Studios de la Victorine, Nice 1955
Vintage print, 17.5 × 22 cm
Edward Quinn Archive, Uerikon
© edwardquinn.com
Fig. p. 4

Villa Notre-Dame de Vie, Mougins 1962
Edward Quinn Archive, Uerikon
© edwardquinn.com
Fig. p. 6

Picasso in his studio Le Fournas, to the left of the door his son Paul, Vallauris 1953
Edward Quinn Archive, Uerikon
© edwardquinn.com
Fig. p. 7

Picasso and Jacqueline, Villa La Californie, Cannes 1956
Edward Quinn Archive, Uerikon
© edwardquinn.com
Fig. p. 8

Picasso amused by a tourist wearing a
Picasso shirt, Vallauris, 1955
Edward Quinn Archive, Uerikon
© edwardquinn.com
Fig. p. 198 top left

Picasso pretending to get arrested at a corrida
in Vallauris (behind him: Jacqueline Roque
and Jean Cocteau), Vallauris, 1955
Silver gelatin print, 18 × 17.5 cm
Edward Quinn Archive, Uerikon
© edwardquinn.com
Fig. p. 198 top right

Picasso dancing with a man dressed as a
woman on the occasion of a bullfight put
on in his honor, Vallauris, 1953
Barite paper, 40 × 50 cm
Edward Quinn Archive, Uerikon
© edwardquinn.com
Fig. p. 198 bottom

Picasso showing his children Claude and
Paloma a photograph of himself as a child
from 1888, Villa La Galloise, Vallauris 1953
Barite paper, 40 × 50 cm
Edward Quinn Archive, Uerikon
© edwardquinn.com
Fig. p. 230

WILLY RIZZO

Picasso landscape, Vallauris, 1952
Lambda print, 48 × 48 cm
Studio Willy Rizzo, Paris
© Willy Rizzo
Fig. p. 166

Picasso, Vallauris, 1952
Lambda print, 48 × 35 cm
Studio Willy Rizzo, Paris
© Willy Rizzo
Fig. p. 167

Picasso seated, Vallauris, 1952
Lambda print, 48 × 48 cm
Studio Willy Rizzo, Paris
© Willy Rizzo
Fig. p. 168

Picasso and *The Goat,* Cannes, 1955
Lambda print, 48 × 36 cm
Studio Willy Rizzo, Paris
© Willy Rizzo
Fig. p. 169

Pablo Picasso, Cannes, 1952
Silver gelatin print, 48 × 48 cm
Studio Willy Rizzo, Paris
© Willy Rizzo
Fig. p. 170

Willy Rizzo with his model, Milan 1962
Silver gelatin print, 48 × 30 cm
Studio Willy Rizzo, Paris
© Willy Rizzo
Fig. p. 249 bottom

JACQUELINE ROQUE (attributed)

Self-portrait, undated
Silver gelatin print, 28.9 × 20.8 cm
Museu Picasso, Barcelona
© Jacqueline Picasso
Fig. p. 66

Picasso and Jacqueline with a
ceramic sculpture, undated
Silver gelatin print, 20.8 × 28.9 cm
Museu Picasso, Barcelona
© Jacqueline Picasso
Fig. p. 129 top

Jacqueline with a ceramic sculpture, undated
Silver gelatin print, 20.8 × 28.9 cm
Museu Picasso, Barcelona
© Jacqueline Picasso
Fig. p. 129 bottom

GOTTHARD SCHUH

Portrait of Pablo Picasso at the opening
of his exhibition at Georges Petit, Paris, 1932
Silver gelatin print, 17.6 × 20 cm
Fotostiftung Schweiz, Winterthur
© Gotthard Schuh
Fig. p. 94

MICHEL SIMA

Picasso in Vallauris, ca. 1950
Silver gelatin print, 48.2 × 47.9 cm
Galerie Fischer Auktionen AG, Lucerne
© Courtesy Dr. Kuno Fischer Galerie,
Lucerne
Fig. p. 158

Picasso and the owl, 1946
Silver gelatin print, 36 × 27 cm
Galerie Fischer Auktionen AG, Lucerne
© Courtesy Dr. Kuno Fischer Galerie,
Lucerne
Fig. p. 159

Pablo Picasso, 1946
Silver gelatin print, 30.4 × 30.3 cm
Galerie Fischer Auktionen AG, Lucerne
© Courtesy Dr. Kuno Fischer Galerie,
Lucerne
Fig. p. 160

Picasso next to *Centaur and Ship,*
Antibes, 1946
Galerie Fischer Auktionen AG, Lucerne
© Courtesy Dr. Kuno Fischer Galerie,
Lucerne
Fig. p. 161

Picasso in front of the triptych *Satyr, Faun,
and Centaur with Trident,* Château Grimaldi,
Antibes, 1946
Silver gelatin print, 27 × 36.1 cm
Galerie Fischer Auktionen AG, Lucerne
© Courtesy Dr. Kuno Fischer Galerie,
Lucerne
Fig. p. 162

Picasso in Vallauris, ca. 1950
Silver gelatin print, 35.8 × 25.6 cm
Galerie Fischer Auktionen AG, Lucerne
© Courtesy Dr. Kuno Fischer Galerie,
Lucerne
Fig. p. 163

Double portrait Sima/Picasso with
self-timer, 1946
Silver gelatin print, 27.2 × 35.9 cm
Galerie Fischer Auktionen AG, Lucerne
© Courtesy Dr. Kuno Fischer Galerie,
Lucerne
Fig. p. 250 bottom

BERT STERN

Irving Penn, 1962
Silver gelatin print, 19.8 × 19.6
Museum Ludwig, Cologne/Gruber Collection
© Bert Stern/RBA
Fig. p. 247 bottom

HORST TAPPE

Pablo Picasso, Cannes, 1963
Silver gelatin print, 30 × 40 cm
Fondation Horst Tappe, Morges
© Fondation Horst Tappe
Fig. p. 221

Self-portrait, ca. 1961
© Fondation Horst Tappe
Fig. p. 251 top

ULRICH TILLMANN

Pablo Gruber, 1984
Silver gelatin print, barite print, 30 × 30 cm
Privately owned
© Ulrich Tillmann
Fig. p. 40

ANDRÉ VILLERS

Pablo Picasso, Cannes, 1955
Silver gelatin print, 27.3 × 37.3 cm
Peter und Irene Ludwig Stiftung, Aachen
© André Villers
Fig. p. 31

Picasso with Pierre Daix, Vallauris, 1954
© André Villers
Fig. p. 48

Filming of *Le mystère Picasso* by Henri-Georges
Clouzot, Studios de la Victorine, Nice 1955
Silver gelatin print, 37.4 × 27.5 cm
Peter und Irene Ludwig Stiftung, Aachen
© André Villers
Fig. p. 134

Filming of *Le mystère Picasso* by Henri-Georges
Clouzot, Studios de la Victorine, Nice 1955
Silver gelatin print, 36.2 × 27 cm
Peter und Irene Ludwig Stiftung, Aachen
© André Villers
Fig. p. 135

Vallauris, 1954
Silver gelatin print, 27.4 × 37.4 cm
Peter und Irene Ludwig Stiftung, Aachen
© André Villers
Fig. p. 178

Picasso's hands, ca. 1960
Silver gelatin print, 40.5 × 30.5 cm
Museu Picasso, Barcelona
© André Villers
Fig. p. 179

With revolver and hat given to him
by Gary Cooper, Cannes, 1958
Silver gelatin print, 27 × 37 cm
Peter und Irene Ludwig Stiftung, Aachen
© André Villers
Fig. p. 180

Cannes, 1958
Silver gelatin print, 37.5 × 27.5 cm
Peter und Irene Ludwig Stiftung, Aachen
© André Villers
Fig. p. 181

Picasso as Popeye, Cannes, 1957
Silver gelatin print, 27.4 × 37.4 cm
Peter und Irene Ludwig Stiftung, Aachen
© André Villers
Fig. p. 185

Picasso and André Villers:
Self-portraits in mirror, Cannes, 1955
Silver gelatin print, 27 × 36.5 cm
Peter und Irene Ludwig Stiftung, Aachen
© André Villers
Fig. p. 251 bottom

LUTZ VOIGTLÄNDER

Maki Fingers, 2002, Photo: Lutz Voigtländer,
concept and idea: Philip Grube
© Lutz Voigtländer
Fig. p. 24 top right

HANNS ROBERT WELTI

Picasso and Gotthard Schuh, 1932
Silver gelatin print, 22 × 17.5 cm
Fotostiftung Schweiz, Winterthur
© Hanns Robert Welti
Fig. p. 250 top

Posters

ANONYMOUS
Pablo Picasso: Paintings and drawings
since 1944, Baden-Baden 1968
Offset, 83.2 × 59 cm, photo: Edward Quinn
Deutsches Plakat Museum –
Museum Folkwang, Essen
Fig. p. 15, second from right

ANONYMOUS
Pablo Picasso Live: Photography by
Edward Quinn, Bottrop 1995
Offset, 84 × 59.5 cm, photo: Edward Quinn
Deutsches Plakat Museum –
Museum Folkwang, Essen
Fig. p. 15, second from left

ANONYMOUS
Le mystère Picasso by Henri-Georges Clouzot,
France 1956
Screenprint, 86.2 × 61.6 cm, photo: Man Ray
Cinémathèque Suisse Collection, Lausanne
Fig. p. 130

STEPHAN P. MUNSING
Pablo Picasso: Graphic works 1905–1952,
Cologne 1953
Offset, 56 × 84 cm, photo: Herbert List
Deutsches Plakat Museum –
Museum Folkwang, Essen
Fig. p. 15 left

**FRANZISKA SCHOTT &
MARCO SCHIBIG**
Kurt Blum: The photographer in the
midst of artists, Bern 1992
Screenprint, 100 × 70 cm, photo: Kurt Blum
Deutsches Plakat Museum –
Museum Folkwang, Essen
Fig. p. 15 right

*The editors have made every effort to
identify all rights holders, but in some
cases were, despite thorough research,
unsuccessful; please contact the
Museum Ludwig with any questions.*

Selected Bibliography

Monographs and Articles

Richard Avedon: Portraits. New York et al., 2002.

Baldassari, Anne. *Picasso and Photography: The Dark Mirror.* Paris, 1997.

Barthes, Roland. *Camera Lucida: Reflections on Photography.* New York, 1981.

Bauret, Gabriel. *Lucien Clergue.* Paris, 2007.

Berger, John. *The Success and Failure of Picasso.* London, 1965.

Beslon, Renée. *Rogi André: Portraits.* Paris, 1981.

Billeter, Erika. *Michel Sima: Künstler im Atelier.* Zurich et al., 2008.

Bondi, Inge. *Chim: The Photographs of David Seymour.* Boston et al., 1996.

Bouqueret, Christian. *Les femmes photographes de la nouvelle vision en France, 1920–1940.* Paris, 1998.

Bourcier, Noël, et al., *Denise Colomb* (Collection Donations, vol. 5). Besançon, 1992.

Brassaï. *Conversations with Picasso.* Translated by Jane Marie Todd. Chicago, 2002.

Brookman, Philip. *Arnold Newman.* Cologne et al., 2000.

Butor, Michel. *Picasso's Studios: The Alembic of Forms.* Paris, 2003.

Calvocoressi, Richard. *Lee Miller: Begegnungen.* Berlin, 2002.

Caws, Mary Ann. *Dora Maar: With and without Picasso.* London, 2000.

Caws, Mary Ann. *Pablo Picasso.* Chicago, 2005.

Clergue, Lucien. *Picasso mon ami.* Paris, 1993.

Colomb, Denise. *Portraits d'artistes: Les années 50–60.* Paris, 1986.

Combalía, Victoria. *Dora Maar: Fotógrafa.* Valencia, 1995.

Cowling, Elizabeth. *Visiting Picasso: The Notebooks and Letters of Roland Penrose.* London, 2006.

Daix, Pierre. *Picasso.* Paris, 2007.

Désalmand, Paul. *Picasso par Picasso: Pensées et anecdotes.* Paris, 1996.

Dufour, Bernard. "Rogi André: Negative Work." *Art Press* (November 20, 1999).

Duncan, David Douglas. *The Private World of Pablo Picasso.* New York, 1958.

Duncan, David Douglas. *Picasso's Picassos: The Treasures of La Californie.* New York, 1968.

Duncan, David Douglas. *Goodbye Picasso.* New York, 1974.

Duncan, David Douglas. *The Silent Studio.* New York, 1976.

Duncan, David Douglas. *Viva Picasso: A Centennial Celebration.* New York, 1980.

Duncan, David Douglas. *Picasso and Jacqueline.* London, 1988.

Duncan, David Douglas. *Picasso Paints a Portrait.* New York, 1996.

Duncan, David Douglas. *Picasso & Lump: A Dachshund's Odyssey.* New York, 2006.

Faber, Monika. *Madame d'Ora, Wien – Paris: Portraits aus Kunst und Gesellschaft 1907–1957.* Vienna and Munich, 1983.

Franck, Dan. *Bohemian Paris: Picasso, Modigliani, Matisse, and the Birth of Modern Art.* New York, 1998.

Gyenes, Juan. *Barátom, Picasso.* Budapest, 1984.

Gilot, Françoise, and Carlton Lake. *Life with Picasso.* New York, 1964.

Hagebölling, Heide. *Pablo Picasso in Documentary Films: A Monographic Investigation of the Portrayal of Pablo Picasso and His Creative Work in Documentary Films 1945–1975* (Europäische Hochschulschriften, vol. 28). Frankfurt et al., 1988.

Hierl, Hubertus, and Werner Spies. *Picasso beim Stierkampf.* Cologne, 2002.

Jacob, Max. *Les amitiés & les amours: Correspondances* (vols. 1 and 2). Paris, 2003.

Kahnweiler, Daniel-Henry. *Les sculptures de Picasso: Photographies de Brassaï.* Paris, 1948.

Kempe, Fritz, and Museum für Kunst und Gewerbe, eds. *Nicola Perscheid, Arthur Benda, Madame d'Ora* (Dokumente der Photographie, vol. 1). Hamburg, 1980.

Klüver, Billy. *Ein Tag mit Picasso. 12. August 1916: Photographien von Jean Cocteau.* Stuttgart, 1993.

Koetzle, Hans-Michael. *René Burri: Fotografien.* Berlin, 2004.

Lartigue, Jacques-Henri. *Le choix du bonheur.* Besançon, 1992.

Lord, James. *Picasso and Dora: A Personal Memoir.* New York, 1993.

Lottman, Herbert R. *Man Ray's Montparnasse.* New York, 2001.

Malraux, André. *Das Haupt aus Obsidian.* Frankfurt, 1975.

Maywald, Wilhelm. *Portrait + Atelier. Photos: Arp, Braque, Chagall, Le Corbusier, Laurens, Léger, Matisse, Miró, Picasso, Rouault, Utrillo, Villon.* Zurich, 1958.

Menzel-Ahr, Katharina. *Lee Miller: Kriegskorrespondentin für Vogue. Fotografien aus Deutschland 1945.* Marburg, 2005.

Inge Morath: Fotografien 1952–1992. With texts by Inge Morath und Margit Zuckriegl. Salzburg, 1992.

Newman, Arnold. *Five Decades.* Foreword by Arthur Ollman. San Diego et al., 1986.

O'Brian, Patrick. *Pablo Picasso: A Biography.* New York, 1976.

Olivier, Fernande. *Neun Jahre mit Picasso: Erinnerungen aus den Jahren 1905–1913.* Munich, 1959.

Ollier, Brigitte, and Elisabeth Nora. *Rogi André: Photo sensible.* Paris, 1999.

Palau i Fabre, Josep. *Picasso: Kindheit und Jugend eines Genies 1881–1907.* Munich, 1981.

Penrose, Antony. *The Lives of Lee Miller.* London, 1985.

Penrose, Roland. *Picasso: His Life and Work,* 3rd edition. London, 1981.

Picasso: Die Sammlung des Museums Ludwig Köln. Cologne, 2007.

Picasso, Pablo. *Wort und Bekenntnis: Die gesammelten Zeugnisse und Dichtungen.* Zurich, 1954.

Picasso, Pablo. *Über Kunst: Aus Gesprächen zwischen Picasso und seinen Freunden.* Zurich, 1988.

Picasso, Pablo. *Gedichte.* Edited by Androula Michaël. Munich, 2007.

Preimesberger, Rudolf, et al., eds. *Porträt* (Geschichte der klassischen Bildgattungen in Quellentexten und Kommentaren, vol. 2). Berlin, 1999.

Quinn, Edward. *Picasso: Photographs from 1951–1972.* New York, 1980.

Quinn, Edward, et al. *Picasso.* Frankfurt et al., 1975.

Quinn, Edward, and Pierre Daix. *Picasso: Mensch und Bild.* Stuttgart, 1987.

Quinn, Edward, and Roland Penrose. *Picasso at Work: A Photographic Study.* New York, 1958.

Richardson, John. *A Life of Picasso:* vol. 2: *1907–1917.* New York, 1996.

Rizzo, Willy. *Starsociety.* Text by Jean-Pierre de Lucovich. Munich et al., 1994.

Rosenblum, Naomi. *A History of Women Photographers,* 3rd edition. New York, 2010.

Scheler, Max, ed. *Herbert List: Portraits. Kunst und Geist um die Jahrhundertmitte.* Hamburg, 1977.

Slusher, Katherine. *Lee Miller und Roland Penrose: The Green Memories of Desire.* Munich et al., 2007.

Sobik, Helge. *Picassos Häuser.* Düsseldorf, 2009.

Sobik, Helge. *Picasso an der Riviera.* Düsseldorf, 2010.

Spies, Werner. *Kontinent Picasso: Ausgewählte Aufsätze aus zwei Jahrzehnten.* Munich, 1988.

Stein, Gertrude. *Picasso: Sämtliche Texte 1909–1938.* Zurich and Hamburg, 2003.

Sturman, John. "Julia Pirotte." *Artnews* (November 1984).

Vallentin, Antonina. *Pablo Picasso.* Frankfurt, 1958.

Warnod, Jeanine. *La ruche & Montparnasse.* Geneva and Paris, 1978.

Catalogues

Picasso in Antibes. Text by Dor de la Souchère. Inv. cat. Musée de la Ville d'Antibes/Musée Picasso. Munich, 1960.

Portrait of Picasso. Edited by Roland Penrose. Exh. cat. The Museum of Modern Art. New York, 1971.

Sammlung Gruber: Photographie des 20. Jahrhunderts. Edited by Museum Ludwig. Cologne, 1984.

Picasso at Work at Home: Selections from the Marina Picasso Collection with Additions from the Los Angeles County Museum of Art and the Museum of Modern Art, New York. Exh. cat. Center for the Fine Arts. Miami, Florida, 1985.

Faber, Monika. *Madame d'Ora, Vienna and Paris 1907–1957: The Photography of Dora Kallmus.* Exh. cat. Vassar College Art Gallery. Poughkeepsie, New York, 1987.

Picasso vu par Brassaï. Edited by Marie-Laure Bernadac. Exh. cat. Musée national Picasso. Paris, 1987.

Faces of Picasso: Picasso vu par les photographes. Edited by Marie-Laure Bernadac. Exh. cat. Musée national Picasso. Paris, 1991.

Picasso: Die Sammlung Ludwig. Zeichnungen, Gemälde, Plastische Werke. Edited by Evelyn Weiss with Maria Teresa Ocaña. Exh. cat. Museu Picasso, Barcelona; Museum Ludwig, Cologne; Germanisches Nationalmuseum, Nuremberg. Munich, 1992.

Picasso and Things. Edited by Jean Sutherland Boggs. Exh. cat. The Cleveland Museum of Art; the Philadelphia Museum of Art; Galeries Nationales du Grand Palais, Paris. Cleveland, 1992.

Picasso vu par Villers: Photographies. Exh. cat. Musée des Beaux-Arts de Rennes, 1992.

Picasso and the Weeping Women: The Years of Marie-Thérèse Walter & Dora Maar. Edited by Judi Freeman. Exh. cat. Los Angeles County Museum of Art; the Metropolitan Museum of Art, New York; the Art Institute of Chicago. Los Angeles, 1994.

Max Jacob et Picasso. Exh. cat. Musée des Beaux-Arts, Quimper; Musée national Picasso. Paris, 1994.

Julia Pirotte: Une photographe dans la Resistance. Exh. cat. Musée de la Photographie à Charleroi, Centre d'Art contemporaine de la Communauté française de Belgique. Beaumont, 1994.

Man Ray – Neues wie Vertrautes: Fotografien 1919–1949. Exh. cat. Kunstmuseum Wolfsburg. Ostfildern, 1994.

Inge Morath und die Société Imaginaire. Edited by Konrad-Adenauer-Stiftung et al. Exh. cat. Dresdner Schloss. Dresden, 1995.

Picasso et la photographie. "À plus grande vitesse que les images." Edited by Anne Baldassari. Exh. cat. Musée national Picasso. Paris, 1995.

Roberto Otero: La mayor colección de Picassos del mundo. Exh. cat. Galerie Gmurzynska. Cologne, 1996.

Picasso and Portraiture: Representation and Transformation. Edited by William S. Rubin. Exh. cat. The Museum of Modern Art, New York; Galerie Nationales du Grand Palais, Paris. London, 1996.

Hanns Hubmann: Besuch bei Picasso, 55 Fotografien 1957. Exh. cat. Galerie Klewan. Munich, 1997.

Le miroir noir: Picasso, sources photographiques 1900–1928. Edited by Anne Baldassari. Exh. cat. Musée national Picasso. Paris, 1997.

Edward Quinn – Künstlerphotograph. Edited by the Stiftung Hans Arp und Sophie Taeuber-Arp. Exh. cat. Bahnhof Rolandseck. Remagen-Rolandseck, 1998.

Inge Morath: Das Leben als Photographin. Exh. cat. Kunsthalle Vienna. Munich, 1999.

Picasso, leyenda de un siglo: La mirada de André Villers. Exh. cat. Espacio para el Arte de Caja Madrid. Barcelona, Madrid, 2000.

Dora Maar: Exh. cat. Haus der Kunst, Munich; Musées de Marseille, Centre de la Vieille Charité; Centre Cultural Tecla Sala, L'Hospitalet, Barcelona; Munich, 2001.

Objectif Picasso: Vu par les photographes. Exh. cat. Galerie Kamel Mennour. Paris, 2001.

Picasso: The Artist's Studio. Edited by Michael A. FitzGerald. Exh. cat. Wadsworth Atheneum Museum of Art, Hartford; the Cleveland Museum of Art. New Haven et al., 2001.

Dora Maar: La fotografía, Picasso y los surrealistas. Exh. cat. Centro Cultural Metropolitano Tecla Sala, L'Hospitalet de Llobregat. Tecla Sala, 2002.

Cecil Beaton: Porträts. Edited by Terence Pepper, et al. Exh. cat. Kunstmuseum Wolfsburg. Ostfildern-Ruit, 2005.

Robert Capa: Retrospektive. Edited by Laure Beaumont-Maillet. Exh. cat. Galerie de photographie, Paris; Martin-Gropius-Bau, Berlin, 2005.

Ateliers de artistas: Fotografías de Willy Maywald. Exh. cat. Fundação Arpad Szenes-Vieira da Silva. Lisbon, 2005.

Pablo Picasso (Málaga 1881–1973 Mougins). Prints and Photos: Ausgewählte Originalgraphiken des Künstlers und photographische Portraits von Edward Quinn (Dublin 1920–1997 Altendorf, CH) gegenübergestellt. Exh. cat. Galerie Boisserée. Cologne, 2005.

Ulrich Mack – Françoise Gilot: Ein photographisches Porträt. Graphikmuseum Pablo Picasso, Münster; Kunstverein Ludwigsburg; Kunstsammlungen Chemnitz. Wabern/Bern, 2006.

Picasso – Dora Maar: Das Genie und die Weinende. Edited by Anne Baldassari. Exh. cat. Musée national Picasso, Paris; National Gallery of Victoria, Melbourne. Paris, 2006.

Picasso – Dora Maar: Il faisait tellement noir . . . Edited by Anne Baldassari. Exh. cat. Musée national Picasso, Paris; National Gallery of Victoria, Melbourne. Paris, 2006.

Picasso: Malen gegen die Zeit. Edited by Werner Spies. Exh. cat. Albertina, Vienna; K20 Kunstsammlung Nordrhein-Westfalen, Düsseldorf. Ostfildern, 2006.

Picasso en la plaza de toros: Fotografiás de Hubertus Hierl. Exh. cat. Fundación Picasso. Museo Casa Natal Ayuntamiento de Málaga, 2006.

Lee Miller: Picasso en privado. Exh. cat. Museu Picasso. Barcelona, 2007.

Picasso visto par Antonio Cores: Historia y fotografías de un encuentro. Exh. cat. Museo de Bellas Artes de Asturias. Oviedo, 2007.

Witkovsky, Matthew S. *Foto: Modernity in Central Europe, 1918–1945.* Exh. cat. National Gallery of Art, Washington, D.C.; Scottish National Gallery of Modern Art, Edinburgh. New York, 2007.

Man Ray: Despreocupado pero no indiferente / Unconcerned but Not Indifferent. Exh. cat. Museo Colecciones ICO, Madrid; Sede Fundación Caixa Galicia, A Coruña; La Pinacothèque de Paris; Martin-Gropius-Bau, Berlin; MAN_Museo d'Arte Provincia di Nuoro; Fotomuseum Den Haag. Madrid, 2008.

Lee Miller y Picasso: Evocación y recuerdo. Exh. cat. Fundación Picasso, Museo Casa Natal, Málaga, 2008.

Picasso: L'atelier des combles. Photographies de Michel Sima. Exh. cat. Musée de la Ville d'Antibes/Musée Picasso. Paris, 2008.

Denise Colomb aux Antilles: de la légende à la réalité, 1948–1958. Exh. cat. Jeu de Paume, Hôtel de Sully. Paris, 2009.

La subversion des images – surréalisme, photographie, film. Exh. cat. Centre Pompidou, Paris; Fotomuseum Winterthur; Instituto de Cultura, Fundación Mapfre, Madrid. Paris, 2009.

Picasso. Fotògraf d'Horta: Instàntanies del cubism, 1909. Edited by Elias Gaston Membrado. Exh. cat. Convent de Sant Salvador, Horta de Sant Joan; Museu Picasso. Barcelona, 2009.

Picasso Mosqueteros. Edited by John Richardson. Exh. cat. Gagosian Gallery. New York, 2009.

FitzGerald, Michael. *Picasso: Im Atelier des Künstlers.* Exh. cat. Graphikmuseum Pablo Picasso Münster. Munich, 2010.

Picasso: Die erste Museumsausstellung 1932. Edited by Tobia Bezzola. Exh. cat. Kunsthaus Zurich. Munich et al., 2010.

Picasso – Peace and Freedom. Edited by Christoph Grunenberg and Lynda Morris. Exh. cat. Tate Liverpool; Albertina, Vienna; Louisiana Museum of Modern Art, Humlebaek. London, 2010.

Index
of Names

Author Biographies

PIERRE DAIX Pierre Daix (b. 1922) interrupted his studies in history in the fall of 1940 to join the resistance; he was arrested and deported to the Mauthausen concentration camp. After his return in 1945 he met Picasso, who asked him for his opinion of the painting *The Charnel House*. In 1953 Daix caused a scandal by publishing his "Portrait of Stalin" in the weekly *Les lettres françaises,* of which he was editor in chief. In 1964 he published his first biography of Picasso, and later, with Picasso's help, the catalogue raisonné of Picasso's work from 1900–1906 and the catalogue of Cubism 1907–1916. He has been involved in many of Picasso's exhibitions, including *Les Demoiselles d'Avignon* (1988), *Braque and Picasso: Pioneering Cubism* (1989), and *Picasso et les maîtres* (2009).

FRIEDERIKE MAYRÖCKER was born in Vienna in 1924, where she still lives today. From 1954 until his death in June 2000, she was closely associated with the poet Ernst Jandl. A winner of the Georg Büchner Prize, her most recent publications include *Requiem für Ernst Jandl* (2001), *Magische Blätter I–V* (2001), *Gesammelte Prosa 1949–2001* (2001), *Mein Arbeitstirol: Gedichte* (2003), *Die kommunizierenden Gefäße* (2003), *Gesammelte Gedichte 1939–2003* (2004), *Und ich schüttelte einen Liebling* (2005), *Liebesgedichte* (2006), *Magische Blätter VI* (2007), *Paloma* (2008), *Scardanelli* (2009), *Jimi* (2009), *dieses Jäckchen (nämlich) des Vogel Greif* (2009), *ich bin in der Anstalt. Fusznoten zu einem nichtgeschriebenen Werk* (2010), and *vom Umhalsen der Sperlingswand, oder 1 Schumannwahnsinn* (2011).

KATHERINE SLUSHER is an art curator and writer based in Barcelona who has published widely on photography and contemporary art. She is the author of the books *David Goldblatt Speaks with Katherine Slusher: Conversations with Photographers* (2011) and *Lee Miller and Roland Penrose: The Green Memories of Desire* (2007), and has contributed to numerous exhibition catalogues, among them: *Roland Penrose and Surrealism: My Windows Look Sideways* (2008), *Lee Miller: Picasso in Private* (2007), *Thy Brother's Keeper* (2006), *Alex Harris: Islands in Time* (2000), and *Vilallonga: Poetic Symbolism from Barcelona* (2000).

KERSTIN STREMMEL (b. 1965) studied art history and German in Cologne and Bonn and earned her doctorate in 2000 with the dissertation *Geflügelte Bilder: Neuere fotografische Repräsentationen von Klassikern der bildenden Kunst*. She works as a curator and author for, among others, *Neue Zürcher Zeitung,* and taught for many years at the Hochschule für Gestaltung und Kunst in Zurich and at the University of Cologne. Her publications include, among many catalogue essays, the monograph *Realism* (2004) and *Frame #1* and *#2*, two photography annuals she edited.

Acknowledgments

Thank you to the lenders:

Museu Picasso, Barcelona (Pepe Serra Villalba, Malén Gual Pascual, Anna Fàbregas i Sauret, Margarida Cortadella Segura); Association des Amis de Jacques Henri Lartigue, Charenton-Le Pont (Charles-Antoine Revol); Musée de la Photographie, Charleroi (Marc Vausort, Stéphanie Bliard); Lee Miller Archives – The Penrose Collection, Chiddingly (Tony Penrose, Ami Bouhassane); Médiathèque de l'architecture et du patrimoine/fonds Denise Colomb, Fort de Saint-Cyr (Marie Robert, Jérôme Legrand); Deichtorhallen Hamburg (F. C. Gundlach, Sabine Schnakenberg); Herbert List & Max Scheler Estate, Hamburg (Peer-Olaf Richter, Michael Scheler); Museum für Kunst und Gewerbe Hamburg (Sabine Schulze, Harald Dubau); Galerie Fischer, Luzern (Kuno Fischer); Museo Nacional Centro de Arte Reina Sofía, Madrid (Manuel J. Boja-Villel, Rosario Peiró Carrasco); Association Willy Maywald, Maisons-Laffitte (Jutta Niemann); Atelier Robert Doisneau, Montrouge (Francine Deroudille, Annette Doisneau); Fondation Horst Tappe, Morges (Sarah Benoit); Münchner Stadtmuseum (Ulrich Pohlmann); International Center of Photography, New York (Brian Wallis, Erin Barnett, Cynthia Young); Man Ray Trust, New York (Stephanie Browner, Eric Browner); The Inge Morath Foundation, New York (John Jacob); The Richard Avedon Foundation, New York (Michelle Franco); Estate Brassaï, Paris (Mme et M. Ribeyrolles, Agnès de Gouvion Saint Cyr); Centre national d'art et de culture Georges Pompidou, Paris (Alfred Pacquement, Quentin Bajac, Olga Makhroff); Fondation Henri Cartier-Bresson, Paris (Agnès Sire, Aude Rimbault); Musée Carnavalet, Paris (Jean-Marc Lèry, Françoise Reynaud, Jean-Baptiste Woloch); Willy and Dominique Rizzo, Paris; Jeanine Warnod, Paris; Yousuf Karsh Trust, Santa Cruz/Camera Press, London (Jason Christian, Elizabeth Kerr); Edward Quinn Archive, Uerikon (Ursula and Wolfgang Frei); Fotostiftung Schweiz, Winterthur (Sabine Münzenmaier); Lars Netopil and David Pitzer, Wetzlar, as well as those who wish to remain anonymous

Thank you for advice and support:

Michael Albers, Thomas Möbus, Marion Mennicken, Leon Sinowenka, Rheinisches Bildarchiv, Cologne; Jean-Louis Andral, Musée Picasso, Antibes; Bankhaus Sal. Oppenheim, Cologne; Christel Fallenstein, Vienna; Tatyana Franck, Paris; Sylvie Fresnault, Musée national Picasso, Paris; Gesellschaft für Moderne Kunst am Museum Ludwig, Cologne; Agnès de Gouvion Saint Cyr, Paris; Renate Gruber, Cologne; Barbara Hess, Cologne; Simone Klein, Paris; Daniel Kothenschulte, Cologne; Gérard Levy, Paris; Peter und Irene Ludwig Stiftung, Aachen; Priska Pasquer, Cologne; Claude Picasso, Paris; Ulrich Pohlmann, Munich; Françoise Reynaud, Musée Carnavalet, Paris; Ulrich Tillmann, Cologne; Sabine Schnakenberg, Deichtorhallen Hamburg; Ursula Schulz-Dornburg, Düsseldorf; Pepe Serra Villalba, Museu Picasso, Barcelona; Pierre Smajewski, Tauriers; Patricia Sustrac, Association des Amis de Max Jacob, Bray en Val; Peer-Olaf Richter, Hamburg; André and Chantal Villers, Le Luc; Jeanine Warnod, Paris

This book is published in conjunction with the exhibition

MeMyselfandI. Photo Portraits of Picasso

Museum Ludwig, Cologne September 24, 2011 to January 15, 2012
Museo Picasso Málaga March 5 to June 10, 2012

Museum Ludwig
Heinrich-Böll-Platz
50667 Cologne / Germany
Telephone + 49 221 221-26165
Fax +49 221 221-24114
www.museum-ludwig.de

Museo Picasso Málaga
San Agustín, 8
29015 Málaga / Spain
Telephone +34 952 127-600
Fax +34 952 127-608
www.museopicassomalaga.org

Catalogue

Editor
Kerstin Stremmel
on behalf of Museum Ludwig

Research advisor
Bodo von Dewitz

Editorial assistance
Feride Akgün, Astrid Bardenheuer,
José Antonio Aranda Pérez, Sonja Kruchen,
Natalia Pérez Galufo

Copyediting
Donna Stonecipher

Research
Fondo Fotográfico Roberto Otero, Museo
Picasso Málaga (Juana María Suárez Benítez),
Kunst- und Museumsbibliothek Köln
(Bettina Gembruch, Renate Eimermacher,
Ursula Werner), Alain Willaume

Translations
Alexander Dickow (Max Jacob), Melissa
Hause (Kerstin Stremmel, Biographies),
Liselotte Pope-Hoffmann (Friederike
Mayröcker), Donna Stonecipher (Bio-
graphies), John Tittensor (Pierre Daix)

Graphic design
Kühle und Mozer, Cologne

Typeface Akkurat, Chronicle Deck

Paper LuxoArt Samt New, 150 g/m²

Reproductions
Farbanalyse, Köln

Printing
aprinta druck, Wemding

Binding
Conzella Verlagsbuchbinderei,
Urban Meister GmbH, Aschheim-Dornach

Published by
Hatje Cantz Verlag
Zeppelinstraße 32
73760 Ostfildern
Germany
Telephone +49 711 4405-200
Fax +49 711 4405-220
www.hatjecantz.com

You can find information on this exhibition
and many others at www.kq-daily.de

Hatje Cantz books are available internation-
ally at selected bookstores. For more infor-
mation about our distribution partners please
visit our homepage at www.hatjecantz.com

ISBN 978-3-7757-3199-7 (English edition)
ISBN 978-3-7757-3198-0 (German edition)
ISBN 978-3-7757-3248-2 (Spanish edition)

Printed in Germany

Cover
Denise Colomb, Picasso in Antibes, 1952

Exhibition

Concept
Kerstin Stremmel

Research advisor
Bodo von Dewitz

Design
Bachmann Badie Architekten
Cologne

Educational department
Angelika von Tomaszewski

Public relations
Valeska Schneider
Christiane Wanken

Exhibition architecture
Armin Lüttgen, Leif Lenzner,
Michael Bangert

Conservation
Yvonne Garborini, Heidi Lenning,
Alfred Glasner, Katharina Gruber

Installation team
Ralf Feckler, Axel Kuhn, Paul Eßer,
Jürgen Koll, Saffet Sen

Registrars
Caren Jones, Beatrix Schopp

Administration
Astrid Bardenheuer, Susanne Brentano,
Ilse Probst, Elke Reiff, Mi-Kyung Yoo,
Karsten Zinner